What, After All,
Is a Work of Art?

Joseph Margolis

What, After All, Is a Work of Art?

Lectures in the
Philosophy of Art

The Pennsylvania State University Press
University Park, Pennsylvania

Library of Congress Cataloging-in-Publication Data

Margolis, Joseph, 1924–
 What, after all, is a work of art? : lectures in the philosophy of
art / Joseph Margolis.

 p. cm.
 Includes bibliographical references and index.
 ISBN 0-271-01865-8 (cloth : alk. paper)
 ISBN 0-271-01866-6 (pbk. : alk. paper)
 1. Art—Philosophy. I. Title.
N7445.2.M26 1999
701—dc21 98-41260
 CIP

Copyright © 1999 The Pennsylvania State University
All rights reserved
Printed in the United States of America
Published by The Pennsylvania State University Press
University Park, PA 16802-1003

For Ken-ichi Sasaki
well-remembered among fresh blossoms

Contents

Preface ix

Prologue: Beneath and Beyond the
 Modernism/Postmodernism Debate 1

1 The History of Art After the End of the History of Art 15

2 Relativism and Cultural Relativity 41

3 What, After All, Is a Work of Art? 67

4 Mechanical Reproduction and Cinematic Humanism 101

Epilogue: Interpreting Art and Life 129

Index 139

Preface

After one works long and zealously in any inquiry of choice, what emerges sometimes appears entirely detached from that labor, almost somnambulistically produced. I confess I had just such an impression on completing this small collection of lectures. They seemed initially to be discrete pieces, commissions for rather separate occasions. But now they appear to possess a deeper, tacit unity, if I may say so, then I was ever aware of in working them out separately. Now, on editing the collection, I see that they do indeed intend a grander common theme that cannot be found sufficiently well formed in any single lecture. For instance, the Prologue, on modernism and postmodernism, is drawn from lectures I gave at the Thirteenth International Congress of Aesthetics—in Lahti, Finland, in the summer of 1995—and at the Second International Conference on Philosophy and Culture—held in St. Petersburg, Russia, about a week later. The Prologue had nothing directly to do with preparing the three lectures that follow, which were presented at a number of Japanese universities in the spring of 1997. I had no idea, in writing the first piece, that the other lectures were even in the offing, and I prepared the three lectures mentioned (that is, what have become Chapters 1 through 3) as entirely separate pieces for entirely separate occasions during a marvelous tour in Japan. The final talk (now Chapter 4) was, once again, written in response to an entirely separate invitation to speak to a small group, the Society for the Philosophic Study of Contemporary Visual Arts, meeting in Philadelphia, Pennsylvania, in the winter of 1997.

But the lectures do now confirm the organizing question of the entire set—namely, the sense in which artworks and human selves mutually inform the work of interpreting and understanding one another. In retrospect this is not surprising, for artworks and selves are both culturally fashioned artifacts—of however profoundly different sorts. Their histories are similarly complex, intentionally significant in the same cultural sense and inseparably bound to each other's interpreted careers; as a consequence, their relation-

ship answers the threat of the overwhelming isolation of the life of reflexive consciousness (and meaning) that belongs exclusively to human persons.

Art is one of the principal activities by which we make our alien world familiar and interpretively secure. But it is an endless struggle that proceeds by reinterpreting our historical past—*a fortiori,* that actually changes the meaning of the historical past, hence also the meaning of the accumulating population of artworks—and therefore requires a congenial logic to make sense of the endeavor. I myself find the idea impressively developed in Hegel's lectures on the philosophy of art, though doubtless some will think I betray an anachronistic reading of Hegel in saying so. Perhaps, but I think the idea is the only way to make coherent sense of Hegel's immense conceptual imagination, without falling back to doubtful intuitions about the true *telos* of history. In any case, the four lectures I've collected investigate the principal puzzles (to my mind) obscured by the mistaken focus of the modernism/postmodernism quarrel. The Epilogue is a response gratefully tendered to a suggestion from one of Penn State Press's readers, who had recommended an additional word about the question the final chapter raises. The Epilogue now unifies the arguments of all the separate pieces. That reader was quite right in pointing out the need for a summary word.

The central lectures were given during a stay of three weeks (in the spring of 1997) as an Invited Fellow of the Japan Society for the Promotion of Science (JSPS). My visit coincided with the cherry blossom season in Japan, which I experienced in several cities: Tokyo, Kyoto, and a small resort town near Yamaguchi. My sponsor during the fellowship was Ken-ichi Sasaki, professor of aesthetics at the University of Tokyo, chairman of the department, current editor of the Japanese journal *Aesthetics*, and also my dear friend. He had (it seems to me) arranged the seasons to permit a glimpse of the Japanese sense of the meeting of East and West, viewed through the treatment of citied life within a larger nature, whether by garden or cherry trees or a more explicit conception of alternative forms of civility. I am indebted to him and to a wonderful series of hosts at the University of Kyoto, the University of Hiroshima, the University of Yamaguchi, Keio University, and the University of Tokyo. I single out particularly Professor Ken-ichi Iwaki, professor of philosophy at the University of Kyoto. Yet in saying so, I hope the many others who made my trip such a splendid one will not believe I have forgotten them. A proper list would seem too much like an obligation noted and discharged. Let me simply say that the JSPS has me willingly in its debt, for the opportunity to become acquainted (even slightly) both with the vigorous academic world of Japan

and with a number of excellent talents. I shall say nothing further about Sasaki's original invitation and role as host, except to affirm that I couldn't have been in better hands. What more should be said I reserve for an occasion in which I may myself serve as Sasaki's host.

I have in the text that follows tried to keep the tone of a lecture series. It permits an economy I hadn't noticed before, but it also risks a certain ellipsis and even a touch of unavoidable repetition. I favor it because I imagine one almost hears the speaker's voice, which (I hope) reduces the deadly threat of academic jargon. But that means that I have featured certain strategic turns of thought rather than a ponderous defense of any particular doctrine. The defenses are actually provided, only more lightly than would otherwise have been the case. Apart from that, I must thank Raeshon Fils for putting the manuscript in good form, as she has so many times before; and Sandy Thatcher, director of the Penn State Press, for his familiar mix of efficiency and low-keyed generosity.

Philadelphia, Pennsylvania
February 1999

Prologue
Beneath and Beyond the
Modernism/Postmodernism Debate

When I reflect on the modernism/postmodernism quarrel, I find that I must divide the question. Intuitively, I single out some reasonably well-known views to prompt my remarks. Otherwise, there's not much chance of saying anything useful. When, for instance, I think of the quarrel in terms of modern painting, I single out the views of Clement Greenberg and Rosalind Krauss.[1] When I think of the quarrel in terms of architecture, I find that I must include Robert Venturi's repudiation of the International Style and Charles Jencks's original contrast.[2] When I think of it in terms of film and video, I cannot ignore Fredric Jameson's free-ranging review of late capitalism.[3] When I think of it in literature and literary theory, I find I am

1. For a brief overview, see Joseph Margolis, *Interpretation Radical But Not Unruly: The New Puzzle of the Arts and History* (Berkeley and Los Angeles: University of California Press, 1993), chap. 1. See also Clement Greenberg, "Modernist Painting," *Art and Language* 4 (1965).

2. See Robert Venturi, *Complexity and Contradiction in Architecture* (New York, Museum of Modern Art, 1966); Charles Jencks, *The Language of Post-Modern Architecture* (New York: Rizzoli, 1984), pt. 1; and Charles Jencks, *What Is Post-Modernism?* (London: Academy Editions, 1986).

3. See Fredric Jameson, *Postmodernism, or, The Cultural Logic of Late Capitalism* (Durham: Duke University Press, 1991).

not really sure what to consult at all. I see the advantage of a pertinent and manageable contrast like the one that may be drawn from Michael Riffaterre's and Linda Hutcheon's opposing views (though Riffaterre obviously influenced Hutcheon).[4] Yet neither is linked to the originating discussion in the way the others already mentioned were—in their own bailiwick. For that, I should perhaps have to consider someone like Ihab Hassan.[5] And when I think of the quarrel in philosophical terms, I cannot ignore the three-way circus between Jürgen Habermas, Jean-François Lyotard, and Richard Rorty; although if I dwell too long on the details of their peculiar exchange, I risk losing the possibility of any recuperative postmodernism, for instance, anything as sanguine as what is proposed by Zygmunt Bauman—and perhaps more.[6] And then, I simply find myself in a blind alley.

There is no settled center in the modernism/postmodernism debate. It looks very different from the United States, from Western Europe, from Eastern Europe, and of course from other quarters. The figures I've mentioned in ranging over the separate arts play a somewhat double role in the relevant debates. They are as transient as the modernism/postmodernism debate itself. But they also have an intuitive grip on the deeper, more abiding puzzle that dispute obscures. We are caught in the fashion of the first, but we are not yet prepared for the contest of the second. The debates about the particular arts are noticeably local and specialized. You cannot really discern what is uniformly "postmodernist" in architecture, film, and literature, for instance.

It's a mistake to think that, as one moves from field to field, one is somehow accurately pinpointing a determinate and continuous, relatively homogeneous, converging quarrel between modernists and postmodernists.[7] One is, rather, recommending a way of defining the joints of certain local con-

4. See, for instance, Michael Riffaterre, "Intertextual Representations: On Mimesis as Interpretive Discourse," *Critical Inquiry* 11 (1984); and Linda Hutcheon, *A Poetics of Postmodernism: History, Theory, Fiction* (New York: Routledge, 1988). For an overview, see Margolis, *Interpretation Radical But Not Unruly,* chap. 5.

5. See Ihab Hassan, *Paracriticisms: Seven Speculations of the Times* (Urbana: University of Illinois Press, 1975).

6. See Jürgen Habermas, "Modernity Versus Postmodernity," *New German Review* 22 (1981); Jean-François Lyotard, *The Postmodern Condition: A Report on Knowledge,* trans. Geoff Bennington and Brian Massumi (Minneapolis: University of Minnesota Press, 1984); Richard Rorty, "Habermas and Lyotard on Modernity," *Philosophical Papers,* vol. 2 (Cambridge: Cambridge University Press, 1991); and Zygmunt Bauman, *Postmodern Ethics* (Oxford: Blackwell, 1993).

7. See, for instance, Stefan Morawski, *The Troubles with Postmodernism* (London: Routledge, 1996).

ceptual histories with some sense of being in the middle of a larger transformation one cannot quite fathom. We are engaged here in a prophecy about what grand themes to regard as likely to fall out in defining the seeming *agon* of our world. We sense the need to search for something beyond the obvious.

This is why I've been so casual about dropping names. Later, at appropriate points, I'll pursue one or two of these references—including Clement Greenberg, in whose work the modernism/postmodernism dispute may be made to give way illuminatingly to the deeper questions about what to count as the principal changes in our conception of knowledge and inquiry. The arts, I am convinced, may be shown to provide a better clue than the usual accounts of the natural sciences about how, for instance, to recover "objectivity" at the end of the century. The more familiar frontal quarrels of academic philosophy mislead us here. We need a mode of entry that will elude their peculiarly alert refusal to look beyond the most convenient disputes.

In this regard I am convinced the modernism/postmodernism debate is more a symptom than a full problematic of its own. The different forms the dispute has taken swirl around incommensurable issues and often lead to utterly preposterous judgments. Who can believe, with Krauss, for instance, that postmodernist art simply does away with referential processes altogether? Or that high modernist painting is essentially committed or ought to be (as in Greenberg's view) to not violating the absolute validity of the two-dimensional "flat" surface of easel painting? And who believes, with Lyotard, that second-order "metanarratives" (legitimation) may be discarded without a sustained argument (which would, of course, be legitimative once again)? There are endlessly many silly excesses of this sort that these disputes engender. It is hardly more than an embarrassment to collect them all. The modernists are as bad as the postmodernists. The trick is to penetrate beneath the surface of the ostensible quarrels of the day. There's no question something of importance lurks there, since the entire academy and a good part of the public press are exercised by what appears to be an unending puzzle. But we would do far better to guess at what it all means than to respond in an artless way to the hopeless forms the most persistent quarrels actually take. They have an interest in promoting memorable extremes.

Here is my suggestion. The world has managed to bring itself to the point of wondering aloud whether there is, in our time, a fundamental conceptual transformation in the offing or whether (or in addition) one is already under way that will, or might, eclipse all the canons modernism and

postmodernism have championed or attacked. When I say "the world," I mean of course the world's "representatives" in the academy, who are given to excessive countercharges whenever threatened but who usually lack gifts enough (at such a juncture) to improvise a better option between whatever unacceptable choices may be offered. I suggest that what has been felt more than analyzed concerns the question whether reality and our grasp of it—or of any salient part (the natural and human sciences, the arts, human understanding, politics, or law, for instance)—can still cling to any reliable range of invariant structures, *modal invariances* in particular, or whether, failing such a recovery, we are obliged to concede that reality is a flux and to wonder what that portends for our embattled norms and canons.

Let me offer, here, one small specimen drawn from the immense literature on modernism (or "modernity") to fix our sense of the gathering *agon*. Alasdair MacIntyre, acknowledging incommensurability's role in the diversity of local cultures and histories, chides modernity in the following way:

> This belief in its ability to understand everything from human culture and history, no matter how apparently alien, is itself one of the defining beliefs of the culture of modernity. It is evident in the way the history of art is taught and written, so that the objects and the texts produced by other cultures are brought under our concept of art, allowing us to exhibit what were in fact very different and heterogeneous kinds of objects under one and the same rubric in new artificial neutral contexts in our museums, museums which in an important way have become *the* public buildings of the kind of educated modernity, just as the temple was for Periclean Athens or the cathedral for thirteenth-century France.[8]

MacIntyre is right enough about the conceptual deformation he deplores, but he fails to see the irony in what he says. First of all, the incommensurabilities of "alien" schemes perceived are seen as such by us: they are the horizonal artifacts of our own sensibilities, by which means we "enlarge" our understanding of our own conceptual limitations insofar as we grasp (or at least claim to grasp) the alien incommensurabilities we do. Second, the competence by which we claim to succeed never confirms such success by commanding a neutral level of understanding or by exercising a changeless

8. Alasdair MacIntyre, *Whose Justice? Which Rationality?* (Notre Dame: University of Notre Dame Press, 1988), 385. (Emphasis here and elsewhere in quoted passages is from the original.)

power of reason capable of scanning all the variations of history. The irony is that, in accord with MacIntyre's own sense of modernity, we are all modern and cannot be anything but modern. MacIntyre pretends to have escaped the limitation of history—confirming thereby that he *is* indeed a modernist.[9] In this adjusted sense I take modernity to be no more and no less than the human condition: the temptation—or perhaps, even better, the yielding to the temptation—to believe that the contingent formation of our cognitive powers do not subvert the right to be assured that we perceive the human as well as the natural world in a confirmably neutral way. You begin to glimpse here a deeper puzzle than the postmodernist propounds and the modernist resists.

The question remains whether, within the terms of the "temptation" MacIntyre affords, we are justified in being modernists or postmodernists or whatever else is possible. By "modernism," I mean—or recommend we mean—the claim that, in being modern (ineluctably, trivially), we suppose we do indeed achieve a neutral and objective stance adequate for resolving the whole play of contingency, of local incommensurability, of alien conceptual schemes, historicity, perspectival variety, and the like—that is, the conviction that, whether with regard to physical nature or human culture, we can always discern the "way the world is," appropriately segregated from the perspectived conditions of human inquiry. By "postmodernism," I recommend we mean the denial of modernism's thesis.

Now, the conventional postmodernists, notably Lyotard and Rorty, subscribe (at least implicitly) to what I offer as the postmodernist theme, but they go much further in their arbitrary way, recommending dismantling philosophy altogether and construing such advice as the logical upshot of their own discovery. The consequence of the immense quarrel they set off (a consequence they do not admit) obliges us to consider whether objectivity and neutrality in first-order epistemic matters may be reclaimed by familiar reconstructive efforts applied to the historical drift and apparent effectiveness of our scientific and allied inquiries. I put the philosophical question in local terms, as the postmodernists prefer (quite rightly). But the larger possibility cannot be put down either: there is always a second-order question that such success engenders.

I suppose the double irony of saying all this will not elude you. I am, after all, caught up with diagnosing the inescapable temptation to convert the loss of neutrality and objectivity into its opposite—with respect to both

9. See MacIntyre, *Whose Justice? Which Rationality?* chap. 10.

the modernist's presumption and my own analysis. But the self-referential paradox is much less than meets the eye. What I mean is that the legitimative worry about the modernist's confidence is a brooding fact of life, more than merely encouraged by the entire historical drift of philosophy; hardly put off by any naive, self-serving arguments about the reliability of our own heartfelt beliefs; and now seen to be the intractable worry it is.

There is, of course, a paradox that cannot be ignored, but it is (or may be shown to be) benign enough, *if* (1) neutrality and objectivity are no longer thought to be self-evidently assured, (2) all cognitive privilege is abandoned, (3) we acknowledge that our cognitive powers are historically (hence, contingently and variably) formed, and (4) we concede, as a consequence, that the recovery of objectivity cannot consistently be secured, except, in constructivist terms, under conditions collected as (1)–(3).

Short of reaffirming privilege, there is no alternative unless we abandon legitimated truth and knowledge altogether. About that prospect, postmodernists are understandingly equivocal. For, of course, if fact and knowledge are constructions of some critical sort, then first-order epistemic confidence without second-order legitimation (also a construction) makes no sense at all. (The postmodernist ducks the difficulty.) What I claim is not that we are entitled to reclaim neutrality but that the triangulated puzzle now facing us is unavoidable in our time. We have exhausted the arguments of cognitive privilege; we cannot be put off by the false threat of self-referential paradox. Neither can we convincingly return to the old assurances. We must either reject the entire legitimative enterprise or reclaim our supposed objectivity as no more than a provisional artifact that we may alter and revise unendingly (as we see fit) in accord with whatever (changeably, of course) we take our executive interests to be.

Modernism is the old option championed *now* against the challenge pressed in terms of (1)–(3). Postmodernism is the abandonment of modernism in the face of (1)–(3), or (1)–(4), and, as a consequence, the abandonment of any and every effort to legitimate our truth-claims, our claims to knowledge. To put matters this way is to isolate the *non sequitur* of postmodernism and the stonewalling of modernism. Otherwise, the effort at definition is no more than a caricature of philosophy. You must kick away a very small ladder once you see that there is every reason to go beyond modernism and postmodernism, once you define the contest of our age in its conveniently clichéd way.

I am not recommending any such definition, for it obscures the import of whatever it illuminates. But, rightly read, such a definition does illumi-

nate, in spite of what it obscures. My sense is that Western philosophy has, since the French Revolution, divided its allegiance between items (1)–(2) and (3)–(4) of the tally previously given. That is, as we approach the end of the century—roughly two hundred years after the French Revolution, somewhat less since Hegel's immense contribution reflecting on the Revolution—it has become commonplace to construe the rejection of cognitive privilege as tantamount to the installation of historicity. Of course, the equation fails: no entailment obtains, and all the late currents of philosophy down to the end of the century oppose the lesson. But what you must see is that the reminder of what is perennially modern is tantamount to the defeat of modernism whenever we construe (1)–(2) as actually vindicating (3)–(4).

This is what lurks beneath all the local idiosyncrasies of anti- and postmodernism. This is also what justifies our use and tolerance of the hackneyed distinction. It's not the choice between modernism and postmodernism that counts. It's the recovery of historicity: the admission that thinking has an inherently historied structure, that thinking *is* history, that the norms of argumentative validity, evidence, confirmation and disconfirmation, truth and knowledge, legitimation, rationality, and the rest cannot be captured abstractly ("syntactically," "logically," or "formally," as said in the modernist idiom) but only in the regularized use of interpreted discourse, which (on the argument) is itself historically formed and transformed.[10]

I say that the modernist/postmodernist dispute deflects us from the deeper contest that, largely unperceived, has gripped our age. Philosophically, we are engrossed in the altogether comfortable, familiar, canonical, seemingly straightforward questions of cognitive privilege and legitimation. In reality, we are sensing, we are constantly moving closer to (but never quite embracing), the contest regarding historicity that the apparent modernist/postmodernist contest embodies.

The modernist/postmodernist *agon* is the mark of our distraction. That is why, for instance, Hutcheon's (postmodernist) proposal to discount, as in the novels of E. L. Doctorow, the reasoned disjunction between fiction and reality or between fiction and history is such a brilliantly intuited but altogether wrongheaded displacement of the real issue.[11] The unqualified denial of the distinction—doubtless part of Paul de Man's dreadful legacy, somehow insinuated into de Man's otherwise excellent interpretive readings (a

10. For a fuller sense of this line of reasoning, see Joseph Margolis, *Historical Thought, Constructed World: A Conceptual Primer for the Turn of the Millennium* (Berkeley and Los Angeles: University of California Press, 1995).

11. See Hutcheon, *A Poetics of Postmodernism.*

matter that, for many, is an intolerable embarrassment)—makes complete mincemeat of any serious effort to preserve conceptual coherence.[12] But then, Riffaterre's alternative distinction (the opposed maneuvers intimated at the start of these remarks) is hardly better: that is, the deliberate but inexplicable segregation of "true" reference (in the world) and mere "literary" reference (reference to the literary texts of the literary world modularly separated from the quotidian one).[13] In a word, the refusal to segregate the elements of the first set of notions (Hutcheon's) and the insistence on segregating the elements of the second (Riffaterre's) count as little more than ingenious ways of disallowing the historicity of thought to surface. There you glimpse what strikes me as the most promising diagnosis of our times.

One sees in Hutcheon and Riffaterre, therefore, a pair of revealing symptoms of just how the local streetwise contests between modernism and postmodernism deflect us from the grander but well-nigh invisible question of historicity. Look around you. Nearly all the strong currents in philosophy and in the more philosophically minded work in criticism and the human sciences are now quite ahistorical—often completely entangled in one or another local quarrel of the modernist/postmodernist sort. Modernism signifies an escape from historicity within the bounds of history, and postmodernism signifies the impossibility of such an escape—defined by way of cranky reasons that have nothing to do with the bearing of historicity on the *recovery* of legitimate claims. Self-deception is embedded in accepting the terms of the modernism/postmodernism debate.

You will say that no one denies the relevance of history and context and changing perspectives. True enough. But these words hardly touch on the historicity of thinking, on the very idea that the structure of our concepts—their range, their internal order, their applicability to exemplary cases, pertinent norms of rational assessment in theoretical and practical matters—changes in the course of history and the use of theory, so that the practices of discursive reason change as artifacts of that same history. It's not history but historicity that's scanted. You will find history in Thucydides—and even Aeschylus—but you will not find historicity in either. Because historicity signifies the end of the necessary changelessness of the very structure of

12. See Paul de Man, *Blindness and Insight: Essays in the Rhetoric of Contemporary Criticism,* 2d ed., rev. (Minneapolis: University of Minnesota Press, 1983).

13. See Riffaterre, "Intertextual Representations."

rational thought and, under post-Kantianism, the end of the changelessness of the very structure of the intelligible world. Historicity is the collective change of the structure of encultured thought through the processes of historical life.

If you see that, you also see, beneath the hubbub of the modernism/postmodernism dispute, a deeper contest looming: one between the partisans of modal invariance and the partisans of the flux. My own reading of recent intellectual history confirms that, in the short run, the entire thrust of Western philosophy and allied disciplines has become increasingly ahistorical—that is, opposed to historicity. In philosophy the trend is marked by the colonizing success of Anglo-American analytic philosophy, particularly in France and Germany. In Germany it takes the form of replacing Marx with Kant, with different degrees of thoroughness: for instance, in the salient recent philosophies of Karl-Otto Apel, Ernst Tugendhat, Niklas Luhmann, and Jürgen Habermas. The clearest symptom may be found in the nearly total reversal of the trend toward the fluxive in the early Frankfurt Critical figures, who, however, also obviously longed for the return of the changeless *telos* (or at least the changeless norms) of human nature and reason. In France it takes the form of the exhaustion of postmodernist and poststructuralist extravagance: for instance, in the nearly complete eclipse of such notorious figures as Jacques Derrida, Michel Foucault, Jean-François Lyotard, Gilles Deleuze, and the recovery of theologized philosophy and the frank sense of an intellectual vacuum produced by having exorcised Heidegger—well, partly at least.

I take all this to be a pale reflection of the collapse of the sense of history tethered to, but deeper than, the Gulf War victory and the fate of the Soviet empire. Of course, both events are peculiarly tied to the theme of historicity—that is, to its public reversal—but both are also comic-strip events: they already signify a prior, deeper loss of a genuine grip on history.

We are now experiencing the slow revenge of time: the gathering, renewed, subterranean insistence on historicity. It manifests itself, I claim, in the local, displaced, distorting focus of the modernism/postmodernism dispute. I cannot say when it will return to its full vigor. But you must realize that the modernism/postmodernism dispute is a tame quarrel that ignores the bearing of global forces outside the enclave of the Eurocentric world. Seen thus, modernism is a plea for the old order that, we are assured, will remain more or less in place through a kind of "Enlightenment" tolerance of the somewhat picturesque variety of the customs of different peoples. You

will find evidence in the work of the two principal Kantian liberals of our time: the German Jürgen Habermas, and the American John Rawls.[14] Between them, one senses the near irrelevance of history, except as a field for thought-experiments in which the changeless rules of practical reason find their application in the sheer variety of human life. Although Rawls and Habermas rely on something like a timeless and contextless tribunal of universal Reason elevated beyond the various modes of historically constructed practices of reasoning functioning within a contingently interpreted world, they nowhere provide the evidence that any such competence is actually accessible.

You have my meaning exactly if you see in this the ultimately ahistorical convergence, in practical affairs, between the Kantian forces and the Aristotelian—what I had briefly sampled in mentioning MacIntyre earlier. You have my meaning if you see that that convergence is finally no different when applied to the splinter groups (of philosophy, the arts, the human sciences) already marked by such quarrels as those between Greenberg and Krauss, between Riffaterre and Hutcheon, between Habermas and either Rorty or Lyotard.

The deeper theme—historicity—is too much to spell out here.[15] It represents the single, largest, most original philosophical contribution the post-Revolutionary modern world has made to the armamentarium of the West's conceptual resources. It comes to this: the historicizing of the flux, the denial of necessary invariances *de re* and *de cogitatione,* the historied or horizoned sense of thought itself.

How far concessions will go in the direction of the flux is not entirely pertinent here. Certainly, historicity in the local quarrels the modernists and postmodernists have shared (as in the specimens mentioned) will take us much further in a radical direction than we have yet been. In this regard, you must see the misleading sense in which postmodernism presents itself as radical. In every salient instance—in Rorty, Lyotard, Krauss, Hutcheon— you will find an insuperable *aporia* or paradoxical dictum; in such more interesting figures as Derrida, Foucault, Levinas, Irigaray (all, by the way, associated with French exhaustion), you will find a profound disinclination to present discursively—in some recuperatively "systematic" order—the

14. See, for instance, Jürgen Habermas, "Discourse Ethics: Notes on a Program of Philosophical Justification," *Moral Consciousness and Communicative Action,* trans. Christian Lenherdt and Shierry Weber Nicholsen (Cambridge: MIT Press, 1990).

15. See Joseph Margolis, *The Flux of History and the Flux of Science* (Berkeley and Los Angeles: University of California Press, 1993).

effort to get beyond the blinkered opposition between modernists and postmodernists.

I can venture no more than another small clue. I hope it will show at least the new direction the theory of art and criticism may (should) take if it is to eclipse modernists and postmodernists alike and seize the fresh possibilities historicity affords. Two themes are central—strenuous, I admit, but intuitively plausible at this late moment in our century's argument and impossible to fault on grounds of internal coherence or of avoiding self-referential paradox. They go utterly against canonical philosophy, of course, but that is part of their essential charm.

First of all, since denotation and reference and also predication cannot be assigned any algorithmic criterion or test or grounds for confirming their success, these ineliminable linguistic acts cannot be legitimated except within the terms of tolerance (*not* themselves criterially applied) of the consensual practices of this or that historical society. Correctly read, this means that the individuation of our *denotata,* whether in science or in literary and art criticism, need not depend in any way on the fixity of the nature of what is individuated. This, of course, is tantamount to the denial of the essential thesis of Aristotle's *Metaphysics* Gamma that has been the deepest underpinning of the work of the entire modernist tribe.

In the arts the denial signifies that, in interpreting a literary text, for instance, as (say) in Roland Barthes's analysis of Balzac's *Sarrasine,* it is no longer conceptually necessary to confine "objective" criticism to any supposed model of a well-defined individual thing (as in New Criticism) or to any supposed model of a well-defined genre to which individually uttered texts belong (as in Romantic hermeneutics).[16] The radical idea is that, contrary to the most entrenched views in the West, the *number* and *nature* of individuated entities need not be linked by any essentializing conception. (That is what the art world promises to make clear—particularly in terms of the history of the interpretation of certain artworks.)

This is not the place to argue the matter. I am concerned here only with giving a fair impression of the difference the modernist/postmodernist quarrel makes and what may be glimpsed beyond its own horizon, by reclaiming historicity.

The second theme reminds us of another ancient thesis under attack, the one usually labeled Platonism. It claims there is no human way to confirm the objective validity of applying general predicates to new instances that

16. See Roland Barthes, *S/Z,* trans. Richard Miller (New York: Hill and Wang, 1974).

arise in the course of actual discourse and (once again) no algorithm that can be supplied toward—or is known to govern—the communicative success of general predicates applied to particular *denotata*. If, then, you bring the two themes together and construe them in a historicized way—that is, with regard to the Intentional predicates of the art world (symbolic, semiotic, representational, expressive, rhetorical, stylistic, genre-bound, traditional predicates)—you will see that the following loosened precepts hold: that no paradox need arise as a result of admitting that the objective fit of predicable and *denotatum* does not presuppose anything fixed or changeless; that the fit is not adequate to any antecedent determination of a given *denotatum*'s nature; that it may change historically with the changing history of critical interpretation; and that it may not fit in any apt way the formal constraints of an exceptionless bivalent logic.[17]

This is the slimmest means by which I know we may escape *through* the modernist/postmodernist contest to the deeper, more promising possibilities that lie beyond—which that contest itself obscures. It is in the theory of the arts and art's interpretation that the past and future I've collected seem to play out their roles most perspicuously. I am convinced that what must be conceded in this arena anticipates what must also be conceded in philosophy in general. But urging that much already requires reversing the usual priorities assigned the analysis of physical nature and the analysis of human culture. For, on the argument implied, nature itself and our knowledge of the independent physical world are, epistemically (not ontically), a posit abstracted from the reflexive world of human culture. I ask you only to consider that the linkage gives a new meaning and a new importance to the conceptual puzzles of the art world. For the truth is, philosophy at the end of the century has largely neglected the essential role of cultural reality in understanding ourselves and physical nature. The recovery of the strategic complexities of artworks is, in its way, the best clue to the recovery of ourselves, and that recovery dispels at a stroke the entire fog of the modernist/postmodernist dispute.

In short, the dispute confronts us with a bogus choice: fall back to invariance and neutrality (which we admit we can no longer secure, having abandoned the pretense of privileged cognitive sources—often called "objectivism") or give up the very idea of objective knowledge anywhere (which, we are told, cannot be rescued, if not by the failed first alternative). The busyness of the modernist/postmodernist dispute blinds us to the fact

17. This, in fact, is the argument of *Interpretation Radical But Not Unruly*.

that *objectivity* is constructed and endlessly reconstructed in the flux of history; that it has always been so (though misrepresented); and that, to the extent it is so, our science and art criticism (among other undertakings) have never really suffered for it. It's in the arts that we find the most natural path to recovering the deeper lesson of our late age that the noisier dispute has completely overwhelmed and kept from sight. This recovery is the intended lesson of all that follows: a rereading, if I may say so, of the relationship between culture and nature.

1

The History of Art After
the End of the History of Art

One would look foolish indeed if, asked to stipulate what an artwork, a "work of art," was, viewed against the irruption of "modern art"—not merely painting, of course, though surely mid-nineteenth-century painting preeminently, above all in its original role in the French tradition following Manet and going well beyond Van Gogh into the twentieth century, and not merely modern or modernist art but all the contemporary currents of art from that time to the present—one tried to oblige by dutifully ticking off as many likely defining features as one could. Those in the know might have kept their eyes locked in the customary stare, all the while savoring the gaffe of having accepted the entrapment at face value. Art, don't you know, is distinguished (nowadays at least) by its power to defeat any would-be postulation of defining traits, by producing on demand an exemplar no one would want to exclude but no one could quite subsume in a canonical way. The trouble with this insider's joke is that it supposes, equally naively, that one cannot *say* what the properties of an artwork are (or the properties of anything of comparable complexity) if, by such an effort, one does not capture or mean to capture the exceptionless and essential properties of all bona

fide specimens. But if the joke's validity rests with the self-cannibalizing ability of art to transform itself instantly (possibly on that provocation alone, by what is sometimes called "appropriation") beyond any stipulated limit, then why should that not also be true of definition and theory?

It's a different world, you say; times have changed. Yes, certainly, but saying that hardly demonstrates that such formulas capture what *is* new about the present state of the arts. My own general answer is that what's new is probably at least two hundred years old, and that what's "contemporary" about what's new is that we are now willing to experiment everywhere with the possibility that there are no principled constraints to honor in art or criticism. It's not that "anything goes" but that we are unwilling to disallow anything except "for cause," where we cannot say in advance what would count as being for cause. Still, that is hardly a clue to what art is or to whether it is all that different from what it was and was thought to be in an earlier and less complicated past. For, as I suggest, what's new about contemporary art is probably what's old (but neglected) in what's new—accelerated, possibly beyond easy recognition, by our technology. The categories of period style and historical movement are largely stopgap measures when used within, or close to, the boundaries of the present. They could hardly be anything else.

People are often mistaken here. They suppose the "modern" or the "contemporary" or the "postmodern" *is a new age,* possibly one that is particularly radical about throwing over all the polite canons of the past. It's closer to the truth to think that we have simply begun to take to heart (in the arts at least—less so in science and philosophy) the historicity of our world and thought, even where, in an earlier time, we thought history was quite legible, that is, periodized. If you grant that much, you see the subtle blunder of supposing that we must now have eclipsed the entire narrative structure of history. For the rejection of periodized history is itself, in a way, the mark of a distinctive period of history. Also, a fixedly periodized or essentialized history is not really history at all but a punctuated span of time within a frozen, changeless space—a teleologized evolution posing as history.

Let me offer, therefore, a name and an accompanying text for the cast of mind I have just called into question. Arthur Danto, a very knowledgeable theorist of art and art history, also a practicing critic of contemporary art, provides, in his recently published Mellon lectures (given in 1995) the following instruction about how to read the recent history of art, that is, its being "post-historical":

As the history of art has internally evolved, contemporary has come to mean an art produced within a certain structure of production never, I think, seen before in the entire history of art. So just as "modern" has come to denote a style and even a period, and not just recent art, "contemporary" has come to designate something more than simply the art of the present moment. In my view, moreover, it designates less a period than what happens after there are no more periods in some master narrative of art, and less a style of making art then a style of using styles.[1]

The obvious answer to Danto begins this way: How do you know, how does anyone know, that the conviction of having eclipsed all possible "periods in some master narrative of art" is not itself a characteristic mark of our own contemporary period within the same narrative? Why is it not reasonable to construe the claim that we have now eclipsed the periodization of history itself as an expression of an essentialized history? I confess I think it is. What if (as I believe) the periodization of a "master narrative" of history is nothing but another transient piece of history, in process so to say, like the art it tracks? What if the presumption of having discerned the master narrative's actual "periods," which we have now finally eclipsed ("post-historically"), betrays the very spirit of the "contemporary" it pretends to map?

The idea that we have definitely superseded the narrative history of art, that we have come to "the end of art," the end of the canonical history of art, is itself the pretended discovery of an alternative historical narrative, presumably secured in the same way in which the history it replaces was rightly validated. The new doctrine invokes the same cognizing resources that misled us in the past—or, better, had accurately defined art's "periods" in the past but has now misled us into thinking that that process must be endless.[2]

I don't deny that this same Platonizing tendency manifests itself with annoying regularity in Hegel's philosophy of art and philosophy of history, which Danto professes to follow in his own account. Yet, in Hegel, but not in Danto, one finds a corrective humor that insinuates a sense of the prepos-

1. Arthur C. Danto, "Introduction: Modern, Postmodern, and Contemporary," *After the End of Art: Contemporary Art and the Pale of History* (Princeton: Princeton University Press, 1997), 10. The book includes Danto's Mellon lectures. A few essays are added to the lectures to round out the book's argument.

2. See Danto, *After the End of Art,* chaps. 2, 6.

terousness of ever supposing we had hit on the completion or fixity of the *phases* of such a history—that is, given actual history. If you admit all that, you will find that you are back to the naive legitimacy of trying to say what art is and what is distinctive among modern and postmodern and contemporary art. For, if the historicity of thought—Hegel's master theme, as "new" as anything we can fathom in our own world, including the modernist and the contemporary—is what is new in our current art, then we need to be wary of any assurance that we have come to the "end of art," to "post-historical art."[3] For, the "end of art" will prove to be a historical presumption of its own, blinded by its own periodizing of the overthrow of periodization.

I hope it will not distract you that I single Danto out in this abrupt way. There's a lesson to be drawn and, if I'm not mistaken, Danto is the most important philosophical theorist of the history of the arts (of painting in particular) practicing at the moment. It is Danto who has touched on the matter in the full setting of modern and contemporary work, and who happens also to have got things terribly wrong. No one else, among the philosophically minded in the West, has probed the meaning of the *history* of art as pointedly as he, and he brings his full authority into play to back a fundamental mistake regarding history, art, philosophy itself, and (as a consequence) the characterization of the "modern," the "postmodern," and the "contemporary."

The fact is, the theory of the history of painting, stemming from Hegel, develops along three completely antagonistic lines: one, I think, is true to history in the deepest way; the other two are not. The first treats thought itself as history or as historicized, meaning that thinking—*a fortiori,* the arts, criticism, science, politics—is historically formed and transformed by its own exercise, ultimately unfathomable in terms restricted to its past categories; hence, its own habit of periodizing its past and future promise is similarly a transient artifact of the very process it means to map. The second believes that history has an inherent *telos,* which, though perhaps never completely fathomed at any moment, justifies our conjectures about the true sequence of periods in the "master narrative" of the human world. The third holds that the second may have seemed true for a long while, but we now realize that the truth of history (the truth of the history of painting) lies with the discovery that objective periodizing is over and that painting, properly in touch with its own history, is now "post-historical." The first sense I assign to Hegel himself, in his best moments; the second, to Clement Greenberg, certainly at the point of discerning modernism; the third, to Danto.

3. Danto, "Modern, Postmodern, and Contemporary," 12.

Let me risk an example from Danto's own account. Danto remarks, very neatly, illustrating what he means by "painting contemporary with modernist art which is not itself modernist," that "French academic painting [in Cézanne's time] acted as if Cézanne had never happened"—that is, went on with its own mode of painting, completely indifferent to Cézanne's innovations.

As it happens (as Danto observes), Clement Greenberg, the immensely influential theorist and critic of modernism, viewed surrealism in rather the same dismissive spirit as Danto now views French academic painting. "Greenberg did what he could to suppress [surrealism,] or, to use the psychoanalytical language which has come naturally to Greenberg's critics, like Rosalind Krauss and Hal Foster, 'to repress' [surrealism]—there is no room for it in the great narrative of modernism which swept on past it, into what came to be known as 'abstract expressionism' " (which, epitomized in Jackson Pollock, was thought by Greenberg to be the very nerve of modernism). "Surrealism, like academic painting, lay, according to Greenberg, 'outside the pale of history,' to use an expression I [Danto] found in Hegel. It happened, but it was not significantly part of the progress of art in the master narrative."[4] You see how remarkable it is to judge what belongs to history and what does not. Could we have rightly supposed, when surrealism was young, when cubism had not yet achieved its distinctive hegemony, when Jackson Pollock had not yet convinced Greenberg of the validity of his thesis, that surrealism was "beyond the pale" of history?

I must pose a minor question here: What does it mean to say that surrealism lay "outside the pale of history"? I don't think the answer is as minor as the question. *Looking back,* I feel certain that part of the answer is akin to remarking that Picasso did not happen to throw his enormous animal energy (as he might have done) into an effort to weave surrealist elements into his best and most influential work. He might have done so, of course, in ways we pilgrims of the art gallery could never imagine. The effort might have failed in spite of that; it might also have gone fatally contrary to Greenberg's dictum regarding the essential "flatness," the two-dimensionality, of modernist painting.[5] And, of course, even though none of this actually happened, there was a phase of art's history in which Greenberg could not have spoken with assurance as he eventually did.

4. Ibid., 9.
5. See Clement Greenberg, "Modernist Painting," *The Collected Essays and Criticism,* ed. John O'Brien, vol. 4 (Chicago: University of Chicago Press, 1993).

If it had succeeded (admittedly a long shot), it would very likely have affected our retrospective periodization. More than that, *it would not then have fallen outside the pale of history.* There is, I suggest, no principled demarcation between what falls within and what falls outside the pale of history, except what a retrospective historical narrative makes plausible (in that way) to the denizens of a later history they (those denizens) deem continuous with the one they thus define. Danto opposes such explanations; he requires an account in accord with the second and third senses of history. Hence, in a very real sense, he stands outside of history. But of course, to parody Sartre, the acknowledged periods of history are merely those that have made it socially—for the time being.

I grant that surrealism is a minor eddy in the modernist canon. But what does saying that mean? Is it perhaps a tribute to Greenberg's extraordinary influence in defining surrealism and the history of art in the New York art scene? For, of course, the fixities of the psychoanalytic narrative (to take one strand of the surrealist movement) could easily have become an emblem of the fixities of modernism itself, *if* Greenberg's compelling essentialism had not so effectively focused the convictions of so many on a theme that marginalized (without absolutely eliminating) the representational side of art. Imagine, for instance, that the surrealist possibilities of painting, prospering to some extent in the film, had caught the fancy of the cubists and attracted Picasso's protean energies. I have no wish to trade in counterfactuals here, except to begin to suggest the puzzle of the very formation of a historical "tendency" or ethos. Of course, the fact is that other art historians (notably, Gombrich) did not regard surrealism as outside the pale of history, despite the supposed trajectory that linked Manet and Pollock.

Was Greenberg right? Well, you have only to think that the same tale that marginalized surrealism entrenched the abstractive work (the so-called "abstract expressionism") of Jackson Pollock as the preeminent exemplar of our age (in Greenberg's mind). Danto thinks Greenberg was mistaken, partly because of the latter's Platonism and partly because, whatever Pollock's charm may be, it would be very difficult to believe that the "validity" of Pollock's work could possibly justify the charge that Impressionism, say, was no more than a form of "false" art.[6] Danto believes Greenberg is wrong about what, in the historical process, *is* the apotheosis of true painting, because he (Danto) believes that painting is now essentially "post-historical." Greenberg may have been right about modernism, but not about painting

6. Danto, "Three Decades After the End of Art," *After the End of Art,* 28.

and not about the history of painting. Yet Danto's judgment is hardly different in kind from Greenberg's: Danto simply offers a different history of art's essential periods. Here's the evidence:

> There is a kind of transhistorical essence in art, [Danto avers,] everywhere and always the same, but it only discloses itself through history. This much I regard as sound. What I do not regard as sound is [Greenberg's] identification of this essence with a particular style of art—monochrome, abstract, or whatever—with the implication that art of any other style is false. This leads to an ahistorical reading of history of art in which all art is essentially the same—all art, for example, is essentially abstract—once we strip away the disguises, or the historical accident that do not belong to the essence of "art-as-art."[7]

Let me urge again that history has no essential structure, *qua* historical narrative, any more than it can be collected as the transient accidents of some ahistorical essence—in art, or science, or philosophy, for that matter. Both doctrines (Greenberg's and Danto's) are forms of Platonism, false readings of history in the first sense of Hegel's doctrine, already given.

David Carrier reminds us rather neatly here—in effect, against both Greenberg and Danto (though that was not his intention)—that Ernst Gombrich viewed surrealism as an integral part of the history of modern art but thought Pollock was "beyond the pale."[8] Of course, Rosalind Krauss has an altogether different reading of Pollock from Greenberg's (and Gombrich's). Krauss pays close attention to Pollock's uneasiness regarding a supposed disjunction between "the idea of abstraction and the idea of subject" (favoring and disfavoring representationality or figuration), which others took to be an "internal contradiction."[9] That is, Pollock believed more than mere formalism was in his "abstract expressionism," the semiotic presence

7. Ibid., 28–29.

8. David Carrier, *Artwriting* (Amherst: University of Massachusetts Press, 1987), 31. See E. H. Gombrich, *The Story of Art,* 11th ed. (London: Phaidon, 1966), 450–51 (on Dali), and *Art and Illusion,* 2d ed. (New York: Pantheon Books, 1961), 287 (implicitly on Pollock). It looks more likely that Gombrich had no place to put Pollock than that he had a clear case for disallowing him. Nevertheless, given Gombrich's strong narrative of art, Pollock falls out in a largely irrelevant way. I am of course taking advantage here of a passing remark of Carrier's. I have no wish to draw him into my own local dispute, but what he wrote has helped me focus my own sense of the easy construction of alternative lines of periodizing.

9. Rosalind Krauss, "Reading Jackson Pollock, Abstractly," *The Originality of the Avant-Garde and Other Modernist Myths* (Cambridge: MIT Press, 1985), esp. 237.

(let us say) of expressive energy that remained loyal to the avoidance of representationality.

In fact, viewed as a test case, Pollock affords at least an impression of the plausibility of treating the validity of art history in relativistic terms. I assure you, however, that, in suggesting this possibility, I am not trading on the comic dustup scrupulously reported by Rosalind Krauss regarding an alleged period (of about one and a half years) in which Pollock is said (doubtfully) to have dabbled in representational painting of a specifically religious nature, just when he was at a high point in his abstractionism.[10] But Pollock's sense that his abstractions were not merely formal or formalistic, not mere "decoration" but visible "equivalents" of "energy and motion,"[11] shows the way to erasing any supposedly clear line between abstraction and figuration (not to be confused with representation). What I insist on is not mere ambiguity or equivocation but the unlikelihood of confirming any such disjunction within the precision accessible to critics and art historians. You cannot fail to see the utopian spirit of critics and historians like Greenberg or, at a discreet remove, Danto.

I

It is difficult to avoid periodizing art, once a variety of styles are admitted to have engaged our interest validly. The attempt to construe artworks as ornamented propositions has had very little currency. I believe it is for some such reason that science and philosophy—but not the arts—have been able to hold so doggedly to their pretensions to have fathomed perennial truths by historical accretion. All that seems very doubtful now. But it was only toward the end of the nineteenth century that it became possible to mount an effective attack on any such pervading confidence. I find a very promising clue in Mikhail Bakhtin's notion of the "carnivalesque"—originally assigned to the novel (an art form that has no essential form of its own but cannibalizes all possible literary forms), now intuitively extended (by Danto, as I read Danto's argument, without attribution) to painting.[12] (That is, I

10. See ibid., esp. 221–36.
11. See ibid., 236–39.
12. See M. M. Bakhtin, *Rabelais and His World,* trans. Helene Iwolsky (Cambridge: MIT Press, 1968).

believe what Danto treats as "attributionism" in contemporary painting—in the work of Mike Bidlo for instance—is a pale analogue of Bakhtin's "carnivalesque." I shall come back to that shortly.) I do think the carnivalesque is a feature of contemporary artistic appetite, but I don't see that it follows that we are now at the post-historical "stage" of art or painting.

The theory of history emulates the would-be deeper invariances of science and philosophy by embracing the idea of progressively discovering the essential *Geist* of each successive historical age within the continuum of all such ages. Now, even that theory has been forced to admit it can no longer prioritize reality over appearance so as to legitimate its own presumption. In Nietzsche, for instance, the radical possibilities of Hegel's own critique of Kant are inevitably turned against Hegel, that is, against the periodizing Hegel, the Hegel who may have obscured a very different voice within the periodizing voice.[13] There are now no essentialized "Spirits" to discover, yet history cannot escape the periodizing habit, even in its more fluxive practice. But if there are "no longer" any essentialized spirits, there never have been any.

I am speaking of the nature of history and of understanding art, for we cannot fathom art except historically, just as we cannot fathom ourselves except historically. Any alternative presupposes that reality has a changeless, contextless structure and that cultural history is simply the phenomenal face of invariant human nature made intelligible on that confession alone. But if, instead, the arts are horizontal constructions made by ourselves (who are also artifacts of history), then the modernist conception would be completely mistaken—that is, the conception that art has a fixed essence or that the periods of art's history are rectified only when brought into line with art's essence (Greenberg) or independently discerned by an ideal observer (Danto).

Regardless of the local quarrel—as to whether modernist art imposes an invariant narrative on art's future (Greenberg) or does not because, as Danto argues, post-historical art no longer agrees that it is bound by such a rule—both Greenberg and Danto remain captive to the same essentializing habit. There's no reason they should have escaped, seeing that the entire tradition has reneged on the discovery, two centuries earlier, of the historicity of thought. The evidence lies in tracing the would-be periods of art's history.

13. See Karl Löwith, *From Hegel to Nietzsche: The Revolution in Nineteenth-Century Thought,* trans. David E. Green (New York: Columbia University Press, 1991).

You cannot find in Greenberg or in Danto any more radical possibility than what you already find in Gombrich or even Vasari, for you cannot find the possibility that human understanding is itself a fluxive history.

I find three precepts helpful here: first, that the practices of criticism and history are ineluctably a function of the disputed conceptions of history and invariance already tallied; second, that the current use of categories like "modernism," "postmodernism," and "contemporary" are not so much period notations as counters by which to take a stand in the disputes just mentioned; and third, that the question of critical and historical accuracy is inherently equivocal—mention of representational accuracy, for instance, may merely signify congruity with the norms of one period style or another *or* with taking a stand on the doubtfulness of all such norms in terms of deeper questions of essentialism or historicism or constructivism or the like. (The historicity of thought is, in this sense, not itself a fixed feature of thought but a *faute de mieux* bet that essentialism and modal invariance cannot succeed.)

The point may be found in Vasari's history. For, as Gombrich observes, Vasari links the Renaissance "mastery of representation" to the naturalistic thesis of mimesis, whereas (of course) Gombrich himself opposes the innocent mimesis of Vasari, preferring another doctrine ("making and matching"), one more hospitable to plural norms of representation informed by the progressive history of science. That is the intended point of Gombrich's pregnant remark, "The question of what is involved in 'looking at nature'— what we today call the psychology of perception—first entered into the discussion of style as a practical problem in art teaching. The academic teacher bent on accuracy of representation found, as he still will find, that his pupils' difficulties were due not only to an inability to copy nature but also to an inability to see it."[14] The plausibility of Gombrich's option precludes the necessity of acknowledging any uniquely adequate norm of painting, but it pretends that there is a neutral stance from which all forms of "accuracy" can still be judged. That, of course, is what Gombrich finds so compelling in Constable's landscapes and Constable's conception of his own endeavor. Gombrich is a pluralist of objectivist persuasion.

Vasari's appraisals—famously, of Giotto—are a function of his conception of art's essence and of what the history of art might reveal, but so are Gombrich's, for Gombrich sees his own conception of criticism and history as a correction of Vasari's classic notion. So also are Greenberg's—and Danto's

14. Gombrich, *Art and Illusion*, 11–12.

and Krauss's, for that matter. The philosophical drama becomes increasingly intense as we approach the end of our century, but I cannot see any fundamental rupture (moving from Vasari to Krauss) in the seamless bond linking the philosophies of art and history and the professional practice of the critic and historian. I see no more than two distinct claims about critical inaccuracy: one centered on the disagreement between Greenberg's and Krauss's readings of Pollock; the other centered on the disagreement between Greenberg's and Danto's readings of the modernist import of Pollock's work. My own sense is that the implicit question is wrongly favored: our commentators are not as disjunctively opposed to one another as they themselves suppose. Only an essentialized conception of art and history could have misled them.

It's one thing for Gombrich to construe Pollock as recycling the refuse of our technological world; it's another for Greenberg to see in Pollock the apotheosis of modernism. It's still another for Krauss to see in Pollock a postmodernist turn toward the rejection of referentiality[15] and, through it, a turn against representationality. It's still another for Danto to look beyond Pollock to a post-historical art that sets aside once and for all the essentializing tendencies of artists' "manifestos" (including Pollock's).[16]

I am not encouraging tolerance here. My point is not to endorse disjunctive choices among such options, although it is plain enough that whoever is genuinely interested in the arts will make such choices somewhere. There is nothing sinister or problematic in that. I mean to draw attention rather to the deepest possible displacement of all such choices—the import, in effect, of the utter rejection of all modal fixities and essentialisms. *Modernism* says or perhaps implies, in this regard, that such a rejection would instantly produce incoherence or chaos. *Postmodernism* applauds the opposition, opposing modernism, but in its turn (notably in philosophy more than in art criticism or history)[17] insisting that if strong cognizing programs could be shown to be valid, they would have to be Kantian-like, transcendental, informed about invariant structures.

Failing that, postmodernists claim, canonical philosophy and all the forms of legitimation (in science or criticism) must fail. Cognitive practice

15. Krauss, "In the Name of Picasso," *The Originality of the Avant-Garde,* 38–39.

16. Danto, "Three Decades After the End of Art," 37.

17. Compare Richard Rorty or Jean-François Lyotard, for instance, with Rosalind Krauss. Richard Rorty, *Philosophy and the Mirror of Nature* (Princeton: Princeton University Press, 1979); Jean-François Lyotard, *The Postmodern Condition: A Report on Knowledge,* trans. Geoff Bennington and Brian Massumi (Minneapolis: University of Minnesota Press, 1984).

falls back to ethnocentric loyalties, which are said to be sufficient for our needs. What postmodernists neglect to add is that the first-order practices they endorse (in science, art criticism, history, morality) make no sense without *some* form of second-order legitimation, and legitimative inquiries are no more committed to invariance or necessity than the first-order inquiries they presume to govern. The entire postmodernist reading is misguided, for postmodernism is merely modernism manqué, that is, philosophical postmodernism.

It's entirely possible that postmodernist art—John Portman's Westin Bonaventure Hotel in Los Angeles, for instance—be architecturally successful even though philosophical postmodernism remains a conceptual sham or a conceptual shambles.[18] Something similar may be found in nineteenth-century modernist painting, among the Pointillists; for, of course, Pointillist theories of color perception proved utterly untenable, without in the least adversely affecting Seurat's *Grande Jatte*. (I am not ignoring the profound differences between these cases.)

Greenberg, plying his trade as a modernist critic, finds Pollock to have perfectly captured the essence of painting; and Danto, plying his as a post-historical Hegelian art critic (but hardly as a post-historical philosopher), finds unacceptable any essentialist history of painting, even while remaining an essentialist about history. Both Greenberg and Danto are Hegelians, differing (on my reading) only in minor ways. But the ways in which they differ do lead (as my assessment requires) to enormous differences in critical and historical perception. Grasping the second source of dispute, one is inclined to deny the pertinence of the first. But that would be a mistake.

II

It would be entirely fair to say that Greenberg is the preeminent champion of modernism in the theory and practice of the history and criticism of Western painting, which Greenberg himself pretty well dates from Manet's

18. See Fredric Jameson, *Postmodernism, or, The Cultural Logic of Late Capitalism* (Durham: Duke University Press, 1991), 38–45. In the atrium of the Bonaventure is a small maze of external stairs suspended in the air that do not take you to all the floors they seem to serve; moreover, you cannot tell which floors they exit on. This situation leads to an initial annoyance and then to a greater sense of playfulness, for you are in a building that functions partly by innocuously baffling part of its commercial function.

pictorial experiments.[19] As it happens, he also regards Kant as the "first real Modernist," because of Kant's development of the reflexive critique of our conceptual resources (85). Greenberg believes modernism to be a "historical novelty"—in painting as in philosophy—and he views the work of Manet, the Impressionists, Cézanne, Picasso, and on up to Pollock as a philosophically inspired process, however subliminally achieved. The whole enterprise, in painting, which he treats as immensely radical, is informed (as he sees matters) by the precept, "flatness alone [is] unique and exclusive to pictorial art" (87).

To be completely candid, I must say that, although I admire the perceptiveness of much of Greenberg's history and criticism, the thesis on modernism is an elementary howler, quite misleading about the nature of art and painting—*a fortiori,* about the objective significance of the entire history he scans. That is a harsh judgment, I don't deny, and you would be right to demand a proper reckoning. Let me drop the other shoe, therefore, before going on. I must add that, although with the publication of his Mellon lectures, Danto bids fair to be the counterpart champion of "posthistorical" art, he makes a mistake that is indistinguishable from Greenberg's. I may as well say, I find it extraordinary that the underlying rationale for both visions is absolutely the same: each commits the same conceptual mistake in vindicating the art-historical innovation each claims to find. That is not likely to be believed. Simply put, each confuses artworks with ordinary material objects. I concede that this charge may be contested. But I argue that if it is set aside, then both Greenberg's and Danto's theories will be deprived of the only seemingly plausible ground on which to avoid a deeper charge of arbitrariness. I believe the dilemma cannot be avoided: either they confuse the ontology of the merely material with the Intentionality of art, or they are arbitrary Platonists.

If you ask, for instance, what Greenberg means by the "flatness" of painting, it should be clear that he must be referring to the flatness of canvas stretched over a wooden frame (or something of the sort). *It can't be the flatness of painting* (the flatness of the pictorial space of a painting), unless either the two are one and the same, which is plainly false, or one (flatness in painting) is essentially and rightly governed by norms derived from the other (flatness of canvas), which is plainly arbitrary. *Tertium non datur.* Once you admit that it is the glory of a vast run of painting—whether Chinese

19. Greenberg, "Modernist Painting," 86. Further references in Chapter 1 to this work will be noted parenthetically in the text.

and Japanese or French and German—to have produced the pictorial representations we treasure, it must surely strike you as preposterous (in the way only academic history and criticism can be preposterous) to suppose, with Greenberg, that representational painting intrinsically generates a "contradiction": that of affirming and denying flatness at one and the same time (87–88).[20]

To put the matter straightforwardly, one could say that flatness in a canvas is physical, altogether non-intentional (or "non-Intentional," in the culturally freighted sense I am beginning to explicate), whereas "flatness" in painting (in the sense pertinent to Manet and Cézanne and Picasso) is fully Intentional. There is no convincing rationale for supposing that the ubiquity of the second depends on the ubiquity of the first or, therefore, that the second *is,* or necessarily ought, to be ubiquitous in painting.

Surely it is wrong to insist on "the ineluctable flatness of the surface" of a painting (87). For instance, even in a piece like Picasso's "Three Musicians," which catches up the extreme pictorial features that Greenberg attributes to cubism, the flatness of the *canvas* plays an assignably witty but obviously limited and dependent role within the representational space of the painting, which is not flat. How could that be denied, and on what grounds could we possibly suppose the flatness of the canvas rightly governs the rational and normative "purpose" of pictorial space? Consider only that the history of art has explored endlessly many notions of pictorial volume—say, in Egyptian, Byzantine, Chinese, Renaissance, Cézanne's, and cubist space. In what sense are they all governed by the "flatness" of the canvas (or substitute material) or by the Platonist Form of Flatness in painting? There seems to be no answer.

I hasten to add that there is a difficulty in reading Greenberg's essay. Greenberg has now added an explanatory postscript to the original paper denying that what he first wrote represents his own sense of stylistic and evolutionary necessities, or even his own taste in painting. Fine. But the error I speak of cannot be dislodged by this sort of nicety. The more serious confusion can be discerned by juxtaposing the following remarks: first, "Because flatness was the only condition painting shared with no other art, Modernist painting oriented itself to flatness as it did to nothing else"; and, second, "the making of pictures means, among other things, the deliberate creating or choosing of a flat surface, and the deliberate circumscribing and limiting of it. The deliberateness is precisely what Modernist painting harps

20. "Contradiction" is Greenberg's own carefully chosen term.

on: the fact, that is, that the limiting conditions of art are altogether human conditions" (87, 92).

There can be no doubt that Greenberg viewed his own speculation as an improvement on Lessing's *Laocoön* and that he believed in "the present superiority of abstract art" (writing in 1940), because of the defining condition of painting.[21] But never mind. It is more important to remark that Greenberg does not sort carefully enough the difference between the physical *material* (or medium) and the artistic *space* (or medium) of painting. The first is merely physical, and the second, essentially cultural and historical. Furthermore, the second is indissolubly embodied in the first as a result of cultural choices. Hence the "flatness" of modernist painting is utterly, utterly different from the "flatness" of a stretched canvas. For, of course, the flatness of stretched canvas is "common" to the painting of every age that may be thought to form the usual family of easel and allied painting about which the thesis regarding modernism counts as a revelation. Thus, in spite of such facts, Michelangelo's Sistine Chapel is definitely not modernist in inspiration: neither flat in the physical sense nor legibly Flat in the Platonist sense. On the contrary, one hears it said of Michelangelo that his paintings are characteristically sculptural.

Hence, when, in the second remark cited, Greenberg draws attention to "altogether human conditions," I think we can safely assume that he is talking about the *continuity* of the Western tradition of painting. But if so, then we must concede that nothing that bears on the first sense of flatness has anything to offer in the way of a commanding pictorial constraint or norm on painting as such—except sheer physical possibility. Something is terribly amiss. I don't deny that the tendency toward flatness in pictorial space *is* a genuine tendency in Manet and Cézanne and Picasso and Pollock, but I don't see any essential Form there.

Danto's mistake is remarkably similar, for Danto takes as his point of departure, both philosophically and art-critically, the pop inventions of Andy Warhol rather than the great groping experiments (toward pictorial flatness) that Greenberg finds in Manet. Greenberg is forever searching for what is rationally necessary and uniquely essential to painting, what runs continuously through the entire tradition of the West, whereas Danto seeks rupture, radical discontinuity, the ultimate freedom of the artist's right to repudiate the norms of all past histories. Greenberg means to be a perfect mandarin of

21. See Clement Greenberg, "Towards a New Laocoon," *The Collected Essays and Criticism,* vol. 1, ed. John O'Brien (Chicago: University of Chicago Press, 1986), esp. 57–58.

art who finds the *Geist* of painting apotheosized in modernism, whereas Danto is a utopian enthusiast who would legitimize the perfect overthrow of historical constraint (though not humanity) in the sheer exuberance of pop self-expression.

Both are American Hegelians. Greenberg reads Hegel as a Kantian even in the history of painting; and Danto celebrates, as a Whitmanesque rhetor, our final escape from the shackles of history—even as he traverses the whole of history itself. Greenberg validates modernism as the finally discerned *telos* of the history of painting, and Danto validates the final free play of all possible styles of painting as the upshot of discovering once and for all the historical impossibility of ever fixing the rational essence of painting. Both offer "plausible" visions—no more than plausible, for neither is strictly correct, in spite of providing a narrative sense of the continuing practice of painting sufficient for mobilizing fresh talent.

Danto's mistake, I should add, is a variant of Greenberg's. Greenberg's Hegelianism requires that we hew to the modernist's discovery of the essential meaning of the history of painting; Danto's Hegelianism requires us to admit that *that* history has now come to an end with the discovery that it had always rested on a paradox—one that subverts the need to adhere any longer to historical norms as such. Greenberg says we must be loyal to the *telos* of history, now that we know what it is. Danto says we are free of history, now that we know that its would-be *telos* cannot rightly constrain the liberating import of the paradox it conceals.

What is the marvelous lesson promised? you ask. I suggest you approach it from the following rather startling pronouncement, one in which Danto tries to distinguish between modernist (and even postmodernist) and posthistorical art:

> Anything ever done could be done today and be an example of posthistorical art. For example, an appropriationist artist like Mike Bidlo [who produced, in 1995, *Not Andy Warhol (Brillo Box)*] could have a show of Piero della Francescas in which the entirety of Piero's corpus was appropriated. Piero is certainly not a post-historical artist, but Bidlo is, and a skilled enough appropriationist as well, so that his Pieros and Piero's paintings could look as much alike as he cared to make them look—as much like Piero as his Morandis look like Morandis, his Picassos like Picassos, his Warhols like Warhols. Yet in an important sense not easily believed accessible to the eye, Bidlo's Pieros would have more in common with the work of Jenny Holzer,

Barbara Kruger, Cindy Sherman, and Sherrie Levine [as an appropriationist] than with Piero's proper stylistic peers. So the contemporary is, from one perspective, a period of information disorder, a condition of perfect aesthetic entropy. But it is equally a period of quite perfect freedom. Today there is no longer any pale of history. Everything is permitted. But that makes the historical transition from modernism to post-historical art all the more urgent to try to understand. And that means that it is urgent to try to understand the decade of the 1970s, a period in its own way as dark as the tenth century.[22]

Now this, I think, catches up Danto's flaw in a telling way. The issue is not a local or textual quarrel. Because, if you look carefully at what he says, you will see that Danto equivocates in exactly the same way Greenberg does (speaking of modernism). For, surely, when he says Bidlo "could have a show of Piero della Francescas in which the entirety of Piero's corpus was appropriated"—or when he says, "anything ever done could be done today and be an example of post-historical art"—Danto must be using terms like "appropriated" and "do" in two very different ways: first, to say that something *physically* indistinguishable from the Pieros might be offered as Bidlo's art (or, as he elsewhere says, might even not be art at all); and second, to say that the work that "appropriated" the Pieros or was "done" now to look like a Piero was *not* Piero's work at all but could not be distinguished by physical means alone or by perceptual means keyed only to physical differences.

In any case, Danto can't be right: what he says is demonstrably false—or devilishly equivocal. What Piero produced were genuine "Pieros"; what Bidlo produced are not "Pieros" at all but "products" of some sort (genuine "Bidlos" perhaps) that "look like" (are "indistinguishable from") Pieros, only if we confine the perception of Pieros and Bidlos to what can be discerned only "sensorily," non-Intentionally—which, after all, is to reason *per impossibile,* since neither Pieros nor Bidlos exist (as yet) or can be "perceived" on that condition. Since artworks possess Intentional structures, their perception (what we should understand as our perception of *them*) must allow for discerning their Intentional structures: anything less would erase their presence, by erasing the perceptibility of their distinctive properties.

But that is precisely what Danto trades on (the equivocation) in bringing us to the end of art and the brink of post-historical art. I charge him—I'm afraid, without any saving tact—with a dreadful blunder. Bear with me

22. Danto, "Modern, Postmodern, Contemporary," 12.

please, if I press the evidence on you. For Danto goes on, in the lead article of his Mellon lectures, to insist,

> There was [in the sixties and after] no special way works of art had to look in contrast to what I have designated "mere real things." To use my favorite example, nothing need mark the difference, outwardly, between Andy Warhol's *Brillo Box* and the Brillo boxes in the supermarket. And conceptual art demonstrated that there need not even be a palpable visual object for something to be a work of visual art. That meant that you could no longer teach the meaning of art by example. It meant that as far as appearances were concerned, anything could be a work of art, and it meant that if you were going to find out what art was, you had to turn from sense experience to thought. You had, in brief, to turn to philosophy.[23]

If, by the impossible, Danto were right, then there'd be no art at all (on his own thesis). Of course, the terrible truth is, there *is* no art on Danto's deeper theory, the theory of his famous "Artworld" paper and the *Transfiguration* volume—no actual art at all.[24] To admit art in the first place means denying that the *perception* of an artwork, or the *visual appearance* of any artwork, could possibly be confined to whatever was relevant to the perception, or the mere appearance, of "mere real things" (in Danto's idiom). To perceive a Bidlo Piero is to perceive the difference between a Bidlo Piero and the real Piero it appropriates, even if what is perceived cannot be discerned by the sensory powers of the eye alone. What needs to be done is explain the nature of perceiving artworks, in virtue of which the difference *can* be discerned—without denying that mistakes may be made for sensory reasons. The conceptual puzzle is, I am convinced, a profound one. We shall need a little patience. But bear in mind that the difference between the Piero and the Bidlo cannot be perceived at all on Danto's view of "perception," yet if not, then there would no longer be any ground for speaking of the history of art.

The trouble is, Danto nowhere explains the puzzle. As a result, he fails to see that the paradox he insists on is a nonstarter; hence, he has no basis for what he calls post-historical art. There is of course another reading of the Hegelian conception of history, far less troublesome than either Greenberg's

23. Ibid., 13.
24. See Arthur C. Danto, "The Artworld," *Journal of Philosophy* 61 (1964).

or Danto's: namely, that the essentialized structures of the history of painting are nothing but artifacts of the work of human historians—who, in their turn, are similarly constituted within similarly shifting cultural processes. (I have mentioned the possibility before.) Admitting that, we may tolerate the categories of modernist and post-historical art (if we find these useful), without pretending to have fathomed the uniquely correct structures of art or the history of art. Hegel, we may suppose, was entirely aware of the comic, or generous, possibility that all the supposed necessities of history reflect, at different times, the skewed imagination of encultured creatures like ourselves. On such a view, there is no end to history (in the double sense Danto favors), because that would require an end to human life itself—read more prosaically.

III

The lesson I draw is that it's no use favoring Greenberg or Danto on the orienting importance, for criticism, of modernism or post-historical art, unless either can be shown to have a valid conception of the nature of art or painting or of the history of painting. Neither succeeds, because of course both conflate what *is* art and what is not. That is the point of remarking that "flatness," in Greenberg's analysis, conflates (to gain its effect) the difference between physical flatness (the flatness of easel painting and its allies) and pictorial flatness (the flatness of cubism, Impressionism, the experiments of Manet and Cézanne). Otherwise, Greenberg is simply a Platonist or a canny art historian who sees the advantage of disguising his *obiter dictum* as a Platonist revelation. In any case, it is helpful to recall that Lessing (in *Laocoön*) had also supposed that the "limits" of painting and poetry ultimately depended on certain physical limits. (I find a similar tendency in Hanslick's account of music.)[25] Let me simply say again—I shall return to the matter in a moment—that the pictorial sense of flatness is "Intentional," whereas the physical sense is not. The same contrast applies to physical sound and musical sound.

Surely that is the same flaw one finds in Danto when he equivocates on terms like "similarity," "perception," and "appropriation" by maintaining no

25. See Eduard Hanslick, *On the Musically Beautiful: A Contribution Toward the Revision of the Aesthetics of Music,* 5th ed., trans. and ed. Geoffrey Payzant (Indianapolis: Hackett, 1980).

real discernible difference exists between art and non-art or between the art
of any historical period and its post-historical "appropriation."

For example, it explains completely the magical meaning of Danto's
term "transfiguration" ("transfiguration" rather than "transformation," as in
the expression "the transfiguration of the commonplace": the rhetorical,
purely contrived, ontically insubstantial characterization of "mere real
things," non-art, as art, whether a Warhol or a Giotto). Actually, on Danto's
theory, *art is never real*, never more than the conceptual shadow cast by a
habit of speech applied to what alone *is* real.[26] For what is real (on Danto's
view) specifically lacks the Intentional properties that mark art as art. No
one could possibly legitimate the would-be rigor of history and criticism
on such terms. And yet, of course, Danto supposes his discovery of post-
historical art rightly corrects the implied mistake in Greenberg's theory of
modernism. I hasten to add that, of course, Danto addresses actual artworks
in his critic's role. I should never deny that. I say only that he nowhere offers
an account of what an artwork is, or how it can be identified or distin-
guished from a "mere real thing," or how (as a consequence) his own de-
scriptions and interpretations are *objectively* confirmed by examining the
artworks he considers. (That is not likely to be believed.)

However, any theory of art worth its salt must accommodate at least one
condition: namely, that whatever is said to be a painting or a work of art—
or, in general, a cultural *denotatum*—must count among its properties the
salient property of being a historied artifact. That may seem preposterously
obvious. But it is more telling than it seems, for it signifies that (1) cultural
entities, but not inanimate natural objects, possess, as an intrinsic property, as
part of their "nature," a certain historicality; (2) such historicality cannot be
sensorily discerned in the way in which purely physical properties can be;
(3) the perception of historicality is *sui generis* to the analysis and under-
standing of the cultural world; (4) the perception of art and history is an ex-
tension of human self-perception, the understanding of oneself and one's
society; and (5) the perception of cultural phenomena is inseparable from
the perception of physical phenomena.

I collect all this in a word, by affirming that artworks possess, where
"mere real things" do not, Intentional properties: all representational, semi-
otic, symbolic, expressive, stylistic, historical, significative properties. If that is
granted, then of course artworks cannot be numerically identical with

26. See Arthur C. Danto, *Transfiguration of the Commonplace: A Philosophy of Art* (Cambridge: Har-
vard University Press, 1981).

"mere real things." I put it to you that you cannot escape impossible diffi-
culties if you deny that we actually *hear* speech, not merely sound, to which,
somehow, we impute meanings. If you grant that, then I think you must also
grant that we *see* paintings, not merely daubs of paint on a canvas.

You begin to see, here, that the local paradoxes of Greenberg's and
Danto's practice as critics and historians of painting seriously compromise
the coherence of their most important judgments. I doubt there is any
single way to understand the history of art, any more than there is a unique
way to understand what it is to be a human person. In fact, the two are ulti-
mately one and the same achievement. We ourselves, I should say, are "arti-
facts" of cultural history: "second-natured" selves, first formed (transformed,
not "transfigured") by acquiring, in infancy (as the gifted members of *Homo
sapiens* that we are), the language and practice of our enculturing society. It
would be impossible to explain here all that implies: such a task would re-
quire an entirely fresh beginning. (I shall save all that for Chapter 4 and the
Epilogue.) The important thing to grasp is the complexity of what it must
mean to say *one sees a painting as a painting.* For even that is ruled out by
Danto's theory.

I object to Danto simply because he denies that anything of the sort
suggested ever occurs, and I object to Greenberg because his analysis of
modernism obscures the conditions on which our ability to distinguish
modernism and other periods depends. Think, for instance, of the remark-
able fluency with which we understand the utterances of our native lan-
guage. We cannot pretend to do no more than "transfigure" the physical
sounds we first ("really") hear by imputing "meanings" to what we must
hear, for how should we ever explain our aptitude for doing that? (This
would involve a hopeless regress.) I can't see how, in this regard, the percep-
tion of a painting relevantly differs from our understanding language. If you
concede, in the same spirit, that Shakespeare wrote in the same language I
am speaking—but in an earlier incarnation of English—and that Shake-
speare's and my linguistic resources differ as a result of being artifacts of dif-
ferent histories, then you see the radical puzzle of being able to understand
the paintings of different periods. *What we perceive in the paintings of past his-
tories must be a changing function of our present changing history.*

Consider only that there is no algorithmic rule for inferring, from any
determinate span of sounds, what words have been uttered or, from the
words that we (surely) hear, what sounds must have been uttered. There is
an indefinitely open-ended linkage (in both directions) between sounds
and words. Something analogous holds in the world of art. We cannot

therefore convincingly deny that we perceive artworks as artworks, if we mean to claim any critical objectivity at all. Danto restricts "perception" to the perception of "mere real things"; hence, he cannot even admit the presence or existence or identity or *perception* of artworks, though he speaks of them in perceptual terms.

I want to impress on you the complexity of what we mean by a work of art—that is, the metaphysics of its nature: what it is we claim to perceive when we see a painting, and what we suppose we are accomplishing when we rightly understand it. There is no standard way to specify the nature of an artwork or the nature of understanding artworks. It is entirely possible— both Greenberg and Danto seem committed to the idea—that the very nature of a painting and the nature of what is involved in understanding it may change rather drastically from age to age and from style to style. I agree, but neither Greenberg nor Danto explains how our grasping the historicity of a painting is ever achieved, or how we may be sure we are not falsifying its true properties. The interesting thing about Greenberg's and Danto's critical practice is that each intends to influence readers (or auditors) to see paintings in a significantly new way. Fine. But what we want to know is whether they may be said to have got things right, so that, following their lead, we too can claim to have correctly fathomed what they now invite us to perceive.

I'm afraid I shall disappoint you in what I must now say about the perception of artworks. I don't discount the importance of the categories of modernism and post-historical art, but I deny that Greenberg and Danto ever *discovered* their features in the history of art in the same way in which we suppose we once discovered the melting point of gold. (For convenience, I allow the verbal slippage regarding gold: the process is the same, however, whether we speak of the Intentional nature of paintings or the non-Intentional nature of gold. But this is not the occasion to pursue the matter.)

I deny that "modernism" and "post-historical art" are simply descriptively accurate categories fitted to an independent practice of painting. Rather, they are effective constructions recommending how best to reform the ongoing narrative of painting and how we should regard paintings perceptually. Their objective standing depends on gathering influence within a living practice. They are narratized reconstructions of the history of painting, clever and apt enough to draw in their wake a good measure of compliance on the part of critics and painters and a supporting public, such that thereafter (for a while at least), our way of understanding painting sponta-

neously appears as *objectively descriptive* within its adopted terms and in its favor.

Correspondingly, its standing is enhanced (somewhat in the manner of a self-fulfilling prophecy) by the willingness of strong artists to view their own efforts conformably. Think of Pollock and Warhol! The significance of cubism, for instance, evolves with the complicit strength of Picasso's endless inventions in its favor, perceived in a congruent way by an entire receptive art world. Cubism was never simply "there," spotted by Picasso himself, its presence as the discovered past of all those futures that confirm its relevance now is itself the continually reinvented artifact of the not entirely innocent conspiracy of that continuation. Pollock's apotheosis of modernist flatness is an artifact of the symbiosis between Pollock's strength as a vital painter and Greenberg's as a vital critic (within the life of the New York art world, of course).

The essential point is this. The perception of an artwork is, first of all, the perception of an entity that cannot be identified by whatever minimal means serve to identify a physical object or "mere real thing," for the one possesses and the other lacks Intentional properties; and, second, in perceiving artworks, we *do* perceive them as possessing Intentional properties. If, as Danto holds, perception itself is restricted to "mere real things" and thus cannot be directed to Intentionally qualified properties, then artworks cannot be perceived at all, and their description and interpretation become an insoluble mystery. I cannot find any reasonable answer in Danto. I'm afraid there isn't any.

I shall add only a few further observations—drawn from some remarks by Danto (rather than Greenberg) because, as Danto says (fairly enough), Greenberg was a kind of progressivist about art and criticism, and he (Danto) is not.[27] Danto means to disrupt history. Nevertheless, he fails, I claim, to draw the full lesson of his own intervention. Let me cite a bit of what he actually says—this time about how he arrived at his theory of art and art history. His story is very gracefully turned and shows, in a good-humored way, how Warhol and other pop artists bested Plato.

Danto begins by reminding us of what Plato says about a painter painting a bed (which, I am prepared to believe, was probably a joke on Plato's part):

> They [the painters, Plato remarks through Socrates] "know" only
> the appearances of appearances. And now, all at once, one began to

27. Danto, "Pop Art and Past Futures," *After the End of Art,* 125.

see [with pop art, Danto says,] actual beds in the art world of the early sixties—Rauschenberg's, Oldenberg's, and, not long after that, George Segal's. It was, I argued [in the "Artworld" paper], as if artists were beginning to close the gap between art and reality [*sic*]. And the question now was what made these beds art if they were after all beds. . . . [Warhol's] *Brillo Box* made the question general. . . . The example made it clear that one could not any longer understand the difference between art and reality in purely visual terms, or teach the meaning of "work of art" by means of examples. But philosophers had always supposed one could. So Warhol, and the pop artists in general, rendered almost worthless everything written by philosophers on art, or at best rendered it of local significance.[28]

Apart from the question of history, you must realize that if artworks can be perceived, then there must be a fair sense in which perception can be the perception *of* Intentionally qualified properties. Of course, what is decisive here is simply that the truth of that conjecture holds as well in ordinary life as among artworks, as the visual perception of a signed check and the auditory perception of a verbal command make clear.

Furthermore, if Danto is right in what he says about pop art, then, of course, the art-theoretical-and-art-historical past of pre-1960s' art will have been altered by the pop art development—which would run completely contrary to his own theory of history,[29] as well as to the philosophical and art-historical *discovery* he now puts before us. For, as he goes on—he means to instruct us—"For me, through pop art, art showed what the proper philosophical question about itself really was. It was this: What makes the difference between an artwork and something which is not an artwork if in fact they look exactly alike?"[30]

Of course, this last remark confirms the fatal equivocation on "perceive" already noted (also, the equivocation on "look exactly alike") and, I may as well add, the equivocal disjunction between "art" and "reality." (Of course, art *is* real; it *is* a part of "reality.") But a deeper difficulty remains: Danto wishes us to believe that his discovery brings art history to an end, whereas the truth is, the end of art is an artifact of his own constructed history of the end of art. Change *that* history and Danto's claim is completely outflanked.

28. Ibid., 125.
29. See Arthur C. Danto, *Narration and Knowledge* (New York: Columbia University Press, 1985).
30. Danto, "Pop Art and Past Futures," 125.

I am not objecting to Danto's verdict in the passage cited: I am trying to place it plausibly, to explain the nature of the *sui generis* objectivity of history—*a fortiori,* the objectivity of the periodizing of art history and criticism cast in its terms.

The answer rests with the decisive philosophical judgment that the past of history is itself an artifact of our evolving present history. Not the past of physical nature but the significant (Intentional) past of cultural life incarnate in the physical past. You may destroy a painting once and for all by destroying its canvas, but you may also change the historical import of modernist painting—of Pollock, for instance, read in Greenberg's way—by constructing the post-historical pop world of Warhol and Rauschenberg. And if you can do that, you can do it again and again—in diverging ways. Danto would resist my reading. It would bring him too close to relativism. But he has no effective grounds for resisting. Certainly he would need some notion of the perception of artworks.

More than that, on the argument being sketched, to change the history of painting—*to construct new pasts* for our present reflection on the course of painting's history—is to alter the painter's own (Intentional) nature, for painters are themselves histories constituted by internalizing (and continually transforming) the focused sensibilities of a tradition of painting. If you see that, you see at once why understanding the history of art is inseparable from understanding ourselves.

The strange thing—that is, the strange thing seen from a canonical vantage that ignores the Intentional nature of cultural entities—is that the "number" or numerical identity of cultural entities need not change, in spite of changes in their (Intentional) "natures." That goes entirely contrary to canonical forms of essentialism (Aristotle's, classically). There's the reason for resisting the admission of the *reality* of artworks: Danto's fatal difficulty. For to admit the ontic peculiarity of artworks and other cultural entities (ourselves, of course!) is to challenge in an ineluctable way the entire Western conception of objective knowledge and independent reality. Here, you begin to see how the modernist/postmodernist dispute obscures the deeper question of the historicity of thought and all that entails. Hence, if the intended distinction between number and nature is admitted to be viable (without fear of "incoherence"), then it is easy enough to see that the "nature" of an artwork (open to historical and critical description) may well include, in various complicated ways, selected parts of its own history (so labeled from some supposed initial vantage).

I can only add, by way of closure—I trust it will be convincing—that the

objectivity of art history (for instance, its periodization, its tolerance for competing narratives and competing interpretive practices) brings into play a kind of objectivity that has more in common with the consensual practices of understanding one another's speech in a language we agree we share than with the putatively neutral criteria of physical science applied to the discovery of the details of an altogether independent world. To be quite frank about it, I regard the last conviction—about an altogether independent world—as a form of self-deception. If so, then the local puzzles of the history of painting are also paradigms for the deepest puzzles of knowledge and self-understanding.

2

Relativism and Cultural Relativity

It is a truism at once baffling and reassuring that there are apt bilinguals for every known natural language. It is the corollary, of course, of an equally baffling and equally reassuring truism, namely, that a newborn child can have learned any language as its first language if it can have learned the language it eventually acquires. And yet, at the point of mature competence, everyone is aware of the deep uncertainty of understanding the speech and behavior of others belonging to the same culture as well as to another culture. In fact, we may as well admit that we are not always clear whether we understand ourselves at certain critical moments or, indeed, are clear about what we may have done or said or made at some moment in our past. Plato broadly suggests in the *Ion* that the gods make captive the minds of poets in order to express through them their own thoughts. But the gods are notoriously difficult to understand. Furthermore, we are hardly confident about what it is we do when we understand ourselves, one another, those of our own culture, and those of another culture. No one, I think, has satisfactorily answered the question.

When we ponder these familiar puzzles, we begin to suspect that,

often—possibly always—what we call understanding and knowledge may not be capable of being as crisp or as univocal or as confirmable as we should like. If, to take a compelling example, I stand before a number of Paul Klee's enigmatic drawings, I am aware that part of their great charm rests with the fact that I can place them with assurance in an art tradition I am well acquainted with, though I am unable to state their meaning and what their purposive structure is with a precision and assurance matching their obvious mastery. I fall back to weaker claims, and I take the Klees to convey not so much a dearth of evidence I might otherwise have collected as a sign I am at the limit of what could possibly be added in the way of evidence that could ever bring my interpretive conjectures to any single, final, exclusive truth about these pieces.

I am myself impressed with the uncertainty (that is, the certainty) that what Klee produced might not be able to support any uniquely valid description or interpretation or explanation of their "meaning," and that what holds for the Klees holds everywhere, or for the most part, or often enough that we must make conceptual room for such occasions. Others may not believe as I do, may not be struck in the same way I am. It is for that reason I confess I am a relativist, though I am aware that others are not.

Of course, in mentioning the Klees, I am not insisting so much on the possibility of alternative interpretations of any particular piece as I am on the initially problematic nature of first confronting a Klee. Anyone familiar with the usual Klee prints and paintings knows how difficult it is to determine what to regard as the right way to "read" them. No telltale clues reassure us, confirming that we're simply right, after all. We are obliged to construct (within our sense of the tradition of receiving art) what we judge to be a fair way of entering the (Intentional) "world" of any particular Klee. (I am convinced that the same is true as well in getting our bearings on, say, a more "legible"Vermeer.) But the deeper point is that *how* we enter Klee's "world" is a function of how we ourselves have been formed and altered by the ongoing history of painting we suppose we are able to master, well after the original Klees were produced.

In the West, the history of relativism is a conceptual disaster: not, as one might imagine, because of the futile efforts in its defense but rather because of the remarkable constancy of philosophy's adverse judgment that relativism cannot possibly be made coherent. It is an extraordinary fact that, from ancient times to the very end of our century, there have been no more than one or two principal objections against the coherence of relativism—

already formulated by Plato and Aristotle—that have been thought so decisive that we still invoke the ancient arguments almost without modification.

As far as I know, there is no other doctrine of comparable importance—skepticism (which is altogether different) springs to mind—that shows the same degree of philosophical inertia. The ancients thought of the matter primarily in logical or formal terms (even if ontologically or epistemologically), and in the modern world, the ancient puzzles have been additionally complicated by the general admission of historical and cultural diversity (the consequence, I should say, of philosophy's reflections on the meaning of the French Revolution). You see the difference at once when comparing Plato's *Theaetetus* and Aristotle's *Metaphysics* Gamma (both addressed to Protagoras) to the more diffuse accounts of Thomas Kuhn's *The Structure of Scientific Revolutions* and Michel Foucault's "Nietzsche, Genealogy, and History."[1] Of course, the modern exemplars are hardly canonical in the same sense the ancient texts are thought to be. But the plain fact is, the ancient arguments are remarkably easy to defeat (though they have hardly been strengthened over the centuries) and the modern discussions are not so much arguments one way or another as unavoidable confirmations of the kind of cultural site at which the threat of relativism must be met. Any proper defense of relativism must address both themes.

I am convinced that the ancient and modern ways of rejecting relativism depend on the same unearned conviction, namely, that whatever is truly real possesses some unchangeable structure, that whatever changes occur in the real world may be explained only in terms of what is changeless, and that whatever we come to know of reality involves a grasp (however approximate) of that underlying structure.

The opponents of relativism are aware that its deepest defense relies on its *not* being demonstrable that this executive conviction can ever be shown to be necessary or inviolable in reality or in thought—that is, to avoid paradox or self-contradiction. Aristotle is entirely explicit on the matter. In fact, what I have just offered is a summary of his argument in *Metaphysics* Gamma, and Plato's sketch of Protagoras's thesis on the meaning of truth shows how opposing the canonical view of fixity (in at least one way, certainly not in every eligible way) instantly produces a self-defeating paradox.

1. Thomas S. Kuhn, *The Structure of Scientific Revolutions,* 2d ed., enl. (Chicago: University of Chicago Press, 1970); Michel Foucault, "Nietzsche, Genealogy, and History," *Language, Countermemory, Practice: Selected Essays and Interviews,* trans. Donald F. Bouchard and Sherry Simon, ed. Donald F. Bouchard (Ithaca: Cornell University Press, 1977).

Protagoras seems to have been aware of the underlying confrontation between necessary invariance and flux; very possibly, he meant his famous doctrine, "Man is the measure," to accord with the rejection of Parmenides' dictum, which (we may suppose) Plato and Aristotle wished to reconcile with the reality (or the appearance of reality) of the changing everyday world. But I must warn you in the bargain that part of the argument that is needed cannot altogether escape certain formal considerations. (I intend to press these to advantage.)

You see how complicated the underlying quarrel is. I have no wish to pursue it here, though its relevance can never be rightly ignored. In the modern world, the ancient doctrine of invariance is most compellingly championed in the familiar dictum that nature is governed by universal, changeless, and exceptionless laws, and that the work of the sciences is directed toward their discovery or approximation.[2] The fact is, now, at the end of the twentieth century, even that notion is no longer thought unassailable: the laws of nature, we suppose, may (without contradiction) be artifacts or idealizations of some sort from the informal and imperfect regularities of the observed world.[3] Furthermore, the world of human culture—of language, languaged thought, history, technology, art, and, most provocatively, whatever we suppose are the competence of science and the conditions of the world's intelligibility—is clearly contingently formed, impressively variable in structure, eminently alterable by human intervention, problematically intelligible under conditions that change with changing history, and endlessly novel and creative.

In that sense, the prospects of defending relativism are paradigmatically focused in the puzzles of interpreting the art world. For, it may be argued, if relativism can be defended in the world of the arts, then, assuming that modal invariance cannot be secured philosophically and that it cannot be unreasonable to regard our conceptual resources as common coin for theorizing about nature and culture alike, what is gained in one corner of inquiry may be pressed into service in another. Seen that way, you realize that the contest regarding the defense of relativism harbors rather grand pretensions—for instance, about essentialism and the fixed conditions of intelligi-

2. See, for instance, Carl G. Hempel, "The Function of General Laws in History," *Aspects of Scientific Explanation and Other Essays in the Philosophy of Science* (New York: Free Press, 1965); and Wesley C. Salmon, *Scientific Explanation and Causal Structure of the World* (Princeton: Princeton University Press, 1984).

3. See, for instance, Nancy Cartwright, *How the Laws of Physics Lie* (Oxford: Clarendon, 1983); and Bas C. van Fraassen, *Laws and Symmetry* (Oxford: Clarendon, 1989).

bility. I set these aside here, but only as an economy. The fact remains that the classic defeat of relativism is given in ontological terms or in logical terms brought into accord with an unquestioned ontology.

Now, the defense of relativism joins two lines of reasoning: one is more or less confined to formal, uninterpreted, or logical considerations bearing on the treatment of truth or what we should take our truth-values to be, as far as admissible inferences go; the other addresses what, regarding one or another local sector of reality and knowledge, favors or disfavors the relativistic preferences arrived at in the first. The division is obviously artificial, since the intended benefits of the first are offered in the service of the second, and the possibilities the second suggests must be shown not to produce difficulties for the first.

For convenience, I tag inquiries of the first sort "alethic," and inquiries of the second, "ontic" and "epistemic"; also, I urge they be viewed as no more than distinct aspects of a single indivisible inquiry. You see, therefore, that a responsible relativism must provide an alternative "logic" on which its larger rationale depends, but it cannot pursue the large claim if it does not exceed the alethic issue. By the same token, attacks on relativism that are purely formal but are thought to bear on epistemic or ontic issues (once the coherence or nonparadoxicality of relativism is admitted) are, to put it mildly, philosophically irresponsible.

The alethic question is entitled to a certain priority, however, because if it may be shown that relativism's logic cannot but be self-defeating, there would be little point to going on to the ontic and epistemic questions artworks and other cultural artifacts oblige us to consider (that is, in defense of relativism). But, of course, if you take seriously the inseparability of the two sorts of question, you see at once that its priority is no more than a convenience. For what the appropriate logic should be, in servicing, say, the interpretation of the arts, will be a function of what we take the objective features of the arts to be. Alethic, ontic, and epistemic questions are inseparable from one another relative to truth-claims because they are inseparable within objective inquiries. To deny that would be no more than to favor another version of the invariantist thesis: for instance, to claim that, regarding reality, only some form of bivalence (taking True and False as disjunctive and exhaustive truth-values) could possibly serve coherently and adequately. That is exactly Aristotle's claim in the *Metaphysics*.

No evidence shows one cannot depart, coherently, from an all-encompassing bivalence, and there is no reason to object to the compatibility of employing both a bivalent and a relativistic logic—wherever

wanted—provided only that such policies be properly segregated, on grounds of relevance, so as to avoid avoidable difficulties. It is also excessive to insist that no such division of labor may be conducted in as informal a way as we please, for all that is needed is that we fit the picture of our practice to what is reasonably close to the actual practice.

It is *not* a necessary part of the relativist's brief, for instance, that in accommodating diverse interpretations of Velázquez's *Las Meninas,* which, on the evidence, cannot be reconciled with a bivalent logic,[4] we should be obliged to forego the advantage that there are indeed uncontested descriptive claims about *Las Meninas* that rightly fit a bivalent model and even provide, as such, the initial grounds on which relativistically disputed interpretations of the painting effectively vie for objective standing. That comes as a surprise, though it is hardly problematic. In fact, it suggests the general irrelevance of that larger well-known canard holding that relativism can only be "true" relativistically—that, if relativism holds anywhere, it must hold everywhere, which is plainly arbitrary and absurd. What the canard insists on is simply that no relativism can be coherently formulated. As it turns out, that implicates a version of the usual sense of Socrates' devastating defeat of Protagoras in Plato's *Theaetetus.* But, as I say, such an interpretation is neither inescapable nor plausible, given Protagoras's great reputation in the ancient world and the options available to us still. (Protagoras cannot have been as stupid as the counterargument requires.)

I have introduced three important caveats in approaching the alethic question. I find them reasonable and compelling. More than that, they are not noticeably skewed in relativism's favor. Before going on and in order to avoid misunderstanding, I restate them here: (1) alethic, ontic, and epistemic questions are inseparable in analyzing would-be truth-claims; (2) the proper "logic" of any set of truth-claims is a function of what we take to be the domain of inquiry and the conditions of knowledge; and (3) no formal reason precludes us from mingling the "logics" of different sorts of truth-claims, provided only they are rightly segregated on grounds of relevance.

These are very slim constraints, but they touch on much more fundamental questions than I am willing to pursue here. I allow them to surface for strategic reasons, but they are too global for the local issues that metonymically arise in interpreting the arts. I give fair warning, however, that if what I have been saying is reasonably correct, there will be no defen-

4. See Michel Foucault, *The Order of Things: An Archaeology of the Human Sciences,* translated (New York: Vintage, 1970).

sible disjunction between inquiries into nature and inquiries into culture (though they are plainly not the same); in that case, if relativism seems apt in cultural matters, then it cannot (I say) be altogether inapt among the natural sciences. That, however, is not my concern here.

Item (2) is the operative thesis of the tally just given. I read it in the spirit of Aristotle's *Rhetoric* (in the spirit of holding that the valid forms of argument are embedded in social practices), but (2) is not in accord with Aristotle's actual policy. For, of course, Aristotle is committed to ontic invariance and the necessity of bivalence, and there is no compelling argument in favor of either. The most recent formulas directed against relativism in interpreting artworks claim either (*a*) that relativism (which eschews bivalence) cannot do more, or anything other, than what can be done with a bivalent logic or (*b*) that if one insists on departing from bivalence, one inevitably produces results no one would sensibly favor. I reject both claims. I should add, however, that the interpretive theories of Monroe Beardsley and E. D. Hirsch (which adhere to bivalence) are indeed philosophically responsible, albeit uncompelling.[5]

In any case, I draw your attention to the measure of philosophical freedom I've secured by proceeding as I have, for the opponents of relativism

5. For evidence of recent tendencies, see Robert Stecker, "The Constructivist's Dilemma," *Journal of Aesthetics and Art Criticism* 55 (1997). Stecker pretends to attack relativism by addressing its alleged ontic and epistemic implications, but that puts the cart before the horse. You will look in vain for any sustained discussion on Stecker's part of the peculiar "nature" of artworks that might invite a relativistic option. My own argument (which Stecker has in mind, at least in part) is, as I have said, committed to item (1) of the tally given. (I return more pointedly to Stecker's paper in Chapter 3.) The weakness noted appears more egregiously in Robert Stecker, "Relativism About Interpretation," *Journal of Aesthetics and Art Criticism* 53 (1995). A more careful formulation (along related lines) appears in Stephen Davies, "Relativism in Interpretation," *Journal of Aesthetics and Art Criticism* 53 (1995). But see also Robert Stecker, *Artworks: Definition, Meaning, Value* (University Park: Pennsylvania State University Press, 1997), 227–31.

The last two papers mentioned (from the *Journal of Aesthetics and Art Criticism*) were invited for a symposium on my own paper, "Plain Talk About Interpretation on a Relativistic Model," *Journal of Aesthetics and Art Criticism* 53 (1995). Stecker relies (in his book) on Davies's paper, but I cannot see how the arguments of either count at all. They fail for the following reasons: (1) they do not show that relativism is not viable, fruitful, or worth preferring; (2) they nowhere address the ontic peculiarity of artworks in virtue of which relativism might be tempting; and (3) they confuse (what may be called) biographical considerations with philosophical ones. I don't doubt it is unlikely a convinced interpreter of a particular artwork will concede that another's interpretation of the same work (incompatible with his own, on a bivalent logic) might be as valid as his own, but that seems to bear on vanity and bias and not on philosophy. The question remains whether a *society* (through its professional practices) may be willing to concede the validity of competing ("incongruent") interpretations. One can find evidence for that. If I understand Stecker and Davies correctly, both are guilty of the same mistake.

usually ignore the inseparability of alethic and both ontic and epistemic matters. They claim we must adhere in an invariant way to bivalence wherever truth-claims are at stake, but they neglect to explain why our local "logic" should not be tailored to what we believe a given sector of reality can rightly support in the way of truth-claims, and they cannot satisfactorily explain why a restriction in the scope of bivalence should be thought to produce an insuperable paradox. For instance, they surely cannot show that a three-valued logic is inherently self-defeating, or that a would-be bivalent logic cannot accommodate truth-value gaps.[6] Here, of course, I am approaching the logical needs of an interpretive practice addressed to the Intentional complexities of artworks. I therefore invite your patience.

I can now provide an answer to the alethic question. The following are the essential elements of a relativistic logic—where, by a "logic," I mean nothing more than a policy regarding the formal conditions for the choice and assignment of truth-values affecting admissible inferences in the space in which they are applied, without (yet) specifying the evidentiary grounds on which they are empirically assigned: (1) the concept and practice of a bivalent logic are assumed to be in general play in all our inquiries, but the bivalent values themselves (True/False) are restricted in scope or denied application among the truth-claims admitted to the domain in question; (2) within relativism's scope, the values True and False are treated asymmetrically: False is retained, but True is denied application, and a many-valued set of truth-values (not a three-valued set—one that merely adds Indeterminate to the usual bivalent pair) replaces True, so that "not false" is no longer equivalent, as in a standard bivalent logic, to "true," but is equivalent instead to values drawn from the replacing many-valued values; (3) within the scope of (1)–(2), truth-claims that, on a bivalent logic but not now, would be formally contradictory or incompatible may be logically compatible when assigned one or another of the replacing many-valued values; these may be termed "incongruent" values, meaning, by that term of art, that what they permit would be incompatible on a bivalent logic but are (now) formally consistent within the alethic scope intended; also, that further constraints of inconsistency and contradiction may be admitted (on substantive grounds) involving opposing the value False and one or another of the replacing values; (4) bivalent and relativistic logics remain compatible and may be jointly used, provided only the scope and relevance constraints binding

6. See, in this connection, W. V. Quine, *Word and Object* (Cambridge: Harvard University Press, 1960), sections 15–16; and P. F. Strawson, "On Referring," *Mind* 14 (1950).

different sets of truth-values and their applications are segregated—in as ad hoc a way as we please; (5) the resultant logic may, when rightly joined to ontic and epistemic considerations, be as *realist* in import as the applications of any standard bivalent logic; and (6) the values invoked remain entirely formal—lack all epistemic and ontic import—until the domain in which they are applied is pertinently interpreted.

To offer a small clue about items (1)–(6), I should say that I can easily believe what Roland Barthes called "readerly" and "writerly" reading—in effect, a bivalent and a relativistic reading of Balzac's *Sarrasine*—may be jointly supported (without contradiction).[7] I also believe descriptive considerations are bound to form the common evidentiary ground for both practices, so that they may still be assigned the value "True" (in the bivalent sense) but may then be used to justify confirming that a relativistic reading is as "objective" in its own sphere as bivalent claims are in the bivalent sphere.

Plainly, the rationale for so speaking will depend on how we characterize the interpretable properties of a literary piece like *Sarrasine*. How could the supposed normative but purely formal invariance of bivalence possibly decide the right way to proceed in accommodating would-be interpretations of *Sarrasine*? It seems an awkward question for the enemies of relativism. Furthermore, we may invoke bivalent values wherever we speak of consistency of usage, that is, when using terms in the same way in different contexts, but that shows the benign sense in which we may reconcile bivalence and many-valued values. Alternatively, of course, consistency and noncontradiction arise in many-valued contexts just as they do in bivalent ones.

A few explanatory remarks may be helpful here. For one thing, I treat cultural entities in a "realist" way—in other words, no more than that they are real and that their properties may be fairly said to be discerned. In this minimal sense, *realism* is neutral as between bivalence and a relativistic logic (though, of course, many would not be willing to admit as much). Second, on my view, a relativism regarding interpretation is not precluded from treating certain "descriptive" (even certain "interpretive") attributions bivalently; that is just what I had in mind in admitting an informal and relatively ad hoc mix of bivalent and relativistic values in interpreting familiar artworks (for instance, speaking of Hamlet's procrastination). But admitting this much goes no distance toward admitting *any* antecedently fixed general range of application of bivalent values in interpretive contexts, and what we

7. Roland Barthes, *S/Z,* trans. Richard Miller (New York: Hill and Wang, 1974).

should understand as the right relationship between description and inter-
pretation depends on our theory of what an artwork is. It certainly cannot
be decided by appeal to how things may go (analogously) in speaking, say, of
physical objects. This is often overlooked.[8] Third, in defending relativism, it
is irrelevant that interpreters often believe their own accounts preclude
other "incongruent" interpretations, if a disciplined practice (as among pro-
fessional critics and scholars)—that is, a collective practice, as opposed to an
individual idiosyncrasy—finds it worth conceding that such interpretations
may be jointly valid. And fourth, the entire issue is worth very little if the
alethic questions are disjoined from a reasonably ramified account of the
ontology of art and the epistemology of interpretation. It is extraordinary
how many discussants disregard these very modest constraints.

The marvel is that it is so terribly easy to accommodate (in a formal
way) the practice of contemporary literary and art criticism as at once ob-
jective *and* relativistic. The objections of the ancients and of contemporary
antirelativists like Monroe Beardsley and E. D. Hirsch have no force at all, or
if they do, it rests on ontic and epistemic grounds suited to one or another
domain of inquiry—*not* for the formal reasons usually advanced—which is
precisely what I wish to champion.[9]

Many who have been sympathetic to the relativist's view of criticism but
who both despair of ever recovering the required alethic policy and are
simply unwilling to oppose bivalence must themselves now come to terms
with the obvious coherence of the relativist's alethic policy. This is especially
true of those who have been tempted to drop the notion that interpretive
judgments take truth-values at all (for instance, in an otherwise excellent
study, by Torsten Pettersson, of interpretive options in poetry).[10] They too
are now obliged to explain their stand in terms that have nothing to do
with avoiding formal difficulties. That is a considerable gain.

I should perhaps add that I am entirely willing to label my many-valued
values in any way that suits the occasion in hand ("apt," "reasonable," "plau-
sible," or the like). All I insist on is that, thus far at least, they are merely
"alethic"—that is, *not yet* interpreted epistemically or ontically. It is of
course entirely possible that such values as "apt" or "plausible" should also

8. The complication regarding description and interpretation is overlooked in Richard Shus-
terman, "Beneath Interpretation: Against Hermeneutic Holism," *The Monist* 73 (1990).

9. See Monroe C. Beardsley, *The Possibility of Criticism* (Detroit: Wayne State University Press,
1970); and E. D. Hirsch Jr., *Validity in Interpretation* (New Haven: Yale University Press, 1967).

10. See Torsten Pettersson, *Literary Interpretation: Current Models and a New Departure* (Åbo, Fin-
land: Åbo Academy Press, 1988).

be construed in evidentiary ways. However, if you allow them here in the alethic sense, they are not yet epistemically informed. I should say that something similar obtains in a many-valued logic that admits "probable" or "probably true," although it is characteristically linked to a bivalent logic and likely to be intended in nonrelativistic ways. There may be many such loosely similar distinctions to consider. (Relativist values, however, are not probabilistic values of any kind.)

We have reached a stalemate, then, on the alethic issue. Whatever advantages accrue to bivalence or relativism depend entirely on our picture of the world in which they apply. Even that is a stunning gain. For, if you review the history of relativism, you will not fail to see that it has never been conceded that a relativism close to Protagoras's conception could possibly escape one or another lethal paradox. That now turns out to have been a mistake.

I trust you approve my initial constraints on the airing of relativism's prospects. I have, in the foregoing, confined my analysis to the alethic in order to demonstrate, within the usual terms the canonical opponents of relativism insist on, that relativism remains as coherent as bivalence—and need not even refuse to be linked to the use of bivalence. In arguing thus, I may have prompted objections of two related sorts that I should like to offset. For, many will say, if you treat relativism in the alethic way, you have yourself fallen in with relativism's opponents; you must believe that a relativistic logic is, on objectivist grounds, the right logic to prefer everywhere. By "objectivism," I mean no more than there is an "independent" order of reality—including artworks and other cultural entities—and we are fortunately endowed with the cognitive capacity to discern its determinate structure as it exists "independently."[11]

No. What I have offered in the foregoing is an attempt to vindicate relativism within the terms of reference the opponents of relativism insist on: my limited claim here is that they fail under that constraint. But I also want to insist, first of all, that the entire alethic policy I am advocating is *not* detachable from the encompassing ontic and epistemic considerations relative to which a relativistic logic (or a bivalent logic, for that matter) works at all; and second, that here the invariances and modal necessities of the "objectivist" orientation are to be rejected.

11. See, further, Richard J. Bernstein, *Beyond Objectivism and Relativism: Science, Hermeneutics, and Praxis* (Philadelphia: University of Pennsylvania Press, 1983); and Joseph Margolis, *The Truth About Relativism* (Oxford: Basil Blackwell, 1991).

You will notice that I have avoided introducing flux or historicity or in-commensurability in speaking of the mere alethic structure of relativism. That was meant to preclude certain irrelevant objections. Nevertheless, *once,* on independent grounds, you acknowledge historicity, the range of application for a relativistic logic is bound to be much larger than might otherwise be supposed. Relativism is hardly interesting, presented as a mere abstract possibility. It gains standing only by being put to use in one important sector of inquiry or another. Here, of course, I am attempting to show its advantage in the criticism of the arts, but I set no antecedent limitations on its use. On the contrary, you see that vindicating relativism in the formal sense is only a small part of recovering the puzzle that the modernist/postmodernist dispute obscures.

I

Matters change abruptly once we turn from formal to substantive considerations, for relativism has its best inning in judgments about cultural phenomena. Even if admitting that were tantamount to admitting a restriction on relativism's range of application, nothing would be lost: as I have said, relativism need not be an all-or-nothing affair. The opponents of relativism forever point to inquiries that (as they believe) could not possibly recommend a relativistic logic. Perhaps. But if relativism may be defended piecemeal, for different sectors of inquiry, the objection would be irrelevant. There are also, I may say, arguments to the effect that physical nature is itself a distinction drawn from within the scope of culturally qualified phenomena. I cannot do full justice to these deeper speculations—they would be out of place—but they might easily affect our sense of the conceptual link between nature and culture and the fortunes of Protagorean relativism. In particular, if realism with regard to physical nature must take a constructivist form, as I believe it must, then the prospects of relativism will be greatly enhanced even with respect to the physical sciences. I shall leave the matter thus—quite unresolved.

It is hard to convey how far we've come. To grasp the full force of what has already been said, you must realize that what is still needed to clinch the argument (in relativism's favor) is simply to show a proper fit between some sector or sectors of inquiry and the accommodating logic. That's all. Wherever we want to admit "incongruent" truth-claims, we need only fall back

to a relativistic logic. The question remains whether there are any such sec-
tors of inquiry—whether it would be no more than stonewalling to deny
they exist. Of course they do! I shall come to the argument in a moment.
But, more to the point, you must realize that what remains to be supplied is
not so much a further formal defense of relativism as an ontic and epistemic
characterization of the phenomena of certain exemplary inquiries and of
what it is possible to claim and confirm about them. These, it may be
hoped, can be shown to fit especially well the peculiar resources of a rela-
tivistic logic. What this shows is the misplaced zeal with which relativism
is usually condemned and the profound mistake of conflating relativism
with skepticism—or worse. For to justify relativism is to qualify the logical
variety of admissibly objective truth-claims and to explain why relativism
should be favored in certain domains at least. That runs absolutely contrary
to skepticism's objective—as well as anarchism's and nihilism's, for that
matter.

One extremely tame concession is too easily confused with the rela-
tivist's claim. We need to be clear about this possibility in order to dismiss it
as a false pretender. The irony is that, when certain further distinctions are
put in play, the tame concession in question—often dubbed "cultural rela-
tivity"—suddenly takes on a meaning that *does* indeed bear in an important
way on relativism's (ontic and epistemic) fortunes. Nevertheless, by itself, it
is a truth no one would ever dream of disputing or would ever rightly sup-
pose was equivalent to the relativist's thesis. For, of course, if it were the true
nerve of the issue, we would all be both instant relativists and relieved to
say so.

By "cultural relativity," then, I mean no more than the pedestrian fact
that different societies have different histories, languages, customs, values,
theories, and the like. I do *not* mean, in that sense, that what is true is also
different among different peoples, or that knowledge differs among differ-
ent peoples because knowledge must be relativized to what is already rela-
tivized in the way of truth. Such a position would be a conceptual blunder
as well as a complete *non sequitur.* What, substantively, is claimed to be true
will doubtless differ from one cultural orientation to another, but truth and
knowledge, as such, cannot be construed, on pain of contradiction, as cul-
turally variable. For that would mean what is (rightly) true might also be
(rightly) false. This is the reason for distinguishing between truth and truth-
claims.

Simply put, the theme of cultural relativity is a matter of first-order fact,
whereas the relativist's thesis is a matter of second-order legitimation. That

languages and customs differ is no more than a tiresome first-order fact; but that a relativistic logic should fit certain inquiries better than a bivalent logic, *without yet implicating any variability in truth or knowledge as such,* is a question open to serious second-order philosophical dispute. I see no quarrel here. By themselves, the bare facts regarding cultural relativity have no philosophical importance at all. They acquire importance only when they are pressed in the direction of the blundering thesis I have just flagged or of whatever, more defensibly, may accord with relativism proper. This matter is almost universally overlooked.

What is potentially interesting about cultural relativity is that the differences noted between cultures may also obtain within them—that intersocietal differences are no different in any principled way from intrasocietal differences; therefore, it is just as philosophically difficult to fix objective truth and knowledge within any one society or culture as it is between very different societies or cultures. That, I should say, was the absolutely splendid thesis of W. V. Quine's enormously influential book *Word and Object,* though that connection is never pointedly addressed in *Word and Object* (in the sense relevant to relativism) or anywhere else in Quine's publications.[12] For, of course, it is also the central thesis of Kuhn's *Structure of Scientific Revolutions* and Foucault's "Nietzsche, Genealogy, and History," which, by and large, are inchoate relativisms addressed to the possible philosophical importance of cultural relativity and historical change. For what Kuhn and Foucault were willing to concede—which Quine was not—was that what we count as truth and knowledge (that is, the legitimated concepts, not the bare, first-order facts accumulated by different societies) are *artifacts of history* in the very same way first-order facts are. Yet that is no longer mere cultural relativity but relativity housing relativism, the conjunction of alethic and ontic/epistemic issues.

We don't actually know what Kuhn's and Foucault's theories of relativism were. They were never explicit enough. Kuhn was content to deny that we could ever directly discern any principle of "neutrality" regarding objective truth (objectivism), and Foucault had no patience with the question. The usual philosophical error spun from the facts of cultural relativity is, in effect, the same error Socrates attributes to Protagoras in the well-known exchange with Protagoras's student, in the *Theaetetus.* "True" for Protagoras, Socrates affirms, means "true-for-*x*." Truth is an inherently relational notion, relativized to whatever, contingently, merely "appears"—or is

12. See Quine, *Word and Object,* chaps. 1–2.

"believed"—true by this person or that, or by the same person at different times. This has become the standard reading of Protagoras's doctrine over twenty-five hundred years.[13] Of course, if that is what relativism comes to, then certainly relativism is absurd—because it is self-defeating in an insuperable way.

One could never, for instance, say what anyone took to be true by his or her own or anyone else's lights; every effort to do so would be caught in the "relationalism" of the original definition of "true." I trust it is clear that I have, by what has already been offered in the way of analyzing relativism's logic, completely obviated the need to fall back to this preposterous reading of either cultural relativity or Protagoras's doctrine. We must go further. I do acknowledge that a bewildering number of commentators suppose either that cultural relativity *is* what relativism comes to or that, in virtue of cultural relativity, adopting relativism is tantamount to admitting Socrates' formula.[14] But that is surely a *non sequitur.* I am unconditionally opposed to both readings.

All this is by way of clearing the air. The primary point about cultural relativity is not mere first-order variety but rather that, within such variety, we must single out the possible import of its being the case that expressive, representational, stylistic, rhetorical, symbolic, semiotic, linguistic, traditional, institutional, and otherwise significative features of artworks and other cultural phenomena fall within the scope of the culturally variable. For, if such properties are subject to cultural relativity, then it must dawn on us that we may not be able to defend the objectivity of truth-claims about them in the usual bivalent way. We may have to fall back to the relativist's option. Such is the full connection between the two questions I originally distinguished.

I call all such properties (the expressive and the representational, for instance) "Intentional" properties, which means they designate meanings assignable to certain structures or meaningful structures as a result of the various forms of culturally informed activity (speech, deeds, manufacture, artistic creation), such that suitably informed persons may claim to discern these properties and interpret them objectively. "Intentionality" is a term of art here, which I designate by capitalizing the initial "I." (I have introduced the notion before, informally.) I use the term predicatively, to mark a family

13. It is repeated, for instance, by Myles Burnyeat, a specialist on Plato, in "Protagoras and Self-Refutation in Plato's *Theaetetus,*" *Philosophical Review* 85 (1976).

14. See, for instance, Hilary Putnam, "Why Reason Can't Be Naturalized," *Philosophical Papers,* vol. 1 (Cambridge: Cambridge University Press, 1983), 235–37.

of *sui generis* properties confined to the cultural world—that is, to designate the collective, intrinsically interpretable features of societal life. I do *not* equate the term to the essentially solipsistic, ahistorical, and acultural forms of intentionality featured in the theories of Brentano and Husserl, yet I apply "Intentionality" in a way that still provides for something like the use they intended, but only under enculturing conditions (the conditions of acquiring, in infancy, a natural language and a grasp of the practices of one's surrounding society).[15]

That is a large story of its own, which I cannot properly relate here.[16] I merely co-opt the benefit of admitting its relevance. The most strategic theorem it offers—not the most important for our question—rests with the fact (congenial to cultural relativity) that Intentional properties are quite real. For convenience, I recommend the following postulate: the Intentional is equal to the cultural. For what is normally contested (remember Danto) in admitting the world of human culture is whether it is real at all—as real (say) as physical nature—and, *qua* real, marked by the *sui generis* properties I've just collected (the Intentional). That, of course, lays a proper ground for the objectivity of interpretive truth-claims that is conveniently indifferent to the alethic quarrel between bivalent and relativistic logics.

There's much more to the story than that. I'm being more than cautious in drawing your attention to the unfinished tale on which the completion of the argument favoring relativism depends. It's not needed in any narrow sense here, but it would help to reassure you that, both prephilosophically and philosophically, questioning the reality of the cultural world would produce instant and insuperable paradox. On my own argument, it would involve questioning our own existence. As I see matters, we ourselves (or "selves") are also artifacts of cultural life formed by transforming the members of *Homo sapiens* into linguistically and culturally apt subjects, marked (by that process) for discerning the Intentional features of whatever, as selves, we make and do. To put the point in its most provocative form, one could assert that no principled ground exists on which to disjoin the realist reading of human selves and the realist reading of the artifacts of their world; both are culturally constituted in similar ways and subject to similar interpretive interests. I would not press the point, except for the fact that

15. For a convenient summary, see Jitendra Nath Mohanty, *The Concept of Intentionality* (St. Louis: Warren H. Green, 1972).

16. For a sense of its bearing on the defense of relativism, see, further, Joseph Margolis, *Historied Thought, Constructed World: A Conceptual Primer for the Turn of the Millennium* (Berkeley and Los Angeles: University of California Press, 1995).

the most fashionable analytic theories in the West (particularly in the philosophy of mind) completely discount the reality of the cultural (and the intentional in general) or make it entirely derivative, logically, from whatever may be specified in purely biological or computational terms.[17]

Even that might not be troubling, since these theorists often have little interest in the philosophical problems of the cultural world. But what should we say when leading theorists of the arts—Arthur Danto, most notably—commit themselves to the *denial* of the reality of the cultural (or the Intentional).[18] I must alert you to the fact that even a bivalent account of the objectivity of literary and art criticism would utterly founder on anything like Danto's thesis; so that admitting the reality—*a fortiori,* the discernibility—of the Intentional structure of artworks and human careers lays a needed ontic and epistemic ground for the would-be objectivity of critical interpretations and histories, *whether construed bivalently or relativistically, objectivistically or constructivistically.* Allow the gain, if you will, however provisionally: it does not quite reach to what is decisive for or against relativism, but it makes the debate worth the bother.

Let me summarize what I have already established in this chapter, with an eye to securing a further goal. Thus far we have (1) distinguished a relativistic logic from a bivalent logic and shown its formal coherence; (2) discovered that the defense of relativism, as in a relativistic theory of interpretation or history, is largely occupied with demonstrating, ontically and epistemically, a certain suitable fit between manageable inquiries in one or another sector of the world and the resources and advantages of a relativistic logic; (3) acknowledged that no insurmountable paradox results from using a bivalent and a relativistic logic together, even in a lax and ad hoc way; and (4) determined that relativism and cultural relativity are entirely different doctrines, since the first is a second-order thesis and the second is a first-order thesis. We want, of course, to know how relativism and cultural relativity may be fruitfully linked so that an obviously robust practice—such as the ongoing work of a professional cohort of historians or art critics, or lawyers or moralists, for that matter—could be sustained or would strike us as worthwhile (not prone to any serious loss of investigative rigor)

17. See, for instance, Paul M. Churchland, *A Neurocomputational Perspective: The Nature of Mind and the Structure of Science* (Cambridge: MIT Press, 1989); and John R. Searle, *The Construction of Social Reality* (New York: Free Press, 1995).

18. See Arthur C. Danto, "The Artworld," *Journal of Philosophy* 61 (1964); and the meaning of "transfiguration" in Danto's *The Transfiguration of the Commonplace: A Philosophy of Art* (Cambridge: Harvard University Press, 1981).

and would actually be less arbitrary and more rewarding than champions of the bivalent canon suppose.

The general answer is plain enough: on the one hand, the defenders of the bivalent canon cannot make their own case everywhere and, indeed, inevitably betray their awareness that they cannot; on the other hand, we already have the favorable evidence of the exemplary practices of interpretive critics and historians. The essential clue is this: the switch from bivalence to relativistic values is not a change in rigor at all but a change in what we understand to be the nature of the *objects* on which the relevant rigor is to be practiced. In claiming that the Intentional structure of artworks definitely favors relativism over bivalence, I take the general failure on the part of most critics of relativism to analyze Intentionality to be knockdown evidence of their failure to address the full question of relativism itself. For Intentional attributes are not determinate—though, under interpretive conditions, they are determinable—when compared with what is usually taken to be the determinate nature of physical or non-Intentional attributes. It's this issue that needs to be pursued—along with, of course, its bearing on the question of objectivity.

I can well imagine that Barthes's intuitive discipline in reading *Sarrasine* may set a higher mark for acceptable relativistic interpretations than conventional bivalent readings of established texts. Harold Bloom's ingenious reading of Nathaniel West's *Miss Lonelyhearts,* for instance, is, despite Bloom's own antirelativistic proclivities, a fine example of a relativistic exercise akin to Barthes's.[19]

It may also be that a potential social benefit results from calling *all* pretensions of objectivity into question at the present time. I am willing to concede the possibility, but it is not my principal concern here. Nevertheless, I'll add in all frankness that to reject "objectivity" because one rejects "objectivism" is excessive—and more than misleading. Because, we obviously need *some* normative sense of the rigor of inquiry and the attribution of truth-values. Whatever is best in that sense is what we must recover as objectivity. (There's a danger here of being misunderstood.) But strict postmodernism is conceptual anarchy: whatever first-order recovery may be defended implicates some form of second-order legitimation.[20]

19. See Harold Bloom, *The Breaking of the Vessels* (Chicago: University of Chicago Press, 1982), chap. 1.

20. Since giving these lectures, I have read Barbara Herrnstein Smith, *Belief and Resistance: Dynamics of Contemporary Intellectual Controversy* (Cambridge: Harvard University Press, 1997). There is much that Smith and I share (and have shared in earlier publications). But, with due appreciation of

For present purposes, I bridge the difference between the two issues by admitting straight out that what counts as objectivity is—ineluctably—a reasoned artifact of how we choose to discipline our truth-claims in any sector of inquiry. The assumption is that there is simply no way to *discover* the true norms of objectivity in any domain at all. Acceptable norms will have to be constructed as one or another disputed second-order proposal fitted to what we claim are our best first-order interests in this domain or that. What's important is that such a construction is not tantamount to relativism—in the straightforward sense that even our adherence to a bivalent logic (in physics, say) may have to take a constructivist turn. Constructivism is not, as such, equivalent to relativism.

Kuhn may well be right to say that it is "hopeless" to pretend to discover the changeless marks of objectivity.[21] Some claim to see in this a return to Socrates' interpretation of Protagoras. But that would be a mistake, a complete *non sequitur.* For, as already remarked, "true" is laid down in the *Theaetetus* as meaning "true-for-*x*" and is thereafter rigorously applied (if possible), whereas, here, it is not a question of the meaning or criteria of "true" at all but of how, socially, the practices of what we call objective inquiry are first formed. There is no ulterior judgment to the effect that what is posited as a defensible practice in this regard is tantamount to, or entails, the finding that that (also) *is true-for-x* (where "*x*" is now the society that supports the practice).

II

I freely admit there's a puzzle here, one very close to what I wish to secure— that is, a fifth theorem in the tally I have just collected. But it cannot be captured by the "relationalist" formula drawn from the *Theaetetus* or from any simple Kuhnian-like or Foucauldian analogue applied to history. That would merely repeat the disaster of the standard history of relativism, formed, without protest, from ancient times to the present. We are in uncertain

her rhetorical intent, I find she slights the recuperative side of the epistemological and methodological issues. This gives her account a cast that is more sympathetic with Rorty's postmodernism, Feyerabend's anarchism, or the claims of the Scottish sociologists of knowledge than I would favor. I concede that all of these options make their contribution, but I also find them all (finally) inadequate.

21. Compare Kuhn, *The Structure of Scientific Revolutions,* section 10.

waters here, not because of deeper doubts about relativism but because of
the primitive state of all our inquiries into cultural life. The entire rationale
for shifting from bivalence to relativism depends on how clear we really are
about the *nature* of an artwork or a self.

You see this instantly if you recall the bivalent arguments of Beardsley
and Hirsch. Why do they insist on the inviolability of bivalence in literary
and art criticism? Beardsley claims no fundamental difference exists be-
tween the describability of a stone and the describability of a poem, except
that poems have "meanings" for properties and stones do not. Surely, that's
preposterous. Beardsley himself admits he cannot tell when a meaning is *in*
a poem or merely imputed to it.[22] He certainly cannot offer us anything
like a rule or criterion in support of his bivalent claim. For his part, Hirsch
denies that poems are objects of any kind. They are, he suggests, what may
be imaginatively reconstructed by discerning, among the ordered words of a
text, evidence of the original intent of the one who first assembled them.

And how is that done? Hirsch claims that every possible poetic utter-
ance—effectively, the intentional ordering of words—quite naturally instan-
tiates one or another fixed genre of utterance formed within the ethos of
the would-be poet's voice. Still, human history itself (Hirsch admits) makes
it impossible to fix any of these supposedly essential genres; the entire enter-
prise is an improvisational fantasy ("probabilized," Hirsch says) that cannot
do more than pretend to discover the invariant forms of meaning.[23]

It's the elusive nature of artworks that forces us to give up a strict biva-
lence. (If art is Intentionally structured and if Intentionality is deter-
minable—interpretively—but not independently determinate, in the way
physical objects are said to be, then bivalence must be threatened.) Also, of
course, on Hirsch's own account, authors need not know what it is they
themselves "intend"; their conformity with objective genres decides the
issue. Yet Hirsch's solution cannot escape the indeterminacies of the
hermeneutic circle.

This brings me to the missing theorem we need: (5) the very nature of
cultural entities and phenomena—artworks, histories, sentences, actions, so-
cieties, persons—are such that, for obvious ontic and epistemic reasons, they
cannot support any objective description or interpretation confined exclu-
sively along bivalent lines. The decisive point is that no one can even say
what the logic of criticism should be, unless she or he can also say what the

22. See Beardsley, "The Authority of the Text," in *The Possibility of Criticism,* esp. 36.
23. See Hirsch, *Validity in Interpretation,* chap. 5, section C.

nature of a poem or a painting is, relative to discursive and interpretive truth-claims.

For his part, Danto never tells us what an artwork or a history *is*—except to say no actual artworks exist. Presumably, this is because "their" intentional features—representationality and expressivity—are rhetorically assigned "mere real things," in virtue of which "they" become rhetorically accessible. They cannot be more, since, it seems, the intentional features in question are never more than rhetorically ascribed, so they cannot be objectively discerned. Possibly, no histories exist either. Or, if they do, then artworks do not, and Danto will have succumbed to an incoherent claim (a vicious regress). Even though artworks are plainly "uttered" by human artists as the Intentionally structured expressions "they" are, Intentional properties will (have to) be real in the case of persons but be deemed unreal in artworks. Apparently, for Danto, artworks are what we imagine, fictively, when, by rhetoric or "transfiguration," we construe "mere real things" (physical objects or utensils, chiefly) as belonging to an ethos or an "artworld."[24] But what's the basis for any would-be objective claims about the meaning of a painting *within* that world? Danto never says. Beardsley and Hirsch are more adventurous but hardly more successful, for they are prepared to risk their own peculiar theories of what an artwork is. Plainly, we cannot hope to fob off any theory of interpretation—good, bad, or indifferent—if we have no theory of the Intentional structure of artworks or human careers.

I have just stated the reason for favoring relativism. Relativism is not inherently a subversive doctrine, a way of destroying the fabric of decent society. It is, rather, the upshot of a quite sober reckoning of the false pretensions of a canon that might well wreck us with its own misguided zeal. Imagine that the champions of some political *status quo* insisted they had found the true norms of invariant human nature and therefore were obliged to treat moral, legal, political, and religious questions in accord with a strict bivalence *informed by those ulterior truths:* that would be the analogue of Beardsley's and Hirsch's doctrines. They can't possibly work: the Intentionality of the human world is far too complex, far too equivocal, far too mongrelized, far too transient, and far too easily altered by our own efforts to determine its meaning. Here, you begin to see the advantage of conceding no more than the Intentionality of artworks and the formal resources of relativism.

24. Danto, "The Artworld."

Please explain yourself, you're bound to say. Don't just rail against the honest labor of more conventional theorists. Tell us how you would reconcile relativism and objectivity—in criticism, for example. Tell us that, or go away! Fair enough. I accept the complaint, but my answer stares you in the face. A proper elucidation would doubtless be interminable, but the essential clue is clear enough: Intentional properties—expressive, semiotic, representational, and all the other significative properties I've gathered under the umbrella term "Intentional"—cannot be determined criterially, algorithmically, evidentially, except in ways that are already subaltern to the consensual (not criterial) tolerance of the apt agents of the collective practices of a particular society. That is the reason all analogies drawn from physical nature won't do, for cultural phenomena exhibit, and physical phenomena lack, Intentional properties. Hence, what we mean by description and interpretation is not quite the same in the two domains (though they are not disjoint either).

In our own time, the thesis may be drawn, in different ways, from Wittgenstein's notions of a *Lebensform* and a "language game" and from Kuhn and Foucault as well.[25] Historically, I am convinced it captures the leanest way to read Hegel's notion of *sittlich* as well as *Geist*.[26] It appears as a recognizable stream of thought running from Hegel through Marx, Nietzsche, Dilthey, Heidegger, Horkheimer, and Gadamer, down to Foucault. If you grasp the point, you see at once it is not possible to segregate the theory of interpreting artworks from a general theory of cultural reality. Professional work will have its local policy, to be sure, but its logic and its sense of a viable practice will be governed by our general conception of the *sui generis* features of the culture we share—any culture, as we now understand matters.

The important point to bear in mind is that a proper analysis of Intentionality is in no way hostage to a favorable policy on relativism. It's the other way around: Intentional properties, which distinguish the world of human culture—*a fortiori,* literary and art criticism and, on a plausible argument, even explanatory theories in the physical sciences—will ultimately signal what our alethic, ontic, and epistemic policies should be.

The entire contest can be decided by reviewing two corollaries of my characterization of Intentionality—applied, if adopted, to the special con-

25. See Ludwig Wittgenstein, *Philosophical Investigations,* trans. G. E. M. Anscombe (New York: Macmillan, 1953).

26. See G. W. F. Hegel, *Phenomenology of Spirit,* trans. A. V. Miller (Oxford: Oxford University Press, 1977). The sense of the "*sittlich*" extends, I believe, beyond the "ethical."

cerns of professional critics, historians, or the like. First of all, predication in general cannot be epistemically managed on criterial or algorithmic grounds unless, *per impossibile,* Platonism is proved viable. I claim that general predicates, Intentional predicates in particular, cannot be extended to new instances, except informally, in terms of what, consensually, may be tolerated as effective or incremental extensions from acknowledged exemplars. Any difficulties incurred—for example, in the sciences, with respect to would-be laws, prediction, explanation, or technological control—can be readily resolved along alternative lines that will have to proceed as before.[27]

But the hopelessness of all theories of universals—realist, nominalist, conceptualist—remains confirmed quite independently of all that. If so, then bivalence will *always* be subject to a policy of accommodating predicative similarities that cannot itself be strictly applied (algorithmically, for instance) in bivalent terms. This concession is generally ignored by the opponents of relativism, even though the tolerance that must be admitted is not inherently relativistic in its own right. Bivalence itself must be applied in a constructivist way to predicables. Even a bivalent treatment of predicative truth must acknowledge that informality.

If you add to this (the first corollary) the obvious adjustment—that the particular exemplars on which extended predicative tolerance depends will always be subject to replacement, on the strength of changing convictions of what to look for in the way of observable similarities—then *whatever* we judge to be objective in the predicative way will elude the impossible strictures of any (bivalent) policy informed by one or another form of invariance. What I say here is that objectivity must be a constructed artifact of our consensual practice—whether construed bivalently or relativistically. Furthermore, what holds for predication holds for reference and denotation and for all linguistic powers that bear on servicing truth-claims. I challenge the opponents of relativism to explain how, if Platonism cannot be invoked, the objective practice of making and confirming truth-claims can possibly be restricted in the bivalent way. I think there cannot be an answer.

The second corollary concerns Intentional predicates and the nature of artworks in particular. Imagine someone asks you for the meaning of Anselm Kiefer's use of Nazi symbolism in his enormously intriguing paintings—which may be judged (by opposed lines of reasoning) to be celebrating or exorcising the world's unresolved memory of that terrible past. How should we decide such a dispute? I suggest you take stock of the following

27. See Joseph Margolis, "The Politics of Predication," *Philosophical Forum* 27 (1996).

notions. First of all, any predicative attribution will be *sittlich*—in the minimal (perhaps pirated) sense I have already sketched but not previously named. (I now borrow the term in the slimmest possible way from Hegel.) The perception of predicative similarity lacks, in the last instance, adequate criteria or algorithms of application, because, as I say, to presume otherwise would be to favor a form of Platonism. Thus, if the scope of a general predicate—any predicate—is extended in real-world terms, it escapes utter arbitrariness only by appealing to the *sittlich,* the actual practices of a society of apt speakers. Questions of the fit between such extensions and the theoretical and practical interests of those speakers affect only the choice among various lines of extension amid an indefinite run of such possibilities. Such a choice never affords more powerful epistemic resources. Hence, the fortunes of bivalence cannot fail to be subordinated to deeper epistemic and ontic considerations.

By parity of reasoning, our aptitude for discerning relevant similarities in a run of would-be cases—any cases—signifies our mastery of the same *sittlich* practices within whose bounds such similarities obtain or are reasonably extended. In the art world, Intentional properties bring into play meanings and other significative structures (Kiefer's images, for instance). So—I mention as a second consideration—Intentional properties complicate the initial question of perceptual similarity (in any generous sense of "similarity") by drawing in (within the bounds of the first) specifically interpretive attributions of semiotic similarities. Is Prokofiev's *Classical Symphony* Mozartean, for instance? Is *Miss Lonelyhearts* a fair analogue of Milton's *Paradise Regained?*

To admit these questions is to admit the unlikelihood of adhering to a strict bivalence—yet without refusing the advantage of a laxer use of bivalence under consensual conditions. If you bear in mind that ordinary discourse is the usual exemplar of our treatment of truth-claims—both in the sense that any would-be greater precision of reference and predication is tethered to the possibilities of conversational precision and in the sense that, at the conversational level, consensual solidarity (again, *not* in the criterial way) cannot fail to be in play—you must grasp as well that the precision of critical discourse (like the precision of science) cannot exceed the precision with which we understand ourselves and one another. In this sense, relativism is a reminder of our epistemic frailties. How could it be otherwise?

I have deliberately kept the argument to the slimmest possible assumptions, that is, to the internal coherence of a relativistic logic and to the contingent standing of the argument for an exclusive appeal to bivalence.

Beyond that, if you merely add the indefensibility of objectivism, the indemonstrability of modal necessities *de re* and *de cogitatione,* and the conceptual difference between cultural relativity and relativism itself, there would seem to be no conceivable way in which to disqualify invoking relativism in interpretive contexts (or elsewhere), if an analysis of the domains in question would otherwise justify doing so.

Now, in cultural matters, some form of constructivism seems inevitable; and if in pursuing the import of the analysis of predication, reference, and discursive contexts, we find we cannot segregate our discourse about the natural world and the world of human culture, then some sort of constructivism will be implicated once again. As I have said, however, constructivism is *not* tantamount to relativism. Neither is cultural relativity, nor the relativity of truth-value assignments on evidentiary grounds formed in accord with the first-order patterns of cultural relativity. All that is often overlooked—or misconstrued. Certainly, saying the ascription of "true" to a given statement is relative to a society's evidentiary practice is not equivalent to agreeing that "true" means "true-for-x" in anything like the relational sense Socrates cleverly imposes on Theaetetus. Beyond that, if human thought is, as I suggest, historicized as well, and if objectivity must (as in the predicative case) be artifactually constructed in accord with our consensual practices, then (I suggest) it is well-nigh impossible that relativism will not have a very strong inning in interpretive and other cultural contexts (and elsewhere as well). Nevertheless, I insist I have built the argument up from the least contestable considerations.

But what of artworks? What of their ontic structure—relative to our quarrel? The answer must be judged in a double way (alethically and also in epistemic/ontic terms). First of all, artworks (like persons, actions, and sentences) are not fully determinate but are, characteristically, interpretively determinable in Intentional ways, for Intentional properties are not fully determinate. (Only if meanings were properties and at least as determinate as the properties of physical objects would Intentionality be determinate at all. But Intentionality, remember, is a fluxive artifact of history, inherently subject to interpretation and reinterpretation under the historicized conditions of human life.) Second, in spite of the preceding statement, and in spite of having such a nature, artworks are reasonably *determinate in number,* individuatable, and reidentifiable. This goes against the entire tradition of philosophy. In particular, it goes against Aristotle's *Metaphysics* Gamma and the standard attack on Protagoras. You begin to glimpse, therefore, the subversive possibilities of the rather bland line of speculation I am offering here.

In fact, I am now able to bring the entire argument to a trim close in a way that is hospitable to both the usual bivalent practice and the radical possibilities relativists would be unwilling to disallow. All that would be needed would be to abandon the standard conviction that bivalence cannot be coherently breached and that reality must possess determinate unchanging structures. On the foregoing argument, those conceptual dinosaurs cannot be restored to their towering eminence. All that needs to be added is a third consideration, namely, that the boundary conditions for interpretive discourse, both as far as referential fixity is concerned and what should be relevantly construed as the salient features (the nature) of a particular work, are themselves decided in accord with the same *sittlich* practices noted above or by endorsing one or another critical revision of them.

Beyond that, practice goes on as before. I see in this an explanation of the ironic possibilities of Barthes's having favored *scriptible* ("writerly") interpretations without disallowing *lisible* ("readerly") interpretations—that is, roughly, what I am sorting as relativistic and bivalent criticism. Each proceeds by imposing its own restrictions and liberties. Each may be consensually endorsed, and the two practices may be reconciled. This signifies that many further questions will have to be resolved to make a reasonably tight case. But most of the best-known challenges to relativism fall within the terms already sketched.

Here, criticism recovers the resources collected in the name of cultural relativity. Here, surely, criticism follows the inventive glory of the arts themselves. I find the Western emblem of the world's diversity displayed, however problematically, in Picasso's *Les demoiselles d'Avignon*. For, within that interrupted painting, one sees the impossibility of avoiding the spontaneous urge to bend the Intentional forms of one society to the art and criticism of another. The acknowledged importance of *Les demoiselles* signifies both that you cannot fully grasp the significance of the painting in terms of historical resources confined in any way to what is internal to the Western tradition *ante* and that you cannot rightly grasp its Intentional structure by reference to any well-formed hermeneutically defined "genre" within the standard practices of painting. Admit the practice and give in to the irresistible temptation, within the bounds of the theory I propose, and you will find that you have already become a friend of relativism.

3

What, After All, Is a Work of Art?

It is incredible—but true enough—that, if you ask professional aestheticians what a work of art *is*, they will not be able to find a compelling answer in the whole philosophy of art.[1] Theorists are skittish on the question, for a variety of reasons: (*a*) they have been burned many times; (*b*) they are aware some ingenious artist will make a point of producing a "work" theorists will be uneasy about excluding, though it will defeat their definitional darlings; (*c*) they find it so difficult to say, in the face of art's baffling variety; and (*d*) would-be answers tend to be too ambitious and too abstract. Behind the scenes, knowledgeable theorists mutter that artworks are obviously not "natural-kind" entities, hence not definable in the way camels and gold are; or else these theorists pointedly remark that the question has no explanatory interest if, after all, it's essentially a matter of convenience or discursive fiat. But if we abandon the hapless idea that there's no point to empirical

1. For a fair sample of recent theories, see Stephen Davies, *Definitions of Art* (Ithaca: Cornell University Press, 1991). My impression is that there's little point in separating the question of defining art from substantive analysis of the arts themselves.

definitions or broad generalizations along definitional lines that are not meant to be essentialist or concerned to capture the necessary and sufficient conditions of every admissible specimen, we may well discover much that would otherwise hardly be mentioned.[2]

The fact is that artworks are very strange "entities" if your best specimen of an entity is a stone, a tree, or a camel—or even a carving knife or a pencil or, anticipating more notorious cases, a urinal, a snow shovel, or a Brillo box. I am not concerned in any strenuous way with official definitions of art. I have tried my hand at that and see no harm in it, but its benefits are regularly misread as a result of a certain literal-mindedness about definition itself.

I am quite sure about two constraints at least in making any definitional effort: (1) the would-be definition should be offered against the backdrop of a reasonably clear-cut range of central specimens and for the sake of answering a specific question about them—no more than that; and (2) we should abandon all pretensions of a modally necessary, essentialist, or invariantist sort regarding art and freely admit there is bound to be a use for endlessly many alternative such definitions relative to other questions and other runs of core specimens. It's almost never the definition that matters: it's more likely to be one or another contested theory about the arts that a would-be definition serves to focus in a certain felicitous and systematic way. Seen thus, the comparison of entirely detached abstract definitions really has no point, since it risks all connection with the living parts of the tradition of the arts that probably called the effort into play in the first place.

I myself have, in this regard, favored the generic (not yet specific) formula "artworks are physically embodied and culturally emergent entities"—which has drawn a certain amount of controversy.[3] However, in offering it,

<hr />

2. Perhaps the best-known analytic discussant of the futility of defining "work of art" is Morris Weitz. Weitz holds, arbitrarily I fear, that definitions are defenseless against the "open" nature of the arts; thus *any* definition would necessarily be defeated. (He never demonstrates why this must be so.) He maintains, accordingly, that definitions thought to be true must be essentialist in intent; hence, they are invariably false unless restricted "for a special purpose." See Morris Weitz, "The Role of Theory in Aesthetics," *Journal of Aesthetics and Art Criticism* 15 (1956); *The Opening Mind* (Chicago: University of Chicago Press, 1977).

3. I draw here on Davies's summary of my own definition, since that is pretty well the way it is most briefly reported (*Definitions of Art,* 162). But see also Joseph Margolis, *Art and Philosophy* (Atlantic Highlands, N.J.: Humanities Press, 1980). My views have evolved considerably since this early formulation. I find it useful still, but I have explored more fully what we should mean by "entity" and, in particular, "cultural entity." What I offer here accords with my earlier views but is leaner.

I agree many questions should be answered if we are to credit it properly. In any case, we should want to know what it is, about art thus construed, that draws our interest and how the definition serves it.

For example, it is often remarked that a poem is *not* "physically embodied" since it is composed of words. It is also remarked that poetry often belongs to an oral tradition and so may be neither clearly individuated nor physically embodied, hence not an entity at all. One also hears that artworks in the performing arts are simply not "entities" or "objects" but, rather, "events."[4] The conceptual picture is murky, I admit, once you go down the road of physical embodiment and cultural emergence (and even if you don't). I have no wish to pursue the minutiae of the definition I offer here. (I have done so a number of times in the past.) Nevertheless, a clarification or two may serve a deeper objective.

First of all, I treat "entity" in a sense that signifies *any* individuated, reidentifiable *denotatum* in the world of existing things. I rule out at a stroke, therefore, numbers, predicables, types, universals, kinds, and the like: none of these *exist,* though they may well be *real.* What I say in this regard is that what is real but does not exist *is*—at a first approximation—*real if true,* predicatively, of what exists.[5] This rules out at once all theories pretending that artworks (of whatever kind) are kinds, types, or universals. (There are in fact a number of prominent theories of this sort.)[6]

The reasons against the option are straightforward enough. If artworks are kinds or types, they must lack perceptible properties. But that is plainly false. If the perceptible properties of their earthly instantiations—performances of a Mozart sonata, say, or prints pulled from one of Dürer's engraved plates—are derived in some way from the prior properties of some corresponding kind-entities, then artworks possess certain everlasting properties (as Nicholas Wolterstorff is prepared to claim), even if those properties answer to the historically contingent features of the human world. (Wolterstorff considers the properties of Gogol's *Dead Souls* as involving a contingent "selection" by Gogol—somehow—from the everlasting properties of

4. See, for instance, Nicholas Wolterstorff, *Works and Worlds of Art* (Oxford: Clarendon, 1980).

5. I give a summary of the pertinent arguments in *Historied Thought, Constructed World: A Conceptual Primer for the Turn of the Millennium* (Berkeley and Los Angeles: University of California Press, 1995).

6. The best-known recent specimen views include Wolterstorff's *Works and Worlds of Art;* Peter Kivy, *The Fine Art of Repetition: Essays in the Philosophy of Music* (Cambridge: Cambridge University Press, 1993); and, most problematically, Richard Wollheim, *Art and Its Objects,* 2d ed. (Cambridge: Cambridge University Press, 1980).

the kind DEAD SOULS that belong to God's providential order: Wolterstorff says nothing about the contingency of nineteenth-century Russian history here.)[7] But the most important objection rests with the obvious fact that no one from Plato to the present has ever been able to say just how we might discern such changeless Forms, Kinds, or Universals. Surely it is a mad extravagance to go that way.

Again, I don't deny that what we carve out of an oral tradition as the particular artworks ("entities") we mean to count will undoubtedly be reconciled (will have to be) with our practices in the gallery, concert, museum, and library worlds. I see no difficulty with this, though I admit a certain degree of freedom. It's the same freedom we find in admitting differences between the numbered performances of a Mozart sonata for which we have a score. There are technical difficulties here, but (I believe) they are all easily resolved by introducing the notion of a "token-of-a-type" (solely for individuative purposes). Nevertheless, there are no types (in the sense explained), and where the "token" instances are reasonably collected as admissible instantiations of "types," the usage is merely heuristic and meant only to service our critical practice.

Artworks are individuated as entities, but critical discourse may appeal to scores and notations that subtend a run of would-be instantiations. Think, for instance, of Kenneth Branaugh's recently filmed version of *Hamlet,* which is said to use Shakespeare's "complete entertainment," that is, the entire text of the play—which cannot be said of any important theater performance of *Hamlet* in recent years.

The point, of course, is that criticism and history are largely occupied with predicative questions and therefore require an individuative strategy applied to "objects" and "events" alike. Explicit ontologies range all the way from firm assertions about "what there is" to reasonable "ontic commitments" under given circumstances to convenient idioms that service our referential and predicative practices but admit a wide range of taste and preference and heuristic tolerance. Certainly, we mean to include various shortened performances of *Hamlet* among the admissible instances *of Hamlet,* though to do so requires a somewhat flexible notion of numerical identity. The evidentiary considerations are worth an effort, and additional complications need to be addressed. Nevertheless, I set all that aside here by suggesting that the salient puzzles cannot be managed by any known extensional treatment of performances via scores and scripts (Nelson Goodman's

7. See Wolterstorff, *Works and Worlds of Art,* pt. 3.

allographic proposal, for instance).[8] These are not negligible puzzles, I admit, but neither are they the most interesting complications.

Finally, on my own view, language, like thought, is an abstraction from the life and behavior of encultured selves—ourselves—as the apt members of a particular society. Our fluency is such that we imagine too easily that language is an autonomous, abstract, communicative medium of some sort only contingently bound to the physical and perceptible properties of sounds, bodies, actions, institutions, histories, and the like. I take all that to be utterly mistaken, utterly wrongheaded: for instance, thoughts are often characterized propositionally, hence abstractly, though it seems to me that thinking is complexly incarnated in a way that includes the neurophysiology of the brain *and* the culturally habituated behavior of our society (assuming, of course, that the latter cannot be reduced to the former). I draw the same lesson from language and, accordingly, find no serious difficulty regarding my original definition. On the contrary, the point of that definition—"physically embodied and culturally emergent entities"—was, precisely, to feature art's most puzzling attributes as a preparatory step in confronting and testing the adequacy of the most important theories of art in our day.

I

So much for preliminaries.

I should add immediately that I don't at all wish to discount the importance of the formal analysis of reference and predication—or of individuation and reidentification, for that matter, or of the mode of existence and the nature of an artwork. Far from it. Interest in the peculiarities of art criticism and art history oblige us to ask ourselves how best to render the defining features of artworks in such terms. For instance, if (for argument's sake) the interpretation of artworks favored a relativistic logic (as I believe it does), then we should have to ask ourselves how that might be reflected in our theory of what an artwork is—unless, of course, it could be shown on independent grounds that such a theory could not possibly fail to be incoherent. But there is no such argument. As soon as the challenge is voiced, an extraordinary fact glides into view. For it must dawn on us that there is

8. See Nelson Goodman, *Languages of Art: An Approach to a Theory of Symbols* (Indianapolis: Bobbs-Merrill, 1968).

simply *no criterial or algorithmic solution to the problems of reference and predication*—or, *a fortiori,* to the problems of individuation and reidentification, which depend on a solution to the first.[9] General injunctions against avoidable incoherence and inconsistency remain completely vacuous, in any case, until they are suitably interpreted in terms of what is actual or real—and then we are back again to the details of criticism and history.

But if all this is so, then we will have made an enormous gain without much conceptual exertion, certainly without yielding to any unfriendly canon. For, on the argument—that is, granting the logical informality of referential and predicative success—there cannot be any advantage in adopting essentialism or modal invariance, or in insisting on modeling the metaphysics of artworks on what may be thought canonical in speaking of physical, natural, or natural-kind entities. For instance, it is not necessary to favor anything as unyielding as Aristotle's ontology, in *Metaphysics* Gamma, or indeed any contemporary approximation. The point is, we should be entirely within our rights in equilibrating our choice of a metaphysics and our choice of a logic for critical and historical inquiries. (Disputes about the definition of art are bound to accommodate such informalities.)

Notice, for instance, that if we supposed a critical reading of *Hamlet* could never rightly disallow plural, nonconverging, otherwise incompatible interpretations of the play—which we should then want to say were jointly valid (no longer contradictory: "incongruent," rather, as I have explained in the preceding chapter, I prefer saying, in accord with a relativistic logic)—such a possibility would never be admitted on Aristotle's model, for Aristotle holds to an omnicompetent bivalence fitted to what is antecedently invariant in reality.[10] Aristotle claims that the denial of bivalence instantly produces self-contradiction. But his argument depends not on bivalence itself but on the modal fixity of reality (at least in the argument at stake), on which (he supposes) the bivalent injunction relies.

Nevertheless, Aristotle nowhere secures that fixity; at no point does he demonstrate that ontic fixity cannot be coherently denied. *No one has ever shown that, for it cannot be done.* (No evidence exists, for instance, proving that the denial of invariance violates the principle of noncontradiction. Only if particular things had fixed essences would the doctrine of the flux produce contradictory truth-claims. But essentialism, of course, is what Aristotle

 9. For the supporting argument, see, further, Margolis, *Historied Thought, Constructed World.*

 10. See Morris Weitz, *"Hamlet" and the Philosophy of Literary Criticism* (Chicago: University of Chicago Press, 1964). On Aristotle and bivalence, see, further, Joseph Margolis, *The Truth About Relativism* (Oxford: Basil Blackwell, 1991).

would have had to demonstrate. It's hardly a logical principle in its own right, but it is indeed the basis for Aristotle's exposé of Protagoras.)

It's perfectly possible to construe artworks—coherently—as lacking a fixed nature (frankly, I should say the same of physical nature), if doing so accords with the salient features of a critical practice we wish to favor and violates no other logical constraints. If we can secure that much, we can easily turn the tables on familiar canons said to govern current practices in criticism and history. It is, I admit, a standard assumption that individual entities possess crisply determinate properties and boundaries. This may be true of purely physical entities (though I doubt it), but I know of no argument that convincingly demonstrates it must be true of artworks or other cultural entities, and I take the modal claim to be demonstrably false. In any case, the counterargument goes against the familiar canon—but does so coherently: it holds that the activities of identifying entities numerically and describing their natures may be no more than loosely or informally linked with one another, without producing paradox. After all, *denotata* cannot, for logical reasons, be captured by predicative means alone.

The logical flexibilities that this single distinction makes possible have been very largely neglected. In fact, if you allow the two distinctions I've already mentioned—one to the effect that Intentional properties are determinable (on interpretive grounds) but not antecedently determinate, the other to the effect that the numerical identity of artworks can be fixed with as much precision as physical entities but without seriously constraining the relative indeterminacy of Intentional properties or (as a result) the logical peculiarities of the interpretive history of a given artwork—you will have in hand the principal premises favoring the viability of a strongly historicized and relativized account of interpreting art (in effect, the intended benefit of my generic definition of art).

The fact is, if the argument goes through, you see at once it is no more than an elementary mistake to suppose that, if an otherwise numerically distinct artwork *may* rightly be ascribed Intentionally determinable (but not determinate) properties in interpretively "incongruent" ways, the would-be singular entity must yield (for logical reasons) to a set of numerically different *denotata* (under the constraint, of course, of a bivalent logic that refuses to countenance incongruent attributions).[11]

11. This appears to be, in part, the motivation of Robert Stecker's "The Constructivist's Dilemma," *Journal of Aesthetics and Art Criticism* 55 (1997). Stecker applies his objection in a somewhat glancing way to my own theory. I return to the issue later. (It is an important matter.) But his direct target is the theory offered in Michael Krausz, *Rightness and Reasons: Interpretation in Cultural*

Let me remind you here of Monroe Beardsley's theory of literary criticism. His thesis may be the best-known contemporary statement by an English-language philosopher of art. While it is certainly as uncompromisingly committed to bivalence as is Aristotle's metaphysics, it proceeds by a different route. Beardsley's argument is genuinely instructive and, for all its brevity, not without force or subtlety. Beardsley writes in defense of what he regards as a fair extension of New Critical policies, and he faithfully recommends (in its spirit) what he calls "the principle of 'the Intolerability of Incompatibles', i.e., if two [interpretations] are logically incompatible, they cannot both be true."[12] You see how sensible this sounds, if you suppose (with Beardsley) that artworks are entities, more or less in the same sense in which physical objects are.

Of course, what Beardsley says *is* true enough: incompatibles cannot both be true. But what Beardsley implies is that at least one of a pair of apparent (but more than apparent) incompatibles must be false, and *that* hardly follows—or, it follows only if a bivalent logic is inescapable.

As far as I can tell, Beardsley offers two very different arguments in favor of his thesis. One is somewhat concessive: if we are prepared to go contrary to the intolerability principle, then we must be admitting "superimpositions" rather than "interpretations" proper. For example, if I construe "Jack in the Beanstalk" as a "Marxist fable," or *Alice in Wonderland* as a Freudian tale, then, though it may be coherent to admit such a reading even where others dispute it, I should have exceeded the tolerance of interpretation proper. Here, Beardsley develops a two-story account of what, informally (but then, incorrectly), may be called interpretation: the first story belongs to interpretation proper; the second, to so-called superimposition. This is because superimposition presupposes and rests on the prior work of valid interpretation—it simply goes beyond interpretation's limits, adding a further externally associated sense of how the story might be treated.

Here, the restrictions of bivalence are not really called into play (though, I should add, they are not really violated either); superimpositions are rather like the contingent idiosyncratic appearances of things viewed under vari-

Practices (Ithaca: Cornell University Press, 1993). Krausz's theory is related to mine. But Krausz and I do not agree on the fundamental handling of the numerical identity of artworks or the logic of interpretation. Krausz has met Stecker's challenge in Krausz's own terms.

12. Monroe C. Beardsley, *The Possibility of Criticism* (Detroit: Wayne State University Press, 1970), 44. Beardsley offers this as an explicit objection to my own thesis, to the effect that interpretation exhibits a certain "logical weakness" (that is, that interpretation may go contrary to bivalence).

able circumstances. (Aristotle had already conceded such a possibility, even in nature.) You see, therefore, that Beardsley's first strategy requires a clear disjunction between interpretation proper and superimposition *and* a view of the metaphysics of literary entities such that interpretation proper must conform with the fixed nature of literary works. But the fact remains that Beardsley nowhere supplies even a rough criterion of the "boundaries" of a literary work in virtue of which interpretations proper and super-impositions can be demarcated in the way he favors. I say it cannot be done.

The reason, of course, is that the Intentional attributes of artworks are interpretively determinable but not determinate in anything like the sense in which physical objects are said to have determinate properties. For, if meanings (or the Intentional significance) of artworks change (very likely in a variety of ways) and cannot be reliably fixed (let us say, in terms of the sheer meaning of the uttered words or of original authorial intent), then the distinction between interpretation proper and superimposition founders, and the relative indeterminacy but interpretive determinability of artworks will have been conceded. Even beyond the world of art, one has only to think of the renewed controversies in our time regarding the correct meaning of the texts of the Bible to realize that the fixity Beardsley requires is ineluctably open to great swings of interpretive conviction and historical perspective. The fact remains that Beardsley nowhere addresses the determinable nature of meanings and Intentionality, except when dismissing any threat to a strict bivalence.

This first strategy may be fairly viewed as the analytic counterpart of the (Romantic hermeneutic) theory offered by E. D. Hirsch, which, for altogether different reasons, also affords a two-story distinction: this time, between the proper "verbal meaning" of a literary text and its secondary "significance" relative to some external or special perspective.[13] Thus, for example, "La Marseillaise" came to acquire, among the French, the symbolic import of the national shame of the Nazi occupation of Paris during the Second World War. Beardsley would, I'm certain, characterize that as the musical counterpart of a literary superimposition, not a proper interpretation of the song at all. But Beardsley neglects to explain how to tell the difference in a principled way (that is, supposing music has representational powers). Hirsch also fails, but he has an answer of sorts.

Beardsley secures his theory in a way very similar to that in which

13. E. D. Hirsch Jr., *Validity in Interpretation* (New Haven: Yale University Press, 1967), app. 1, esp. p. 216.

bivalence is secured in Aristotle's view. Beardsley offers (in effect) a pair of metaphysical principles. About the first, he says, "everyone must agree on [it]." He calls it "the Principle of Independence" and formulates it in the following rough way: "literary works exist as individuals and can be distinguished from other things, though it is another question whether they enjoy some special mode of existence, as has been held."[14]

It is worth mentioning that, on Hirsch's view, literary works are imaginatively "constructed" in the process of reading and interpreting a string of words (or "signs"): a "text." In effect, Hirsch violates Beardsley's Principle: literally nothing constituting an existing literary work (on Hirsch's view) *can* be said to exist independently.[15] What exists (the verbal signs) permits us only to reconstruct what we should take the (thereby constructed) poem or story to mean. The question of existing poems (poems as entities) does not arise.

You must appreciate that if Hirsch were entirely consistent here, he would have to concede that words and texts do not exist either—all we have are sounds or marks, which, arranged as they are, may be imaginatively constituted or reconstructed as a text (that is, interpreted, construed, "transfigured") in accord with the original author's intent. This comes very close to the disastrous doctrine (favored by many in our own time) holding that artworks and texts are posited as what answers to a certain use of purely physical entities.[16]

However, if you adopt the doctrine literally, you will be faced with the need to treat selves (who make such posits) in the same way, and then you will find yourself confronted by a vicious regress (or a doubtful reductionism). Admit the reality of cognizing selves—ourselves as culturally formed entities apt in whatever way you care—and you cannot then deny the existence of the artifacts (artworks) they create. (Otherwise, you must demonstrate the reducibility, in physicalist terms, of our linguistic and creative competence. I say it cannot be done.)

That, at any rate, is a reasonable bet. There is no known successful reduction of the intentional, or Intentional, to the physical; art and language are themselves obviously "uttered" by human selves. The Intentional structures

14. Beardsley, *The Possibility of Criticism,* 16.

15. See, for instance, Hirsch, *Validity in Interpretation,* 48, 216.

16. I take this to be featured in the views of Arthur Danto and Nelson Goodman (which are, however, not the same). See, further, Joseph Margolis, "The Eclipse and Recovery of Analytic Aesthetics," in *Analytic Aesthetics,* ed. Richard Shusterman (Oxford: Basil Blackwell, 1989). See also Jorge J. E. Gracia, *A Theory of Textuality: The Logic and Epistemology* (Albany: SUNY Press, 1995).

of art and language cannot, therefore, be different from the conditions of re-flexive understanding among encultured selves. (I return to this issue in Chapter 4 and the Epilogue.)

Hirsch is every bit as insistent on bivalence as Beardsley is, but he does not concede the independent existence of a literary work. He does insist on an alternative notion of invariance, however, and in doing so comes close again to Aristotle's model. In particular, Hirsch insists on the invariant fea-tures of literary "genres" (abstracted from a society's cultural life) in terms of which a poem is first uttered (authorially) and by reference to which (the sentences uttered) the intended poem can be recovered.[17]

The truth is, Beardsley and Hirsch subscribe to very different models of the human sciences. Both of their theories about literature are untenable, because each requires a form of metaphysical invariance its proponent can-not defend—and nowhere does defend—and each supports a bivalent canon on the strength of such presumed invariance. Furthermore, each con-cedes a certain two-story tolerance for "incongruent" interpretations—which is to say, each admits that the practice of favoring incongruent interpretations need not be self-contradictory.

Hirsch's theory is the more adventurous of the two, since it secures all the advantages of referential and predicative success without succumbing to anything like Beardsley's entitative model. The fault in Hirsch's theory lies with the practical impossibility of ever discerning the supposedly changeless structure of the literary genres governing a society's poetic utterances. Hirsch means to show why, admitting genres, valid interpretations must rest on a bivalent principle and why a two-story practice linking "meaning" and "significance" may be regarded as theoretically benign.[18] But, of course, Hirsch is candid enough to admit that the fixity of genres is a myth, approx-imated (if we may speak thus) by "probabilizing" their "entelechies," which, strictly speaking, genres cannot possess, since they are hardly living organ-isms. This proves to be little more than a tortured way of admitting that genres are open-endedly subject to innovative revision under the terms of the hermeneutic circle. Hence, they cannot possibly play a strict criterial role governing interpretive objectivity

Beardsley offers us a second principle, which he admits is disputatious—incorporating, as it does, the notorious doctrine of "the Intentional

17. Hirsch, *Validity in Interpretation,* chap. 3.
18. See ibid., 173–80. And see, further, Joseph Margolis, "Genres, Laws, Canons, Principles," in *Rules and Conventions,* ed. Mette Hjort (Baltimore: John Hopkins University Press, 1992).

Fallacy."[19] The second principle, which he calls "the Principle of Autonomy," affirms that "literary works are self-sufficient entities, whose properties are decisive in checking [the objectivity of] interpretations and judgments."[20] Of course, if his Principle of Independence fails, so must his Principle of Autonomy. Hirsch suggests a counterstrategy he does not himself pursue.

The local difficulty with Beardsley's theory is simply that Beardsley nowhere explains how meanings could possibly be treated as properties intrinsic, or internal, to the "independent" and "autonomous" *entity,* the poem or story—the literary work—or in what sense meanings are changeless. Here Beardsley supports too literal an analogy between poem and physical object: much more needs to be said about how to secure referential and predicative success in the case of poems. In fact, Beardsley concedes, "The boundaries of textual meaning . . . are not all that sharp. Some things are definitely said in the poem and cannot be overlooked; others are suggested, as we find on careful reading; others are gently hinted, and whatever methods of literary interpretation we use, we can never establish them decisively as 'in' or 'out.' Therefore whatever comes from without, but yet can be taken as an interesting extension of what is surely in, may be admissible. It merely makes a larger whole."[21] This is all that Beardsley has to say on the matter.

I shouldn't want to force the argument on textual grounds alone, but this is a very large admission. The fact is, Beardsley's concession points the way to a deeper challenge—namely, that he cannot supply (even if he tried) a principled disjunction between interpretation and superimposition, or between what is "in" a poem and what is not. But if he cannot do that, he cannot vindicate his bivalent logic either. I am not concerned so much with the argument against bivalence or with what may coherently replace bivalence in the practice of criticism and history as with the inherent informalities of "number" and "nature." Here I assume the validity of the argument against bivalence. (I've barely hinted at it but have addressed it earlier.) The more interesting question asks us to consider what kind of "entity" an artwork is if its description or interpretation eschews bivalence, admits "incongruent" truth-claims, and admits even stranger features answering to the practice of criticism and history—for instance, that the meaning of a poem may change under the very practice of interpretation, or that we can defend

19. See "The Intentional Fallacy," in William K. Wimsatt Jr., *The Verbal Icon* (Lexington: University of Kentucky Press, 1954).

20. Beardsley, *The Possibility of Criticism,* 16.

21. Ibid., 36.

no principled division between putatively admissible and inadmissible sources of interpretation.

Of course, if these adjustments were conceded, both Beardsley's and Hirsch's theories would be subverted at a stroke. The curious thing is, neither attempts to show that the reverse of his policy is more unreasonable or more unworkable or less fruitful. My guess is that both believe (quite wrongly) that the violation of bivalence is *pro tanto* the violation of inviolable *de re* invariances. But that is Aristotle's failed doctrine all over again.

II

We are now on the edge of certain interesting concessions regarding artworks as "entities." Let me offer a specimen theory that is really a halfway house to the radical options that are beginning to dawn. I can think of no better exemplar (for my purpose) than Wolfgang Iser's "reader response" theory, which draws inspiration chiefly from Roman Ingarden's version of Husserl's phenomenology. "The phenomenological theory of art," Iser says, "lays full stress on the idea that, in considering a literary work, one must take into account not only the actual text but also, and in equal measure, the actions involved in responding to that text."[22]

You must catch the humor of the situation. Beardsley makes the literary work autonomous and independent; as a consequence, wishing to save the objectivity (and bivalent logic) of criticism, he is obliged to construe the meanings of a poem or story as the perceptual properties of an "object" in a way that permits no significant difference between the analysis of a poem and the analysis of a lump of coal. This is the inflated price of bringing the practice of criticism and history (*a fortiori*, the human sciences) under the tent of something like the unity of science program.[23] The whole idea fails at the very moment it is tested, for, as Beardsley himself agreeably concedes, there is no way to specify the criteria required for determining what is "in" and "out" of a literary work.

22. Wolfgang Iser, "The Reading Process: A Phenomenological Approach," *The Implied Reader: Patterns of Communication in Prose Fiction from Bunyan to Beckett* (Baltimore: Johns Hopkins University Press, 1974), 274.

23. See, for instance, the treatment of history in Carl G. Hempel, "The Function of General Laws in History," *Aspects of Scientific Explanation and Other Essays in the Philosophy of Science* (New York: Free Press, 1965).

It is true that Beardsley makes this generous concession in the briefest way. It would hardly do to press the advantage too far. But it is also to the point to insist that he nowhere offers a theory for fixing the meaning of actual utterances, and he nowhere considers the essential question, affecting literary theory, of the import of the history of the reception and interpretation of particular works. It is not so much that artworks become enigmatic as the history of their reception lengthens; it's rather that our sustained interest in them, over time, invites continual reinterpretation in ways that are plainly not merely additive.

Hirsch avoids the reductive model by disorganizing at the start the very idea of a literary work being an independent entity, or an entity at all. Hirsch manages to recover a form of objectivity (objectivism, in fact) that he regards as comparable in rigor to the work of the physical sciences. He does so by falling back to the hermeneutic (Romantic) model spanning the theories of, among others, Schleiermacher and Dilthey, which claim resources sufficient for recovering authorial intent by way of invoking the objective genres (or analogues of genres) of a historical culture. Hirsch shifts, therefore, from the analysis of an entity's *properties* to the reconstruction of a linguistic sign's probable *meanings.*

Hirsch fails nevertheless, because the supposed "probabilities" of meaning cannot be shown to converge toward any ideally fixed or independent meanings. Meanings are forever hostage to the drift of history, and the genres Hirsch invokes cannot fail to be constructions continually altered by the fresh pressure of inventions that depend in their turn on a continual revision of the would-be "constituting" genres by which they themselves are said to be grasped. This, of course, is the fatal weakness of the Romantic version of the hermeneutic circle.[24] (Not of the circle itself.) If reading and what is read belong alike to the movement of history, then we cannot exit the hermeneutic circle by fixing, in the objectivist way the Romantic hermeneut pretends is possible, original authorial intent. (This is, of course, no more than a restatement of Gadamer's objection to the Romantic view.)

Still, Hirsch does manage to provide an incontestably valid reason for distinguishing between the verbal signs of a society's linguistic and literary practice and the "subjective" complexities of anyone's attempt to interpret such signs within a larger critical space. Iser is onto a similar distinction. It is what

24. It's the point of Hirsch's frontal criticism of Hans-Georg Gadamer's post-Heideggerian hermeneutics. See Hirsch, *Validity in Interpretation,* app. 2.

he means (following Ingarden)[25] by the difference between an "actual [ver-
bal] text" and the "literary work"—the latter being a "Konkretisation" (In-
garden's term) of the former by means of a reader's reading. (Ingarden's
model of the entitative text that our aesthetic response is said to "concretize"
is, as an ontology, conceptually monstrous but heuristically suggestive never-
theless as a guide to criticism. The ontology cannot be satisfactorily recov-
ered by any likely adjustment.)

Iser outflanks both Beardsley and Hirsch, since authorial intent (however
discernible from a reading of textual signs) cannot, he believes, account for
the full "aesthetic" interest of a poem or story: "the literary work [he says]
cannot therefore be completely identical with the text, or the realization of
the text, but in fact must lie halfway between the two."[26]

This is promising—but hardly more—for reasons rather distant from
Iser's own intention. For what he says suggests the plausibility of even more
radical options directed as much against himself as against Beardsley and
Hirsch. For one thing, Iser is primarily concerned with a kind of empathy
on the reader's part (almost an identification with the original author or
with the author's intention) rather than with the criterial question of how,
on his own bipolar assumption, an objective reading can actually be con-
firmed. In addition, although he recognizes the historied nature of creating
and reading a literary work, Iser nowhere develops a sense of the role of his-
tory in testing the validity of particular interpretations—for instance, along
the horizonal lines Gadamer features.[27] The neglect of this theme appears
already in Ingarden and Husserl, for Husserlian phenomenology (as well as
Ingarden's variant) is unequivocally opposed to any strong commitment to
the historicality of thinking. Of course, if, on Iser's model, you admit the
historicality of thinking (*a fortiori,* of meaning) and *also* admit the pertinent
contribution to the "meaning of the work" made by a reader's response to a
"text," you defeat at a stroke all the fixities theorists like Beardsley and
Hirsch invoke. But how could we escape making such a concession, even if
we did not subscribe to Iser's particular theory?

Iser's account contains an essential tension between a "phenomenological
subject" realizing or "concretizing" a given text (along Ingarden's lines) and a
human reader's historically formed response to an inherently "incomplete"

25. See Roman Ingarden, *The Literary Work of Art,* trans. George G. Grabowicz (Evanston:
Northwestern University Press, 1973).
26. Iser, *The Implied Reader,* 274.
27. See Hans-Georg Gadamer, *Truth and Method,* trans. Garrett Burden and John Cumming
(New York: Seabury Press, 1975).

(schematic) text.[28] This becomes apparent, for instance, in Iser's reliance on the following remark from Husserl's *Phenomenology of Internal Time-Consciousness:* "Every originally constructive process is inspired by pre-intentions, which construct and collect the seed of what is to come, as such, and bring it to fruition."[29] Actually, I object to such expressions as "bring it to fruition" and "complete": they suggest, without defense, that right interpretation is telically directed to the "completion" of a particular work (and thus, by suggestion again, there is a uniquely correct way to complete an artwork). That cannot be shown.

In Husserl's mind, the process is rationally ineluctable, ideally convergent, and uncontaminated by historical contingencies. Iser, on the other hand, wishes to accommodate the plurality of the forms of historical experience within the Husserlian vision. One cannot say for certain whether Iser believes the structure of a text places inviolable constraints on the "concretizing" practice of diverse readers or whether the contingent experience of readers rightly alters the supposed original textual structure that subsequent readers will have to address. You see, therefore, that the phenomenological model of interpretation generates a two-story puzzle that is the counterpart of what we have already noted in Hirsch's Romantic account and Beardsley's New Critical account.

My sense is that Iser never resolves the question satisfactorily. He appears to favor both directions at once—which would be self-defeating—but gets no farther than this: "Text and reader no longer confront each other as object and subject, but instead the 'division' takes place within the reader himself."[30] It is just possible to construe this line as anticipating Gadamer's notion of *Horizontverschmelzung* (the fusion of horizons), but that would be overly sanguine and completely out of character. If Iser actually favored such a reading, he would have brought the phenomenological account into line with that of such theorists as Gadamer, Michel Foucault, Roland Barthes (in *S/Z*), Stanley Fish, and the pragmatists of criticism and history. (That would be very unlikely.) But if his reader is governed by transcendental (phenomenological) constraints, then Iser would be obliged to fall back

28. See Ingarden, *The Literary Work of Art.*

29. Iser, *The Implied Reader,* 277. The idea may be implicit in the usual distinction between describing and interpreting. It is implied in Stecker, "The Constructivist's Dilemma." See also Edmund Husserl, *The Phenomenology of Internal Time-Consciousness,* trans. J. S. Churchill (Bloomington: Indiana University Press, 1964).

30. Iser, *The Implied Reader,* 293.

to a two-story model of interpretation or "response" of his own; he would then have matched in a new way the objectifying (telic) strategies offered by Beardsley and Hirsch. You see, therefore, how extraordinarily labile the theorizing possibilities are. Textually, there is little reason to believe Iser would ever openly yield in the historicist direction.

For my purpose, it hardly matters whether Iser fails us here or does not. He brings to light a better sense of the conceptual possibilities: on the one hand, we begin to see the plausibility of historicizing criticism, whether we adopt a New Critical, Romantic, or phenomenological approach; on the other hand, we begin to see that a constructivist or historicist approach is bound to subvert any privileged—two-story or invariantist (or telic)—constraints on eligible interpretations (and, of course, definitions) of art.

Here, at any rate, is Iser's rather Husserlian account of the reading process: "each intentional sentence correlative [the phenomenological expectation of a sentence in a literary text] opens up a particular horizon, which is modified, if not completely changed, by succeeding sentences. While these expectations arouse interest in what is to come, the subsequent modification of them will also have a retrospective effect on what has already been read."[31] You see how easily this lends itself equally to a Husserlian (an ahistorical) and a historicist reading. In fact, a historicist reading (though certainly not textually indicated) makes very plausible the idea that the historical past (as distinct from the physical past) *can* be altered by the very concatenated process of reading Iser recommends. (Certainly, the historicist reading of Iser would not support the idea of asymptotically approaching any ideal or objective limit of interpretation.)

All that would be required is that, in an ongoing interpretive process, whether by way of a society's reception of a text or in the experience of an individual reader, a fresh conceptual resource appearing late (or unexpectedly) in the process may validate (but hardly in a merely cumulative or linear way) a significant reinterpretation of the meaning of *earlier* historical events or of a text's sentences addressed at an earlier moment in the interpretive process. The structure of interpreting history and literary texts, in this regard, is essentially the same. You begin to see the historicist possibilities of the hermeneutic circle and the analogous possibilities of its phenomenological mate. (Of course, the citation from Iser is meant to be Husserlian, not historicist.)

31. Ibid., 248.

The important point here is that interpretive practice need not be all of a piece. It is a perfectly acceptable way of practicing criticism to offer a reading that collects plausibly relevant resources within an interpretive tradition, without attempting (or even being able) to come to terms with the entire history of interpreting the work in question (or related works). Such an approach is entirely different from the practice—bordering on connoisseurship—that advances an interpretation that seeks to come to terms with the full interpretive history of the work in question. Roland Barthes's interpretation of Balzac's *Sarrasine* remains, for me, the most compelling specimen of the first practice. The second is likely to be practiced only on the most important works: Weitz's summary of the *Hamlet* interpretations suggests how the second might proceed. Stanley Fish's readings of Milton mingle the two sorts of effort in a spirit favoring the first, whereas Helen Vendler's reading of Shakespeare's *Sonnets* suggests the likely conservatism of the second.[32]

My intent is to urge you to consider the implications of admitting that, under interpretive conditions, artworks may change in "nature" without risking a change in "number." Here you see the point of my insisting, earlier, on the *sui generis* nature of cultural entities: the conditions under which they are individuated (and reidentified) as particular *denotata* are informal enough to secure (without losing descriptive or interpretive rigor) the constancy of their numerical identity, despite debated (interpreted) changes in their "nature."

I shall shortly say (as I have said before) that the distinctive mark of cultural entities lies in their possessing Intentional properties and that their natures, incorporating as they do Intentional properties, can (cannot fail to) change through the process of history and interpretation—but not in any simple telic way. What I have already shown is that theories like Beardsley's, Hirsch's, and Iser's are unable to defeat the need for (and the viability of) such an admission. I don't believe any comparably strenuous theories of art

32. See Stanley Fish, *Is There a Text in This Class? The Authority of Interpretive Communities* (Cambridge: Harvard University Press, 1986); and Helen Vendler, *The Art of Shakespeare's Sonnets* (Cambridge: Harvard University Press, 1997). See also Paul Thom's review of Krausz's *Rightness and Reasons,* my *Interpretation Radical But Not Unruly,* and Stecker's "The Constructivist's Dilemma," in *Literature and Aesthetics* (October 1997). Thom is exceedingly clear and instructive here. If I disagree with him in certain details regarding his summary of my view of interpretation, it is largely in terms of the variety of interpretive practices I mean to accommodate. (Which is to say, we largely agree, but that may not have been apparent enough to Thom. I definitely do not favor the recursive, therefore linear and accretive, model he sketches.)

would fare better. But you can also see that admitting the ontic distinction of artworks goes a long way toward ensuring the plausibility of relativism.

III

Now, the serious philosophical question asks whether the extreme historicist alternative is actually coherent and manageable and, if it is, whether objectivisms like those already noted in Beardsley and Hirsch, and now Iser, can be convincingly championed against that option. I should like to persuade you that the radical possibility is indeed coherent and viable and that I have very good reasons for preferring it to more canonical policies. In fact, the objectivist options cannot (I claim) fail to be arbitrary and completely unworkable.

Bear in mind I am trying to explain something of the nature of a work of art by way of what makes sense when interpreting a literary text. All sorts of questions may be fairly raised about the similarities and differences among artworks of different kinds and of different periods. I concede the point. But I cannot believe that if a thoroughly historicist picture may be vindicated for a significant sample of literary texts (or paintings or histories, for that matter), it will then be possible to confine the claim in any narrow way that would relieve the partisans of invariance. That, for instance, is what I understand to be the true import of Foucault's challenge in interpreting *Las Meninas* and Barthes's interpretation of Balzac's *Sarrasine*.[33]

I argue, therefore, in favor of the following theorems: (1) there are no principled antecedent constraints on the cultural sources from which relevant interpretations of artworks or historical events may draw (as of time, place, or home tradition); (2) the consensual acceptance of interpretations in accord with (1) belongs to the open, ongoing practice of interpretation and affects subsequent interpretations of particular artworks and histories (including the historical past of given events and prior phases of the interpretive process itself); (3) interpretive and historical criticism in accord with (1)–(2) is open to as many diverse, even nonconverging, interpretations as memory and interest are able to sustain; and (4) there is no reason why,

33. See Michel Foucault, *The Order of Things: An Archaeology of the Human Sciences*, translated (New York: Vintage, 1970), chap. 1.

admitting (1)–(3), objective interpretation should be linear, cumulative, or approximative of some postulated ideal interpretation, or that it should even be possible to collect an inclusive total history of interpretation that all responsible interpretations should address.

It takes no more than a moment's reflection to appreciate the potential paradoxicality of the proposal. But you see as well that one cannot really oppose it without addressing the bare bones of the metaphysics of a work of art. That, of course, is normally avoided—as if to say it is irrelevant or too obvious for words. But, of course, it is neither irrelevant nor too obvious—notably neither—in our late age, when what we admit as artworks and interpretations depart so radically from canonical practices defined as recently as the writings of Iser, Hirsch, and Beardsley.

As it happens, a number of the strategic notions regarding the treatment of an artwork as an "entity," more or less ignored in the standard literature or discounted without sustaining proof, are particularly hospitable to the interpretive practices I have been sketching. Rightly perceived, these notions invite us to consider whether the rest of the real world might not also be advantageously construed in its terms. I confess I am persuaded that it might, and would. In that case, the master theme is *flux:* not chaos or the denial of intelligible structure but the denial that any and all discerned structures—*de re, de dicto, de cogitatione*—cannot but be invariant or necessarily inviolable, on pain of incoherence or self-contradiction.[34] The global claim is not my concern at the moment. Although our way of understanding history and the arts may be quite instructive about what the natural sciences can actually accomplish, it is enough for my present purpose to draw attention to the need to match our ontic and epistemic conjectures in either direction. For instance, once you favor a historicist account of interpretation, you cannot then adopt the fixities urged by our specimen theorists. Alternatively put, the point of either line of speculation is to arrive at an equilibrated theory that fits our inquiries, as well as the possibility of coherently enlarging the scope of any such practice. Clearly, there is no reason to suppose that if one such alternative metatheory proved promising, there could not be a larger family of similar but diverse options to consider. The telic reading of interpretation would thereupon fail.

So flux is the decisive first posit. Admit only flux—admit the indemonstrability of modal invariance in any interpreted domain—and the arguments that run from Aristotle to Beardsley to Hirsch to Iser instantly

34. The encompassing argument appears in Margolis, *Historied Thought, Constructed World.*

tumble. That is surely a windfall, but it leaves us with a seeming vacuum. If not by the real and rational limits of necessity, then how, we wonder, should we be guided in science or literary interpretation? The minimal answer is plain enough: we must begin with the socially entrenched practices of the various inquiries that we habitually pursue, shorn (if possible) of the pretensions of invariantist philosophies. My own fanciful way of characterizing this economy is to fall back to an elenctic reading of Socrates' original mode of questioning: to take seriously Plato's instruction (in the *Statesman*) regarding the "second-best state" (or second-best science or philosophy) shorn of any knowledge of the would-be eternal Forms.

There are endlessly many models of successful societal life that you may prefer. What they have in common, I suggest, is the admission of consensual practices that do not rest on prior rules, principles, criteria, or algorithms, which we ourselves internalize by mastering (in infancy) the language and practices of our native culture—on which (alone) our would-be rules and criteria depend for their own effective use.

On my reading, the lesson is best limned in the company of such unequal thinkers as Thomas Kuhn, Wittgenstein, and Hegel. What I mean is, if every disciplined inquiry (literary interpretation, say) is second-best in the elenctic sense, then the only philosophical strategy possible is to explore the most salient, most coherent, most manageable, most convincing, and perhaps historically most fashionable ways of pursuing the inquiries we inherit. Is that really all? you may wonder. I see no cause to probe further, for I see no reason to suppose that there must be some single supreme answer to these questions. There are bound to be a thousand viable answers. Whatever we offer can only be strengthened and enriched by acknowledging the interminable *agon*.

Beyond these plain-spoken adjustments, I am prepared to back a small number of contentious theorems:

(*a*) Effectively fixing the reference and reidentifiability of the *denotata* of literary interpretation is relatively independent of, and indifferent to, the assigned nature of the textual entities that are thus fixed.

(*b*) The conditions of successful reference and predication are logically informal, consensual but not criterial, and dependent—whether with regard to natural or cultural entities—on the linguistic tolerance of natural-language discourse.

(*c*) The properties of artworks—all cultural entities, in fact—include, most prominently, "Intentional" properties, that is, linguistic, semiotic, gestural, symbolic, significative properties—for instance, those that are specifically

expressive, representational, rhetorical, stylistic—intrinsically apt, as such, for interpretation.

(d) Cultural entities have historied natures, or are histories, because Intentional properties, which form their natures, are themselves historied and alterable as a result of the ongoing practice of reinterpretation, under the condition of historically changing experience.

(e) Objective interpretations need not conform to the constraints of a bivalent logic or preclude indefinitely many, nonconverging, even "incongruent" interpretations.

(f) The valid practices of interpretation are themselves consensual, collective (not merely aggregative or "conventional" in the usual sense), effectively constrained by their own local histories but capable of drawing into their conceptual space indefinitely many diverse traditions—as additional interpretive resources—to whatever extent they can coherently incorporate such (historically opportunistic) options within their extended practice.

(g) No natural *telos* or ideal asymptotic limit or singular range of tolerance is assignable to the interpretive process itself.

I set no particular store by the precise formulation of items (a)–(g). They are meant only as a reasonable first pass at a thoroughly historicist account of objective interpretation. Accordingly, they define a radical conception of a family of *sui generis* entities utterly at variance with familiar views about the nature of natural and physical entities but not incompatible with such views (once modal claims of necessity are set aside). I make no apologies for the contrast. On the contrary, on the argument I have in mind, if indeed reference and predication depend on the consensual life of creatures like ourselves—or "selves," as culturally constituted entities that accord with the tally I have just given—then the objectivity of the physical and formal sciences must be a function of whatever objectivity belongs to the practices of societal life. For such practices too are culturally constituted competences. Moreover, I should argue, the historicist account of objectivity is coherent—in other words, viable and hospitable to the peculiarities of the globally interpenetrating cultures that now mark the end of our century. It strikes me as altogether plausible that the insular practices of science and literary criticism, formulated in an earlier age when the new technologies of our own age had not yet made it impossible to speak with assurance of the boundaries between different cultures, should be so easily baffled by historicist accommodations. In any case, on the argument, physical objects *cannot* be the exclusive or paradigmatic exemplars of what it is to be an entity.

You must think of a literary text as a denotative construct, reasonably well individuated so as to incorporate a particular string of sentences at least. Local puzzles about what precisely to include or exclude as the words and sentences of an interpretable text are normally not difficult to manage. For example, Emily Dickinson collected variant wordings of her own poems, and Shakespeare's plays have been recorded in different edited forms. In the performing arts, type/token distinctions complicate our notations of numerical identity in benign ways. None of this is troubling as far as the entitative standing of artworks or the logic of interpretation itself is concerned. The important point is that individuative and reidentificatory strategies trade consensually on whatever is already in place in the use of such measures in discourse about the natural world and about language itself. Nothing more strenuous is needed.

But the individuation and identity of artworks are hardly the same as the individuation and identity of the natural or linguistic entities upon which they depend (and which they incorporate). If, for instance, a block of marble, however cut, lacks Intentional properties, whereas a sculpture—say, Michelangelo's *Moses,* which incorporates the marble—intrinsically possesses Intentional properties, then the two *denotata* cannot be numerically the same.[35] So far, so good. It goes some distance toward explaining why so many theorists of art speak of artworks as a way of *using* natural or physical objects or the like, or of transfiguring them rhetorically by imputing all sorts of Intentional properties, which, on the argument, these physical objects could not logically possess. But that is hardly a defense.

Once you see that the individuation and numerical identity of artworks are relatively informal matters—need be (and can be) no more than that— and that they trade on whatever conveniences the practice of individuating natural and linguistic entities affords, you cannot fail to see how admitting all that enlarges our choices regarding what to count as the *nature* of such objects. For instance, when the numbered exemplars of a Dürer print are pulled from an inked plate, they normally count as instances of *that engraving,* even when they differ from one another in perceptual ways. But the bare metal plate (which is not, for individuative purposes, treated as an artwork itself) and the causal process by which the prints are produced are not, as such, sufficient for individuating or identifying a Dürer print in accord

35. This confirms the good sense of Danto's refusal to identify (numerically) artworks and "mere real things," but it does not of course confirm his thesis that artworks are a "transfiguration" of "mere real things." See Arthur C. Danto, "The Artworld," *Journal of Philosophy* 61 (1964).

with one or another type/token convention. There's a conceptual lacuna here that must be overcome.

Now, within limits, a work's "nature" includes what we judge to be compositionally incorporated in the work (a certain painted canvas within a painting, a span of painted cement within a fresco—whether Rembrandt's damaged *Night Watch* or the nearly entirely replaced surface of Leonardo da Vinci's *Last Supper;* whether an abbreviated *Hamlet* or a Bach *Brandenburg* transcribed for modern instruments). The interpretable structure of the work counts as its "nature," whether or not its Intentional structure varies over the span of its interpretive history and whether or not admissible interpretations of the same work assign plausible structures to it that may, on a bivalent logic (but not now), be incompatible ("incongruent," as I should say) with one another. It's the relative (but not complete) independence of the conditions of numerical identity and predicable nature that is the decisive matter. If my argument is a fair one, then the puzzle before us should be possible to accommodate. (But it remains a strenuous puzzle.)

Familiar philosophical canons deny this, of course. (Think of Aristotle!) They prioritize nature over numerical identity because they presume that natures are fixed or nearly fixed in the way "natural-kind" discourse requires and that individuation presupposes a relative fixity of nature. But artworks, like human selves, are better thought of as histories—Intentionally structured careers deployed over time as individuated entities, subject, because of that, to considerable diversity and change of nature as a result of the vagaries of historicized interpretation.

Apart from "natural-kind" entities, cultural entities (preeminently, selves and artworks) are rather informally identified as particulars—certainly without prejudice to what may be offered in interpreting their (Intentional) natures. Since cultural entities are historied, possessing Intentional properties, I view them longitudinally as careers. They have sufficient *unicity* of career (despite lacking the boundaried or determinate nature of physical objects) to support objective interpretation, but their *unity* of nature (matching their unicity) is itself somewhat lax and ad hoc, inconstant in fact—a revisable construct of an artwork's or text's own history of interpretation.

We secure numerical identity and reidentifiability because we regularly recover (hermeneutically, say) the longitudinal unicity of a particular artwork's career as entailing its numerical identity. By "unicity," I simply mean the sense of the integral career of an artwork or cultural entity—in interpretive as in ordinary discourse—in virtue of which we are able to assign a relatively stable number and nature to such *denotata,* though their natures

change.[36] This is often thought to produce an insuperable paradox, which I deny.[37]

The trick is to posit a historied continuum of an artwork's career (its unicity, *not* any random or irresponsible interpretation) by which we favor not only the relative constancy of its physical properties (though bear in mind da Vinci's *Last Supper*) but also the norms of interpretive practice. The matter is, I think, almost entirely neglected in standard accounts of artworks.

In this regard, it is entirely possible that the verbal text (the sentences) of *Hamlet* remain reasonably constant; hence the individuation and identity of *Hamlet* also remain reasonably constant, without imposing prior Intentional constraints on the interpretive amplitude of the play itself (on what we should count as its "content" or "nature"). I have, for instance, always been attracted to the peculiar aptness of George Thomson's Marxist interpretation of Aeschylus's *Oresteia,* in spite of the dubiousness of the evolutionary thesis that lies behind its original claim.[38] The same, I may say, holds true of Ernest Jones's rather more stilted Freudian reading of *Hamlet.*[39] Both are anachronistic (if you discount their scientific pretensions). But what does that matter? Their themes belong in a natural way to our transient ethos. Furthermore, their strength is such that they are not likely to be easily incorporated into, or reconciled with, alternative interpretations. They have a maverick quality and are not likely to be regarded as a connoisseur's reading. Responsible interpretation must to some extent consult the prior history of a work's interpretation, but it need not attempt to build linearly on that history or even know the whole of it.

To think of artworks and persons as histories or historied careers is to deny the conceptual priority of nature over number. A career is at once individuated and distinctive in its nature, so that to collect the diverse and alterable Intentional content of *Hamlet* is to collect such attributions as attributions rightly applying to one and the same play and as falling within the evolving nature of that play—at one and the same time. I see no logical difficulty in this practice, but it plainly departs from the canonical treatment of physical objects. You see at once, therefore, the procrustean arbitrariness

36. See Margolis, *Historied Thought, Constructed World,* 206; and chap. 7.

37. Stecker apparently believes that paradox cannot be avoided if, preserving numerical identity, one holds to a constructivist realism regarding the nature of artworks; but he nowhere provides a decisive proof, and he nowhere addresses my argument. His charge is a strenuous one, but he neglects the complications of Intentionality. See Stecker, "The Constructivist's Dilemma."

38. See George Thomson, *Aeschylus and Athens* (London: Lawrence and Wishart, 1941).

39. See Ernest Jones, *Hamlet and Oedipus* (New York: Norton, 1949).

of Beardsley's policy and the likelihood that the same may be said of Hirsch's and Iser's policies, though for different reasons.

The entire issue of what to make of the entitative standing of artworks obviously depends on what to make of the structure of Intentional properties. (I have, I concede, moved only a little distance from the "genus" to the specific difference of artworks. But I count that an advantage, since it ensures the greatest flexibility with respect to the baffling variety of artworks themselves.)

I capitalize the term "Intentional" (now, a term of art) in order, as I have said, to distance my own use of it from its standard use in Husserl's and Brentano's philosophies and to permit their usage to be incorporated within mine. Broadly speaking, by "Intentional" I mean "cultural" (as I've said before), in the straightforward sense of designating something as possessing meaning or significative or semiotic structure, in accord with the collective experience of a particular historical society. Think, for instance, of stylistic properties: the baroque in painting or music, say.

So the "Intentional" includes the "intentional" (Brentano's and Husserl's alternative versions of the theme of "aboutness") as well as the "intensional" (or nonextensional) treatment of meaning or meaningful structure. It departs from their narrower notions in a number of important respects: first, it is used in a collectivist rather than a (methodologically) solipsistic (or aggregative) way, as when one says that a natural language is collectively (not merely aggregatively) possessed by a people; second, it is inseparably incarnate in the physical or biological or similar materials of the natural world; third, it is *sui generis,* neither reducible nor open to reductive explanation in terms of any of the processes of physical or biological nature, without being ontically separable from such processes; fourth, it is intrinsically interpretable, which is not true of non-Intentional predicables; fifth, it functions solely in a predicative way and so shares (doubly) the peculiar informality of general predicates; sixth, the distinctions it collects are, peculiarly, artifacts of cultural history and subject accordingly to historical transformation; and seventh, being alterable as a result of historicized interpretation, its attribution affects what we should understand as the "nature" of anything so characterized.

I find these distinctions forceful and well-nigh impossible to resist. But the convergent lesson they convey is simple enough: namely, any *entity* that has an Intentional nature cannot but be a history (or historied career) and cannot fail to have the curiously labile form I have been attributing to artworks. Roughly, I have been arguing that the inherent informality of predicative success is complicated, in the cultural world, by the admission of

specifically Intentional properties; that the objectivity of predicables is a function of consensual life; that consensus itself, though not criterial, changes under the conditions of historical practice; that the nature of art-works cannot be rightly specified except in terms of Intentional properties; and that this forces us to acknowledge entities of a kind distinctly at variance with what we suppose holds true in a purely physical world.

Per contra, I have been arguing the following: the practice of interpretive criticism is increasingly hospitable to incorporating resources drawn from whatever cultural tradition may be coherently assimilated to the home tradition in which we first learn our linguistic and allied skills; Intentional restrictions imposed on would-be objective interpretations begin to appear conceptually arbitrary; also, we find ourselves plainly attracted to diverse and changing interpretive possibilities that reflect the history of prior interpretation and the new resources that an evolving and globalizing history begins to fashion. Such findings entail that the historical past cannot fail to be subject to interpretive transformation.

IV

The essential point of the foregoing argument is that the gathering account is quite coherent and immensely plausible. What is startling is how far the conception departs from standard philosophies and the usual philosophies of art. The history of the arts is itself a kind of experimental laboratory in which creative practices impose on us (as would-be theorists of art, criticism, and history) the plain fact that we must forever adjust our theories to the evolving work of fresh artists and fresh critics. What, for instance, can you make of Picasso's *Les demoiselles d'Avignon* if you ignore the deliberate freewheeling reinterpretation of the forms of West African masks as a way of suddenly redirecting the energies of Western easel painting? Neither the specialists of West African sculpture nor the specialists of nineteenth-century Western painting can make sufficient sense of Picasso's arch transformation of the admissible resources of interpretive objectivity in terms of categories already in place. Picasso's innovation cannot be routinely reconciled with any of the would-be canons of well-formed painting up to the intrusion of *Les demoiselles,* including most of Picasso's own previous work.

You find here two degrees of freedom: one, instanced by Picasso's inventiveness in suddenly incorporating within the Western horizon Intentional

structures that were never there before, is still to a palpable degree alien but now more nearly recoverable and open to further improvisation; the other comes from the usual freewheeling curiosity of any home culture that seeks to enlist categories of sensibility and understanding that belong to other ages and other cultures, which it seeks to reconcile (one way or another) with its own modes of sensibility. The truth is, we cannot understand any single sentence, thought, or Intentional structure apart from the *lebensform-lich* "world" in which it is so discerned. That world is itself forever open to further diverging possibilities of change that, once made salient, draw in their wake innumerable threads of remembered and implicated histories through which they gain and lose interpretive influence—which, there-upon, affect our grasp of whatever else belongs to our past history.

It is normally supposed that physical objects are discrete entities. But cultural entities are never entirely such, since they share the Intentional structures of a common interpretive world (and therefore its collective fortunes). Nothing can be said to have Intentional properties, except in terms of stable assignments of what, through such a shared history, makes such assignments consensually acceptable. But such conditions already include the entire milieu of historicized structures that some ingenious mind may suddenly show us how to bring to bear in new ways on the interpretation of particular artworks (or ourselves). Barthes's reading of *Sarrasine* shows us quite clearly how the process works: every particular such entity trails in its wake an atmosphere of interpretive precipitates that confirm the objectivity of its reception. No Intentional fixities are needed, and none can be secured. We abide in the core stability of the historical process; change for instance, cannot viably outstrip the conserving habits of natural-language usage.

The norms of Intentional order in literature and painting clearly follow—often at a considerable distance and always provisionally and improvisationally—the subaltern role of the changing world of art that reflective critics and theorists scramble to seize as well as they can. The intelligible unity of artworks is deeper than our would-be canons because, in moving from one exemplar to another, we are already convinced of the endlessly many possible variants of number and nature artworks generate by their own exuberance. It is not easy to see how Proust's *Remembrance of Things Past,* Joyce's *Ulysses,* Beckett's *Malloy,* or Rushdie's *Satanic Verses* take form as properly individuated novels—or to see what the proper interpretive milieu should be (hence the liberties of "unity" and "unicity"). Their singularity is itself a critical construction of how to interpret their assignable natures. When you judge that the notes to T. S. Eliot's *Wasteland* are an integral part of the poem, you recommend (by that act) a way of defining the poem's

unitary career as a provisional boundary condition for the subsequent inter-
pretation and reinterpretation of its Intentional content and that of the rest
of the repertory.

You cannot merely be interpreting "the" poem—the poem *ante* (prior to
an imminent interpretation). No rigidly fixed single entity need be in place
(think of Dürer's prints). But also, there *cannot* be any interpretively fixed
nature to discern: think of *Las Meninas* and *Sarrasine*. What we take the
stable *denotatum* to be is proposed, revised, and entrenched in the interpre-
tive process itself. The poem viewed as a numbered entity—whose compo-
sitional structure normally includes a certain string of sentences (and now
the notes, in Eliot's case, though that may be argued without seriously dis-
turbing our sense of the poem's reidentifiability)—is already a construction
encumbered by a prior consensual tolerance (regarding the general practice
of reading literature) that takes up the minimal verbal *text* into a reading of
the postulated *poem*. That is why we are justified—both as relativists and
antirelativists—in continuing to speak of interpreting one and the same
poem (or painting): you cannot settle the ontology of art by imposing *a
priori* constraints on the logic of interpretation.

Number and nature are defined together: first of all, their informality is
no more and no less than the inherent informality of reference and predica-
tion in natural-language discourse; second, the identity of an artwork is af-
fected by the *sui generis* peculiarities of Intentionally structured entities,
when contrasted with natural and physical entities; and third, the informal
play of defining a particular artwork's "nature" is specifically designed to ac-
commodate its interpretive history. The important thing is the obvious via-
bility of such a practice, for the plain fact is, we never need a precision cast
in invariantist terms, and we could never secure it if we wanted one. That's
what the opponents of a relativistic model of interpretation mean to resist,
but there is no compelling argument in their favor.

There is a great prejudice against making concessions of this sort. You
sense it obliquely in the proposals of theorists like Beardsley, Hirsch, and
Iser—and, I should add, Danto, Goodman, and Wollheim, who happen not
to have formulated any sustained account of interpretation. This entire
company is persuaded that, whatever they may prove to be, the appropriate
formal conditions of number and nature must be tethered to the minimal
needs of physical objects.[40] But, of course, every such affirmation is com-
mitted, whether it wishes to be or not, to the *foundational* standing of the
physical world—which is itself a noticeably doubtful doctrine.

40. For a glimpse of the evidence, see Margolis, *Historied Thought, Constructed World*.

You have only to think no principled disjunction exists between inquiries into the question, What should we take reality to be like? and the question, What should we take the conditions for knowing reality to be? to grasp the benign antimony that belongs to the post-Kantian world we cannot escape, for although physical nature is (doubtless) ontically prior to human culture, the cultural world is (in its turn) epistemically prior to the physical. Concede that much, and you will have freed up our right to make conjectures about the peculiar logical informality of the number and nature of artworks—without fear of paradox.

In any case, if, as I claim, reference and predication are profoundly informal—successful only in consensual terms that cannot be rendered criterially or algorithmically—the puzzles of number and nature will prove entirely benign, whether applied to physical or cultural entities. For example, it is widely appreciated in the sciences that whether the theoretical entities proposed by competing accounts of the mechanism of genetic inheritance are or are not the same entities (about which we may dispute), when we move from one theory to another ultimately depends on the pertinence of what has been called the principle of charity. A theoretical biology would have no point if charity about reference were not conceded. But if it is admitted in the sciences, it is hard to see why it should be denied in the arts.

The truth of the matter is that what we grandly designate as the logic and metaphysics of entities is often a matter of quite local conceptual carpentry—even *bricolage*. Certainly it need have no invariantist pretensions: it merely follows the developing needs of evolving experience and tries to shape new conceptual habits that will serve us for a useful interval. I find confirming evidence even in the paradoxes of classical mechanics that invite (but still lack) an ontology for quantum physics—which is to say, the evidence lies in various forms of nostalgia, oscillating (when it suits) between the old metaphysics and its rejection. But then, quite frankly, the interpretive theories of figures like Beardsley, Hirsch, and Iser are even more difficult to defend.

Once the practice of literary criticism begins to gather force in the way it plainly does in the work of Barthes, Bloom, Stanley Fish, Stephen Greenblatt, and similar-minded improvisators, there cannot be a principled reason for refusing to invent a congruent logic and metaphysics if such is wanted.[41] For, first, the invariantist conception of reality cannot be shown to be indubitable; second, reference and predication do prove, for their part, to be

41. See Stephen Greenblatt, *Shakespeare Negotiations* (Berkeley and Los Angeles: University of California Press, 1988).

inherently informal; third, the logical puzzles of individuation and number can be shown to be easily reconciled with the Intentional peculiarities of artworks; fourth, it is not difficult to demonstrate the self-consistency of a relativistic logic or to reconcile its use with the use of a bivalent logic; and, fifth, there are already in play actual interpretive practices that favor the adjustments just indicated and do so in a rigorous and coherent way. What more ought to be demanded?

The decisive clue about what our metaphysical policy should be rests with the fact that the things of the cultural world—artworks in particular—are "natural" but not "natural-kind" entities. There are no natural-kind entities, if to be such requires conformity with invariantist constraints. If less is required, for instance, by relaxing our views of what a law of nature is, then it will be seen that no principled conceptual advantage accrues to natural-kind entities over those that are not. It is only necessary that entities of either sort should be accessible to one or another form of disciplined inquiry. But then, they differ only in possessing or not possessing Intentional properties.

My primary objective here has been to assure you of the coherence of endorsing the freewheeling possibilities of literary and art criticism along alethic, epistemic, and ontic lines. I trust it is reasonably clear that no terrible paradoxes lurk in the wings. But I should also like to collect the argument in a trimmer way, perhaps with an eye to suggesting a deeper analogy between artworks and human selves. For of course it is an important part of insisting on the conceptual peculiarities of the art world to expose the more wide-ranging conceptual distortions that infect our discourse about the entire human world.

We ourselves count as discrete physical entities only when counted as members of *Homo sapiens;* as encultured selves, we are linked to one another by sharing a collective culture and Intentional history in ways that appear (to us) to override biology. Sentences, artworks, selves, histories are ascribed determinate meanings, or meaningful structures, only in the way of suitable abstractions made within the shifting milieus of similar assignments made (or already made) of other such *denotata.* To read *Hamlet* now, for instance, is to read *Hamlet* within the practice (within at least the sphere of influence) of the remembered readings of *Hamlet* that have shaped our consensual habits (or, simply within our own practice of reading—within our interpretive sensibilities). What should count as conformity here is bound to be as elastic and as variable as you please. But that hardly disallows the consensual formation of a constructed sense of what should count as interpretive objectivity.

The issue at stake is a triple one: first, there is no formal need for fixed meanings or fixed criteria of meaning; second, the individuation and identity of cultural entities are not bound in any way to the standard assumptions governing discourse about physical entities that lack Intentional natures; and third, the objectivity of interpretation (like the objectivity of science, of course) is ultimately grounded in the consensual practices of our form of life. No epistemic privilege exists there.

All this, I admit, holds within the fluxive space of physical and cultural reality. Epistemically, the saving theme is simply the self-monitoring pace at which societies tacitly permit the processes of history to alter their linguistic, cognitive, and institutional regularities. Practice cannot be so labile that it outruns the fluencies of memory and reasonable expectation, but it also cannot be so inflexible that experienced history is prevented from continually adjusting our critical resources to the latest in interpretive fashion. We move safely enough between these extremes, and neither science nor interpretive criticism needs anything more demanding. On the contrary, if objectivity in the epistemic sense is constructivist in the way I suggest, it cannot justify any greater fixity. Interpretation may be as local, tendentious, opportunistic, free-wheeling, and idiosyncratic as you please. Or it may have pretensions of a connoisseur's authority. But I cannot see any reason to choose between such options, and I cannot see how admitting either disallows the construction of objectivity or the tolerance of historicism and relativism.

What, therefore, I recommend (minimally) is no more than what I began with: namely, that cultural entities are histories, Intentional careers—whether artworks, words and sentences, actions, machines, or selves—indissolubly embodied in physical, biological, electronic, or other artifactual objects or events. By "embodied" I mean only that (1) Intentional and non-Intentional properties may jointly be ascribed to such entities; (2) Intentional properties are "incarnate" in (that is, complexly include) non-Intentional properties; (3) such entities and properties emerge in a *sui generis* way in the cultural space of human life; (4) such entities and properties are intrinsically interpretable as such; (5) interpretive objectivity is best served by a relativistic logic; and (6) the natures of such entities (their interpretable "content" or Intentional history) are open, without paradox or loss of realist standing, to all the diversity, variability, transformation, incongruence, and historicized novelty that cultural history is known to generate.[42]

42. See Joseph Margolis, *Culture and Cultural Entities* (Dordrecht, Netherlands: D. Reidel, 1984), chap. 1.

If everything here holds, then to admit the interpretive *determinability* of an artwork's nature will be seen as admitting to no principled distinction between discerning and imputing a *determinate* nature to an artwork by interpretive means. That, of course follows from the distinction between Intentional and non-Intentional entities and attributes. For to discern an artwork as something other than a mere physical object is already to assign it Intentional "parts" (the sentences of a poem or the steps of a dance) apt for interpretation, and doing so belongs to the same practice within which one or another determinate meaning is interpretively imputed to be an objectively defensible reading of *that* entity's (determinable) nature.

There is no paradox here: discerning something as an artwork is constituting some set of material elements as embodying an Intentionally qualified *denotatum,* and interpreting that *denotatum* is precising its Intentional structure. The first is the interpretive work of a collective culture (in which individual selves share) by which the very reality of the cultural world is sustained; the second is the work of individual inquirers who venture an interpretive claim about the meaning of Intentional entities thus constituted.

Some theorists pretend you cannot interpret what is not antecedently described or describable or that you cannot make an objective interpretive claim if what you claim does not already answer to what is describably present in the entity considered.[43] But that is simply the result of construing the ontic and epistemic features of artworks as if they were the same as the pertinent features of physical objects; accordingly, it is to claim (without argument) that the legible relationship between description and interpretation in the physical sciences (say) cannot fail to hold in the context of cultural interpretation (but, of course, that is to ignore Intentionality).[44]

Furthermore, on the argument, the denoted Intentional "parts" of a discerned artwork may be said to provide (if we wish to speak thus) the describable structures of the work in question; thereupon, the interpretation of its putatively determinate meaning will, if valid, be consensually supported within the same *lebensformlich* practice in which the first is confirmed. In other words, it's the same practice that discerns an actual artwork (*a fortiori,* something possessing an intrinsically interpretable nature) *and* provides for a disciplined way of determining how best, or acceptably, to

43. This is the so-called "constructivist's dilemma" that Stecker, in "The Constructivist's Dilemma," claims is insurmountable in my "constructivist" account of cultural entities and interpretation.

44. See, for instance, Richard Shusterman, "Beneath Interpretation: Against Hermeneutic Holism," *The Monist* 73 (1990), which Stecker cites favorably.

construe its meaning. If you bear in mind that (a) Intentional properties are incarnate in non-Intentional properties, (b) the identity of artworks is managed as well as the identity of physical objects is managed, (c) certain minimal Intentional structures (sentences, musical phrases, dance steps, painted surfaces) are, in practice, acknowledged to be reliably discerned in individuating Intentional entities, and (d) the very existence of an artwork and its Intentional saliencies lie within the *lebensformlich* practices of an actual society, then the ontic and epistemic disanalogies between artworks and physical objects will be seen to neutralize completely any would-be paradoxes drawn exclusively from the side of physical objects.[45]

I believe that all that is true, here, of artworks is true as well of human selves and societies. But that is a longer and much more difficult tale to tell.

45. Some may wish a more explicit reckoning of Stecker's charge in "The Constructivist's Dilemma." I am happy to comply. The "dilemma" Stecker finds in my account is supposed to run as follows: interpretation "completes" the artwork and, at the same time, "makes" an interpretive claim about it. "Both [Michael] Krausz and Margolis believe that interpretations help to complete their objects. If they did not hold this view, they would not be constructivists. . . . The problem is to understand how making a claim about an object . . . can give it a property claimed for it" (50). For my part, I am unwilling to say that interpretations "complete" an artwork: the idiom is suitable to a phenomenological theory of criticism—for instance, to the views of Iser and Ingarden—but not to mine. I am of course willing to concede that interpretation imputes a determinate sense to what (interpretively) is constituted as an Intentional *denotatum*—determinate as a *denotatum* and, as such, determinable in nature. The distinction is critical and is ignored by those (Stecker, for one) who neglect the complexities of Intentionality or who see no fundamental difference between Intentional and non-Intentional properties. But, of course, that is precisely what is at issue. Once you concede the distinction, the validity of historicism and relativism cannot be put at risk by merely formal considerations—that is, by insisting on the preference of bivalence, or on the paradox of truth-claims that merely posit what they claim is true, or on the absence of any need for relativism if the *denotata* that are in question are simply numerically different from one another. Nothing of the like will do.

4

Mechanical Reproduction and Cinematic Humanism

If you bother to consult the theories of film as a fine art produced, say, between the 1930s and the 1960s, or even at the beginning of the 1970s, you will find a baffled attempt to come to terms with a new technology whose creative possibilities then seemed at best murky. I remember the appearance, in 1953, of Susanne Langer's *Feeling and Form* just at the time I completed my graduate work. I had met a sometime graduate student of Langer's who assisted in some way in her research and courses and who told me at the time that he had finally persuaded Langer to include a section on film in her overview of the arts. She was evidently uneasy about doing so because she had doubts about film's standing as an art form, but she did eventually manage to include a second-class entry in an appendix.[1] I find the explanation plausible, as I did at the time, simply because the views of such knowledgeable commentators on the arts as Erwin Panofsky and (earlier) Rudolf Arnheim and, of course, Walter Benjamin and Siegfried Kracauer, and, more recently, André Bazin and Stanley Cavell, writing within the same general

1. See Susanne K. Langer, *Feeling and Form* (New York: Scribner's, 1953).

period as Langer, unintentionally confirm the then extraordinarily primitive standing of film theory—as distinct from endlessly many penetrating observations on particular films.[2]

I have no antiquarian interest in these early quarrels. Most are outmoded. But I believe they harbor a neglected, quite important lesson about human nature and its evolving art and technology. Film is especially transparent about these matters: properly perceived, it informs our understanding of what we are—as well as what we do in perceiving and interpreting language, history, technology, art—in a way no other art form quite equals. Once you see why, you return in a surer way to literature and painting. I put the point this way because the puzzles I mean to explore can be rather diffuse. I ask you, therefore, to bear in mind (through the inevitable distractions) the grand question of what we should understand by "human nature" and how our "nature" is affected by the art world. We seem to be perpetually in danger of overlooking the obvious.

Film has, of course, conquered the world and, in doing so, has not confirmed any of the singular theories that were once the rage. Theorists like Panofsky, for instance, had spoken about film's arriving at the discovery of "its legitimate, that is, its exclusive, possibilities."[3] André Bazin's "myth of total cinema" strikes me as an obvious cousin to Panofsky's intended lesson.[4] And, in general, the late arrival of film seems to have made it wellnigh unavoidable to find a suitable niche for the new art medium in something like an updated Lessing's *Laocoön*—if it were ever to establish its bona fides. Film appeared as a technology longing to be an art. The simple failure to have anticipated that film was bound to have as protean a life as literature or theater now seems a piece of naïveté. The story is familiar, of course; a little distant from my theme, yet close enough to justify its mention.

The truth is, no theory of the arts—no theory of film in particular—is likely to be convincing if it is not a theory about what it is to be a human being or what human beings draw from the arts. I hasten to say I am not

2. See, for instance, Erwin Panofsky, "Style and Medium in the Motion Pictures," reprinted in *Film Theory and Criticism: Introductory Readings,* ed. Gerald Mast and Marshall Cohen (New York: Oxford University Press, 1974); and Rudolf Arnheim, *Film as Art* (Berkeley and Los Angeles: University of California Press, 1957).

3. Panofsky, "Style and Medium in the Motion Pictures," 161.

4. See André Bazin, *What Is Cinema?* vol. 1, trans. Hugh Gray (Berkeley and Los Angeles: University of California Press, 1971).

pressing the point because I believe most theorists have missed what is to be discovered on this score (which I am about to disclose). No, what I mean is, human beings—persons or selves—are formed and transformed in the same way artworks are, are altered by their ambient art world as well as by their technologies; thus altered, humans shape and reshape (in turn) the arts, technologies, and histories of their own culture. What's wrong in most theories of film is the presumption that there is a singular truth about any of the arts—for instance, a right analogy with Lessing's *Laocoön* or a correct psychoanalytic grasp of what it means to be seated in a darkened room watching a movie with strangers. It's the essentialism that's wrong, not the transient or perspectived glimmer of a fragment of a piece of history.

That's probably the difference, for instance, between Kracauer's early intelligent musings about the collective unconscious and Fredric Jameson's late laborious analysis of the postmodern film. Kracauer is content to remark that films "tend to weaken the spectator's consciousness."[5] He insinuates that there is a "normal" state in which human beings collect their world, which film somewhat dissolves, enabling latent (unconscious) collective themes to penetrate to perceptual consciousness; hence, the process entails a certain direct susceptibility to the filmic "text." Jameson holds instead (both as an Althusserean "structuralist" and, later, when he abandons its unearned "objectivism") that "we never really confront a text immediately, in all its freshness as a thing-in-itself. Rather, texts come before us as the always-already read; we apprehend them through sedimented layers of previous interpretations, or—if the text is brand-new—through the sedimented reading habits and categories developed by those inherited interpretive traditions."[6]

Whatever is ahistorical in Kracauer's early pronouncement gives way (in Jameson's analyses) to a more historicized mode of filmic and literary reception—in fact, Jameson specifically denies its "capacity to serve as some supreme and privileged, symptomatic, index of the zeitgeist."[7] There can be little doubt that Jameson is dismantling the prescriptive adequacy of Kra-

5. The remark is from Siegfried Kracauer, *Theory of Film: The Redemption of Physical Reality* (New York: Oxford University Press, 1960). But see also Kracauer's *From Caligari to Hitler: A Psychological History of the German Film* (Princeton: Princeton University Press, 1947).

6. Fredric Jameson, *The Political Unconscious: Narrative as Socially Symbolic Act* (Ithaca: Cornell University Press, 1981), 9.

7. Fredric Jameson, *Postmodernism, or, The Cultural Logic of Late Capitalism* (Durham: Duke University Press, 1991), 67, 69.

cauer's and Benjamin's perennialized collective psychology captured within the material forms of societal life and, therefore, displacing the supposed invariance of a receptive human nature open to historical salience.[8]

The conceptual transformations championed by Jameson and Kracauer are not easily won. Yet, all in all, what Jameson ultimately indicates is this at least: (1) human existence is inherently historical, historicized; there are no timeless or invariant subjective or spiritual values that the drift of "material" history can be accused of violating (Benjamin) or can be applauded for having made accessible (Kracauer); (2) the interpretation of film is, as with all the arts viewed as cultural artifacts, mediated by the conceptual *tertia* of salient material history; and (3) our understanding of film is objective to the extent that it involves some form of historical self-understanding, in the absence of timeless verities. These are very modest, hard-won gains. For, once you grasp the confessional extravagance of theories belonging to film's early history, you see how difficult it is to invent a workable sense of conceptual neutrality and relevance that might enable the early theories to yield a deeper lesson about ourselves.

Panofsky's essay, which dates from 1947, is particularly instructive about the dawning possibilities of film as well as about how easy it is for even the best theorists to go wrong in identifying what is essential and what is not. Benjamin, following Arnheim's earlier *Film as Art* (1936), does have in mind the same symptomatic evidence Panofsky has—which confirms that the actor in a film is *not* an actor in a stage play that happens to have been filmed. But Benjamin chooses to reverse direction; he essentially opposes Panofsky (in advance), linking the rise of the photograph and film to the decline of the sense of "aura"[9]—an idea for which Benjamin is justly famous.

Panofsky is very clear about the contrast between the stage and film. So is Benjamin. But Benjamin sees in the rise of film the loss of an ancient sense of history through the effect of "mechanical reproduction," which, of course, he implicitly associates with the threat of Nazism and whatever in the Western world is subliminally akin to it (its reversal, for instance). Benjamin's essay is an important one, I don't deny, but it seems to me utterly benighted; its reception is evidence of an enormous confusion regarding the import of film as art—*a fortiori,* regarding film's impact on ourselves.

I am not speaking primarily of the technology of film but of its supposed

8. I take this to be part of the meaning of the title "Surrealism Without the Unconscious," from Jameson's *Postmodernism,* chap. 3. But see the running argument of the entire chapter.

9. See Walter Benjamin, "The Work of Art in the Age of Mechanical Reproduction" (1936), *Illuminations,* ed. Hannah Arendt, trans. Harry Zohn (New York: Schocken Books, 1969).

bearing on the human condition and on the human reception of cinema, of film's dependence on the technology it exploits. Benjamin misleads us in the profoundest way about the former, partly as a result, it's true, of his misunderstanding of the latter. But more than that, he obviously misconstrues what the arts of the preindustrial world made possible, and he compounds the mistake in turning to film.

I make out two essential blunders, the exposé of which will help bring me to the larger claim I mean to press. First of all, Benjamin's complaint would have no point if he were mistaken about what history and aura require or if the human values he associates with aura cannot be shown to be perennial or inherently superior to what may replace them in the "age of mechanical reproduction." I take Benjamin to be seriously mistaken here, essentially (if I may say so) in the same way Heidegger was in his well-known essay on technology—perhaps for reasons that, ultimately, are no more humane than Heidegger's, although to say so is probably too outrageous to be allowed.[10] Second, Benjamin's thesis depends on a confusion between the physical and the cultural that has affected a great deal of Western theorizing about the arts—strategically, going back at least to Lessing's *Laocoön,* which is dutifully invoked in different ways by Benjamin, Kracauer, and Panofsky. The error appears most memorably (once again) in Panofsky—in fact, in what many think to be his best perception about film. Speaking about the added invention of the sound track, he says, "In a film, that which we hear remains, for good or worse, inextricably fused with that which we see; the sound, articulate or not, cannot express any more than is expressed, at the same time, by visible movement; and in a good film it does not even attempt to do so. To put it briefly, the play—or, as it is very properly called, the 'script'—of a moving picture is subject to what might be called the *principle of coexpressibility.*"[11]

The question remains, how can Panofsky make such a claim when, in the same paper, he has already said, "The spectator occupies a fixed seat, but only physically, not as the subject of an aesthetic experience. Aesthetically,

10. See Martin Heidegger, "The Question Concerning Technology," trans. William Lovitt, in *Basic Writings,* ed. David Farrell Krell (New York: Harper and Row, 1977).

11. Panofsky, "Style and Medium in the Motion Pictures," 157. I should mention, explicitly, Noël Carroll's careful discussion of versions of Lessing's theory—what Carroll calls "medium specificity arguments"—in "Medium Specificity Arguments and the Self-Consciously Invented Arts: Film, Video, and Photography" and "The Specificity of Media in the Arts," in *Theorizing the Moving Image* (Cambridge: Cambridge University Press, 1996). These papers had been published more than ten years ago, but I'm afraid I hadn't read them until an anonymous reader for the Press alerted me to them.

he is in permanent motion as his eye identifies itself with the lens of the camera [or, better, with the point of view, or points of view, causally facilitated by the camera's lens], which permanently shifts in distance and direction"?[12] If you recall a film as powerful and as baffling—yet also as legible—as Alain Renais's *Last Year at Marienbad* or, for that matter (though it is less enigmatic), Orson Welles's *Citizen Kane,* you see how Panofsky conflates the physical and the "aesthetic" possibilities (to the advantage of his own theory).

I press the point, not merely because Panofsky is as good an early theorist of film as we are likely to find but also because his mistake is linked in a profound way to Benjamin's more serious mistake (the error I associate, as I say, with Heidegger's "The Question Concerning Technology"). In any case, one cannot tell *what* is possible in an art form until artists have actually shown the way. It doesn't pay to ask the theorist or the historian. (Think again of Panofsky and *Last Year at Marienbad*.) Who, looking at Cézanne's still lifes, could have foreseen Picasso's cubism—apart perhaps from Picasso and Braque?

A lot of mischief lies buried in the elementary blunder of conflating the physical and "aesthetic" features of an artwork—even a film. I allow the term "aesthetic" here, since Panofsky invokes it; but it's entirely unsatisfactory. Its weakness goes all the way back to Kant's absurd tripartite division among the would-be logics of science, morality, and beauty. Nothing principled divides these spheres of inquiry. Kant had no theory of art at all, not even an interest in the arts. Why beauty in nature should have anything to do with our critical interest in the arts Kant never explained. It's part of the great scandal of philosophy's pretense that Kant had something profound to say about the fundamental distinction between physical nature and human culture. He did not. Which is not to deny a deeper connection between art and nature or the appreciation of art and nature. Nevertheless, Kant's impoverished notion of the "aesthetic," together with the plausible confusion of Lessing's *Laocoön* and the early naïveté about the technological possibilities of motion pictures, has misled not only Arnheim, Panofsky, and Kracauer about how to understand film as fine art but has obscured the full import of the human reception of motion pictures.

12. Panofsky, "Style and Medium in the Motion Pictures," 155.

I

I am, I must confess, very fond of dwelling on the way Cézanne prepares us step by step for the great innovations of the last Mont Sainte-Victoires through his unfinished occasional watercolors and through the sequence of the early exploratory landscapes in which he himself progressively discovers how far there is yet to go beyond whatever, at the moment of completing any one canvas, he may have yet glimpsed. Our own perception of a *particular* late canvas is a function of the sequential training of our eye through the actual sequence of Cézanne's entire output. That is not always true—or perceived—of painters. (It is not noticed, I may say, by Merleau-Ponty, discussing Cézanne's painter's eye.)[13] For instance, it's not true of Picasso (or not true in the same way), simply because Picasso toyed in his brilliant way with so many (too many) styles of painting at once and changed so abruptly (too abruptly) from style to style. (There *is* a development in Picasso. I shouldn't want to deny it. It's just not instructive in the same way Cézanne's practice is.) Not only was Cézanne committed in an uncertain way to an awkward and touching break with academic painting, he found his way only dawningly, more or less through the mists of a singular self-transformation. You can discover, by studying both Cézanne and how one comes to understand Cézanne, something of the general symbiosis between the painter and the process of painting and between paintings and the self-education of percipient audiences. It's in that same sense that the motion picture, precisely because it involved an entirely new technology (that had to be mastered from ground zero by essentially ignorant innovators who happened to have been armed with a library of theories about the canonical arts and their history), affords a unique glimpse into the interlocking relationship between film and audience.

This is the relationship Walter Benjamin completely befuddles, imperiling our grasp of the meaning of the arts and, as a consequence, our grasp of "human nature" itself. (Cézanne's example helps us here.) It might have remained a matter of minor scholarship but for its fame and its success in misleading us in a grand way. In fact, as I write, the American Congress is preparing to scuttle all Federal funding of the arts largely on the know-nothing pretense of an unfair tax imposed on families of limited means (who may not care to visit the arts) and on the strength of opportunistic

13. See Maurice Merleau-Ponty, "Eye and Mind," trans. Carlton Dallery, in *The Primacy of Perception,* ed. James M. Edie (Evanston: Northwestern University Press, 1964).

moralizing about obscenity and the like. The American Congress has no idea, of course, of the relationship between the arts and their reception. The great irony is that Benjamin's treatment of film, which has been regarded as a perceptive warning about the gathering loss of the most essential safeguards of our spiritual values, in truth entails the deepest possible obfuscation of how humane values are secured at all. The connection between technology and Bolshevism or capitalism (or Nazism) is a distraction (important but confused) formulated out of a benighted fear—not an "illumination"—in a way that is discernibly complicit with Heidegger's impossible complaint against technology. That is the lesson film affords.

I can put the issue in a single line. You cannot understand human nature without understanding how it is first formed and changes, ineluctably, through the whole of human history. You cannot take any one period of political or artistic grandeur to define the human essence, no matter what your loyalties are. The "essence" of human nature is its unfinished history, its intractable inventiveness and diversity, the consequence of endlessly transforming (by way of endlessly different perspectives) whatever it may have succeeded in inventing *ante*. That is what I find so compellingly disclosed in Cézanne's career and what I find transparent (on a massive scale) in the history of film. Benjamin betrays that lesson, arresting history in the service of his perennialist illusions about what he calls "aura": a would-be supreme benefit of a uniquely right relationship between man and his world, obediently served by a modest technology.

Ancient "auratic" art is simply a local feature of art's past; it is not a timeless norm for the entire history of art, though it does afford exemplars for humane analogy. Benjamin's blunder—for that is what it is—rests on a confusion between a reductive account of "mechanical" reproduction and the "spiritual" constancy of the conditions of remaining true to history. In effect, Benjamin deforms at one stroke both the perception of ancient art and the opportunistic possibilities of film in Marxist terms, once the old options are precluded by the new technology. The appraisals of film by theorists like Arnheim, Panofsky, Kracauer, Bazin, Cavell, and others are, however humane in their own right, incapable of penetrating to the great danger Benjamin's pronouncement feeds—for at least two reasons: first, because they too confuse the physical and the cultural (distorting the camera's role); and, second, because they too tend (though rarely explicitly) to subordinate history to the normative constraints of essentialist and perennialist values.

The most attenuated evidence appears in Kracauer. Kracauer subscribes to Panofsky's general theoretical orientation, which, as I say, obscures—even

fatally misreads—the role of physical nature in the art of film, and Kracauer incipiently strains for a kind of universalized humanism that may be drawn out of the profoundly historical situatedness of film itself. Neither feature plays a fully developed role in his account of the early German film, tethered of course to the immense importance of *The Cabinet of Dr. Caligari*.

Kracauer sees the prospects of film (if we contrast his views with Benjamin's) as ultimately liberating—in favor of the technology of the motion picture. But the truth is, Kracauer means to fit his own account of its potentialities into a variant of Lessing's model, informed both by the need to avoid Lessing's rigidity and by his own uncertainty about the new technology.[14] Hence, although, in *From Caligari to Hitler*, Kracauer makes it clear he means to avoid all ahistorical forms of historicism and explore instead "the psychological patterns of a people at a particular time," his adherence (via Panofsky) to something like Lessing's *Laocoön* and his account of psychological matters lead him to endorse the idea (which he finds confirmed in Erich Auerbach's *Mimesis* and Edward Steichen's photographic vision of "The Family of Man") of abstracting certain universal themes and values from the historical variety of film.[15] Kracauer does not actually pursue the matter, for he supposes that penetrating beyond the "ephemeral" features of physical reality (which film is said to capture) is beyond the scope of his own inquiries.[16] But his focus deflects him from the deeper speculation. All the early studies of film do the same. That is what makes it so difficult to get clear about Benjamin. We are the victims of a false beginning. (Remember Jameson.)

I have no wish to belittle Kracauer's important survey. I mean only to draw attention to how difficult it is, in light of his orientation, to recover a thoroughly historicized sense of the connection between film and audience and thus to fend off imperious theories like Benjamin's. Kracauer makes one respectful mention of Benjamin's perceptiveness about photography. But he nowhere takes notice of the fundamental opposition implied by Benjamin's stance on "mechanical reproduction" and the enthusiasm Kracauer himself shares with Panofsky about the liberating possibilities of film. You have to read Panofsky's remarks with considerable care to appreciate precisely what Kracauer is saying, for both Panofsky and Kracauer mean to be theorizing innovators in Lessing's spirit:

14. Kracauer, *Theory of Film,* 12–13.

15. Siegfried Kracauer, *From Caligari to Hitler: A Psychological History of the German Film* (Princeton: Princeton University Press, 1947), 8. Kracauer, *Theory of Film,* 310.

16. Kracauer, *Theory of Film,* 311.

It is the movies, and only the movies, [Panofsky maintains,] that do justice to [the] materialistic interpretation of the universe which, whether we like it or not, pervades contemporary civilization. [Here you have a clue to Benjamin.] Excepting the very special case of the animated cartoon, the movies organize material things and persons, not a neutral medium, into a composition that receives its style, and may even become fantastic or pretervoluntarily symbolic, not so much by an interpretation in the artist's mind as by the actual manipulation of physical objects and recording machinery. The medium of the movies is physical reality as such, the physical reality of [say] eighteenth-century Versailles . . . or a suburban home in West Chester.[17]

Panofsky, of course, is bent on distinguishing film from both theater and painting. But, in doing so, he confuses the relationship between the physical and the cultural and, *as a direct consequence,* makes it nearly impossible to engage Benjamin's mistake. This is the complication I have in mind.

I must, however, concede that recent analysis of film has retreated from "Grand Theory" in the old sense, though I see no real difference between "Grand Theory" and "piecemeal" theories.[18] In fact, there cannot be a difference if one accepts David Bordwell's contention that "no theory of cinema could be valid unless anchored in a highly explicit theory of society and the subject."[19] Still, what I urge is that the critique of Benjamin would be misperceived if it were simply supposed—as the pluralistic, interdisciplinary, "culture studies" cinemaphiles pretend—that the market success of film has put an end to worries of Benjamin's sort. Film's success has only obscured the need to address these questions frontally, for what Benjamin deplored was not the victory of "mechanical reproduction" (which he realized could not be delayed) but the alleged loss of a certain right spiritual role that film (and whatever else it augured) made impossible to hold on to. That question, I daresay, has pretty well disappeared from the theorizing scene. My complaint is that with its disappearance has arisen a profound misunderstanding of the human condition (abetted by Benjamin) and the

17. Panofsky, "Style and Medium in the Motion Pictures," 168–69.

18. See, for example, David Bordwell, "Contemporary Film Studies and the Vicissitudes of Grand Theory," and Noël Carroll, "Prospects for Film Theory: A Personal Assessment," in *Post-Theory: Reconstructing Film Studies,* ed. David Bordwell and Noël Carroll (Wisconsin: University of Wisconsin Press, 1996).

19. Bordwell, "Contemporary Film Studies and the Vicissitudes of Grand Theory," 19.

corrective lesson the motion picture affords—just the lesson, in fact, that Bordwell (as a particularly well-informed commentator) insists on in his very recent overview of the state of the art.

II

Benjamin obviously believed that changes in the technologies of the past could be benignly reabsorbed into the salient practices of human societies whose members remained in touch with the living history that sustained them: because—very simply—those changes did not alienate them from that history. But he also believed that the technology of the photograph and the motion picture brought into play, or into immediate effectiveness, a force that permanently breached that (genuinely) sacred connection. Now, it's perfectly clear that most contemporary film studies—for instance, those David Bordwell and Noël Carroll have recently sampled in a perfectly standard way—are no longer interested in *that* presumption of Benjamin. But they neglect to consider what to put in its place in terms of the humanizing possibilities of the relationship between film and percipient audience. Failing that, the new discussants of film lack a "grand" or even a "piecemeal" theory by which to legitimate their interpretation of particular films or to secure the point of such interpretation in assessing the bearing of all our presumptions of objectivity and normativity in any or every sphere of inquiry. I suggest we fail to understand ourselves in neglecting to meet Benjamin's charge directly.

Ironically, that same neglect lends color to Benjamin's fear (and opportunism) regarding the new barbarism of film—and of materialism and capitalism to boot. Early theorists of film like Panofsky and Kracauer—who, persuaded of the artistic promise of film (*a fortiori,* persuaded of the promise of the materialism Benjamin decried, more equivocally of course than Heidegger), at least implicitly opposed Benjamin's pessimism—failed to step forward with a reasonable conception of the human condition or the import and paideutic influence of movies. We are face-to-face here with a conceptual void, not only with regard to the reception of film but, in general, with regard to the arts, education, history, morality, and religion. I have some suggestions about how to answer the neglected question. In fact, I believe the right answers can be drawn from a close reading of what Benjamin's theory actually implies. A great deal hangs on the answers we choose.

I turn, then, to what Benjamin actually says. Benjamin believes that a certain insuperable inauthenticity in film betrays the moral safeguards of the stage. That might not be important in itself. But it augurs a more general global threat: the anticipated spread of the new technology's inauthenticity to every corner of human life. From Benjamin's vantage, the enthusiasm of Panofsky and Kracauer would be artistically and politically too dangerous, possibly too innocent. Could Benjamin conceivably be right? Here is the beginning of his argument:

> The artistic performance of a stage actor is definitely presented to the public by the actor in person; that of the screen actor, however, is presented by a camera, with a twofold consequence. The camera that presents the performance of the film actor to the public need not respect the performance as an integral whole. Guided by the cameraman, the camera continually changes its position with respect to the performance. The sequence of positional views which the editor composes from the material supplied him constitutes the completed film. It comprises certain factors of movement which are in reality those of the camera, not to mention special camera angles, close-ups, etc. Hence, the performance of the actor is subjected to a series of optical rests. . . . Also, the film actor lacks the opportunity of the stage actor to adjust to the audience during his performance, since he does not present his performance to the audience in person. This permits the audience to take the position of a critic, without experiencing any personal contact with the actor.[20]

Here one finds a bit of ingenuity and some disingenuousness. Also, up to this point at least, very little distinguishes Panofsky's view from Benjamin's, though there are some differences. For one thing, the camera is not doing any of the artistic work; surely it's the director and his or her crew, using the technology of film (which is simply different from the technology of the stage), who are composing and creating a motion picture. For another, film is not a performance in the same sense as is the live performance of a play, though film does incorporate the performance of actors (under direction) in a new ensemble. The situation is obviously different once again from that of recording a musical performance; however, one must bear in mind such innovations as are adopted in Glenn Gould's recordings of Bach, or those

20. Benjamin, "The Work of Art in the Age of Mechanical Reproduction," 228.

(potential "inauthenticities") that the recording of pop music has come to favor.[21] What this signifies, of course, is that if authenticity is the right concern, the site at which it may be judged and the form it takes are not the same as what they are for "live" theater, although, even there, the acting of Sarah Bernhardt and the theories of David Garrick expose Benjamin's overly simple conception.

Yet there's more to it, for in film one finds a sustained personal relationship between actor and audience that Benjamin does not see. I cannot imagine, for instance, how this relationship can be denied in such an extraordinary performance as that of Geoffrey Rush playing David Hilfgott, the Australian pianist, in Scott Hick's recent film *Shine*. Something similar is already evident in live television interviews. Our viewing of newsworthy figures on the tube is in a sense akin to viewing microbes under the microscope or stars through a telescope or (even) one another seated across a table. I see no reason to deny that we are watching a "performance" of actors in film or on television, though it is obviously not the same as watching a performance of actors on stage. Think of the television reception of the Beatles, which was surely continuous with the reception of their live performances, or the Vietnam War unfolding in our living room. But where is the inauthenticity in any of these cases if we know and accept the difference?

You begin to see the instructive possibilities of Lessing's *Laocoön*. Benjamin denies its pertinence in dismissing (for the sake of an entirely new—potentially opportunistic—use of film) the whole of "mechanical reproduction" and the technology to which it belongs. But his argument betrays a false picture of human nature—and of film and the arts in general. (Ironically, he needs the misperception to promote his own political program.)

Now, it is certainly possible to read Benjamin's essay—as, indeed, it was intended—as a Marxist reversal of Nazi aestheticism that captures, in terms of technology, the self-alienation of both the middle class and the proletariat and thus instructs us about the clever, politically redemptive function of film: that is Benjamin's intention.[22] But its "aesthetic" possibilities, Benjamin believes, depend on the loss of genuine aura. There's where he goes wrong—utterly. He pursues a rather complicated target here: the recovery or replacement of the "aura" of traditional art under the modern condition of art's

21. See Glenn Gould, "The Prospects of Recording," in *The Glenn Gould Reader*, ed. Tim Page (New York: Vintage, 1990).

22. See, for example, Sheldon Wolin, *Walter Benjamin: An Aesthetic of Redemption* (New York: Columbia University Press, 1982), esp. 183–97.

autonomy, viewed through the emancipatory *telos* of the Marxist struggle. I have no particular quarrel with that here. My point is rather that, in the process, Benjamin falsifies what we should understand the possibilities of "aura" to be, what the human condition is, and above all what new crisis photography and the motion picture bring to contemporary technology.

There is, apart from Benjamin, a great deal of evidence that the hieratic statuary of ancient Egypt (for instance) was prepared in a "mass-produced" way (that is, within the limits of intensive hand labor) by modularizing the basic parts and forms on which the distinctive features of this or that exalted figure could be more or less cosmetically imposed as the work of a second craft. Wilhelm Worringer had rested his notion of the deliberate stylistic choice between "abstractive" and "empathic" art on just such evidence (given the presence, at the same time, in the same studios, of hieratic and naturalistic sculptures).[23]

I mention the fact only to draw your attention to the probable compatibility, in principle, between "mechanical reproduction" and auratic art. (Egyptian art is not mechanical in Benjamin's sense, of course.) Benjamin has made much too much of the link between the bland acceptance of replaceable copies (for their originals) and the loss of authenticity. The counterargument is surely that, in time, motion pictures will produce (*have* produced) their own version of "aura" or cultural solidarity (if the idea has any legitimacy at all), for film yields a form of authentic linkage to the (*sittlich*) sources of human history every bit as genuine as do the temple arts of ancient Greece. Indeed, there is a difference between ancient art and film, and it comes from a difference in history and technology and in our reflections on history itself. And, of course, industrial society is permanently altered. But where is the ultimate disjunction Benjamin requires? It doesn't exist, I say, although that's not to deny that different forms of authenticity and inauthenticity have always been present.

What do you make, for instance, of Marcus Aurelius's canny provision for respecting all the ancient gods and all the forms of worship? (Is the sense of aura there?) The error lies, once again, with conflating the physical and the cultural (the "spiritual," the "authentic," the "auratic"). When you consider the extraordinary vicissitudes surrounding the auratic consecration of sacred icons and other images in the thousand years between the ancient world and the Renaissance, the eruption of iconoclastic denials, and the gradual

23. See Wilhelm Worringer, *Abstraction and Empathy,* trans. Michael Bullock (New York: International Universities Press, 1953).

emergence (diminishing the effect of "aura") of paintings as artworks (in the modern sense) through that entire process, you surely see the impossibility of ignoring the historical and artifactual standing of what we call auratic.[24] Benjamin does not concede this.

There is in the literature a curious unwillingness to challenge Benjamin's conception. Perhaps a direct challenge would go against his very large spirit; perhaps in a world only recently relieved of Nazism and Stalinism, one would want to move carefully against *their* best critics. Fine. But the errors by which Benjamin recovers a humane vision—regarding the motion picture and, consequently, the arts—is so seriously flawed that no advantage may remain in the exercise.

I count two essential mistakes, both linked to the confusion of the physical and the cultural. One concerns the point just made: the mechanical reproduction of photographs, the various ways of cutting and splicing film produced on different occasions (in effect, montage), has absolutely nothing to do, in principle, with authenticity or the relationship between performing actors and audiences. Believing that it does is simply an immense blunder that depends on an essentialized reading of something akin to the *Laocoön,* in which film, *if it were authentic,* would be a piece of theater. Nonsense! (Panofsky corrects the mistake.) Benjamin's notion corrupts our sense of the redeeming features of our contemporary world. If we accepted what he says, we should be driven in the direction of Heidegger's deeper (more preposterous) criticism of technology (that is, we should be drawn to the idea that *any* idiom wedded to the realism and efficiency of modern technology was intrinsically "inauthentic").

The second error is more fundamental and bears on the human condition itself—on the sense in which, whatever may have been the cultic authenticity of ancient rituals (on which Benjamin dwells), our own technologies can rightly claim a genuine continuity with the ancient forms. Modern technology is (I concede) radically different in certain ways from preindustrial technologies. But it hardly follows that the motion picture is inauthentic or that there is some ancient paradigm of authenticity under which it can be recovered—though only by way of serious compromise ("mechanical reproduction").

The genuinely interesting lesson film affords rests with the following:

24. See, for instance, Hans Belting, *Likeness and Presence: A History of the Image Before the Era of Art,* trans. Edmund Jephcott (Chicago: University of Chicago Press, 1994), esp. chaps. 1–2. You may find particularly intriguing the photograph (as altarpiece) of Saint Guiseppi Moscati, in the Church of Gesù Nuovo, in Naples.

first, every "technology" is, if viable, infused with the *sittlich* values of the historical society that uses it; and, second, among genuinely complex technologies (like film), the possibilities of the first are only gradually and creatively constructed as we transform ourselves by the labor of mastering its evolving possibilities. (Think back to Cézanne.) Benjamin's nostalgia for the "aura" of a preindustrial world has very little to do with the advent of film, both because the loss of whatever virtue prehistoricized traditional societies may have had absolutely predates film and because film itself hardly introduces any new form of relevant inauthenticity that marks the end of whatever may have vestigially survived into the capitalist era. Benjamin gives the false impression that the Greeks reproduced a work of art "only [by] two procedures . . . founding and stamping" (as in casting bronzes and minting coins).[25] But he seems to have forgotten the pottery and the copying practices known among the Egyptians, the Phoenicians, the Romans, and even the Greeks themselves.

Benjamin goes further, saying, "Even the most perfect reproduction of a work of art is lacking in one element: its presence in time and space, its unique existence at the place where it happens to be. This unique existence of the work of art determined the history to which it was subject throughout the time of its existence. This includes the changes which it may have suffered in physical conditions over the years as well as the various changes in its ownership. . . . The presence of the original is the prerequisite to the concept of authenticity."[26] He seems to have forgotten the ancient practice (among the Egyptians—Ikhnaton, for one) of erasing the names of superseded kings from great monuments and of some upstart usurping the "aura" of the past for a new purpose. He ignores all evidence of stylistic borrowing—say, the absorption of Hellenic models in Indian, Buddhist, and Chinese sculpture or, for that matter, the transformation (at some distance from its original home) of the Doric temple in the Periclean world. He actually adds, "An ancient statue of Venus, for example; stood in a different traditional context with the Greeks, who made it an object of veneration, than with the clerics of the Middle Ages, who viewed it as an ominous idol. Both of them, however, were equally confronted with its uniqueness, that is, its aura."[27] Clearly, he has altered his own argument here, confusing the physical and the auratic.

25. Benjamin, "The Work of Art in the Age of Mechanical Reproduction," 218.
26. Ibid., 220.
27. Ibid., 223.

The truth is, *aura is an artifact of history:* the constantly reinvented *sittlich* (even sacred) import of the art of the past viewed in accord with the sense of cultural solidarity favored in some societal present. Think, for instance, of Alexander hiring Greek sculptors to convey a sense of Greek aura for Macedon. The pretense or the delusion—it hardly matters which—that the distinctive form of life of the preindustrial ancient world somehow holds the invariant clue to the validity of the would-be "presence" of contemporary art (if it has any presence) is a form of distraction that keeps us from ever fathoming the significance of being absorbed with any intensity in the art world. Benjamin's perseveration is a form of learned insensitivity that kept him from recognizing the extraordinary "aural" possibilities of film. Perhaps it was too early in film's career. I hardly think so, to judge from Kracauer's discoveries. But that leaves us, of course, with the need to explain the mystery.

III

I offer two clues. Kracauer collects one of these clues from many sources, which he flags by the psychoanalytic suggestion, "Film is a dream . . . which makes [one] dream." He understands the process to be released by the spectator's absorption in the camera's trickery, particularly the editing that produces a *sui generis* sense of "point of view," which baffles certain habitual clues regarding the familiar world and draws one into the phenomenal world of film as if it were its own reality. To this Kracauer adds the dawning sense of a "new sensibility," which is said to "have all the earmarks of genuine first-hand experience."[28] I take the familiar world to be much restored by this but also altered in the process and made more hospitable to strenuous and even improbable change.

The other clue appears in Panofsky's essay (which converges, in part, with Kracauer's but also mentions some instructive analogies to other previously new arts). What Panofsky says here bears on the lesson I have in mind:

> The evolution [of film] from [its] jerky beginnings to [its] grand climax offers the fascinating spectacle of a new artistic medium gradually becoming conscious of its legitimate, that is, exclusive

28. Kracauer, *Theory of Film,* 163–66.

possibilities and limitations—a spectacle not unlike the development of the mosaic, which started out with transposing illusionistic genre pictures into a more durable material and culminated in the hieratic supernaturalism of Ravenna; or the development of line engraving, which started out as a cheap and handy substitute for book illustration and culminated in the purely "graphic" style of Dürer.[29]

I take these two clues to be very solid. One may favor a different way of putting Kracauer's insight, but without question, film characteristically (often) produces a form of perceptual absorption of unusual intensity that need not lose a critical grasp of the detail of its peculiar phenomenal reality—a strange world that, remarkably, grows ever closer to the world we say we inhabit (or that deforms that world congenially).

Panofsky's clue adds an instructive analogy. I bring the two notions together because whatever is "auratic" in the history of modern and contemporary art is surely present in the motion picture. It may even be that Benjamin's emphasis on the cultic and ritual aspects of ancient art is little more than a displaced realization that the powers of the new technology release, form, instruct, and transform our sensibilities in a way that no longer depends on the rather "exomorphic" rituals of earlier societies. I believe that is true and important, but it is not the most important clue about the power of film. To find that, you must fuse Kracauer's theme of a new sensibility with Panofsky's theme about the evolution and mastery of film's technology. Something new emerges there.

We are very close to what eludes us: the conceptual elements are more or less in place. First of all, the motion picture commands our sensibilities in an unprecedented way. No art produces an effect as instant, as irresistible, as polymorphously educable as film—unless it is another technologized art, perhaps the art involved in the electronic concerts of the pop music world. Second, that capacity permits us to share anonymously with others a montaged world abstracted from every possible cultural source and fused again with each such source—according to our grasp of cultural reality. Third, in habituating ourselves to film, we submit to the contrived auratic power of every filmic world, and through it, spontaneously interpret the near-filmic quality of the virtual world we thereupon construct and believe ourselves to inhabit. Finally, within the terms of that evolving paideia, we transform ourselves, becoming the apt agents of that implied society; we extend and

29. Panofsky, "Style and Medium in the Motion Pictures," 161.

deepen by film's technology a definite sense of membership, of personal encounter within the protean world equivocally thus fused. Benjamin implicitly denies such possibilities. He could not be more mistaken. For what the filmic experience recovers—makes more explicit and more transparent than any other art form (or form of history)—is the continuing process of our own enculturation. We are, so to say, confronted, by filmic proxy, with the montaged structures of our own lives and sensibilities. By that, we learn to see how even the more ancient arts once formed and transformed our ancestors much in the way we ourselves become the artifactual selves we are. *We learn—because we see reflexively—that encultured humanity is itself historically and technologically constructed.*

Without question, film is an extraordinary medium. It compels our absorption, even when it is less than at its best, and even when we are distracted. Film tends to focus on closely observed societies. It creates imaginative worlds not very distant from ours but much more labile, more extreme, more completely narratized than our own, from which our own world selects—usually incipiently—ingredient parts and meanings as its own potencies. Watching movies, we gradually acquire the perceptual and interpretive skills film makes possible, which we effortlessly apply to our own lives; we begin to tolerate an entire passage of imaginative fusings between the "real" world and the endlessly many phenomenal worlds of film. We find ourselves open to narrative possibilities (and more, of course) in the "real" world that yield increasingly in the direction of our cinematic worlds. I find the notion very cleverly apotheosized in Woody Allen's *The Purple Rose of Cairo.* (It is also perhaps close to the theme of hyperreality that Baudrillard has so strenuously exploited.)[30] Furthermore, we find ourselves, in the cinematic world, privileged voyeurs—in fact, we are less (or more) than voyeurs, gripped by what is no longer a merely surrogate world.

In the filmic experience, montage (viewed in a sense akin to Sergei Eisenstein's) habituates us to the near tolerance of the continuity between the "real" world and its filmic counterparts. Even the floating heads of television's news camera are part of our direct perception of reality. There is no fundamental difference in this regard between the "conventions" of the "live" stage and the conventions of a film like *Schindler's List.* What Aristotle astutely grasped in the tragic catharsis is easily as true of film as it is of theater—but that's not to say, of course, that the artistic merit of Arthur

30. See, for instance, Jean Baudrillard, *Simulations,* trans. Paul Foss, Paul Patton, and Philip Beitchman (New York: Semiotext(e), 1983).

Miller's *Death of a Salesman* is the equal of *Antigone*. It does reclaim "aura," however.

What you need to bear in mind is that the filmic liberty of the editing process is the artistic counterpart of the interpretive liberty we cannot help applying in the transient discontinuities of our experienced world. Film trains us expertly to assemble the narrative unities of our own world in editing the consensual (montaged) recollections of our society. Think, for example, of attempting to define the true structure of the Second World War. There are no real differences in *predicative* terms between fiction and reality, and the *referential* scruple between fiction and reality is mastered (where it is mastered) in film and "reality" in the same consensual way.

Film, then, is the metonymic form of our continuing enculturation, made more transparent, more accessible, to ourselves than by any other art—except perhaps for those (laggards) who still make a fine (a slower) study of the formation of their own sensibilities (in, say, painting and poetry). We see the world (imaginatively) through film; its variety and ubiquity compel us to view the gradual transformation of our own world as constructed, variable, manipulated and manipulable, plural, evolving, and, above all, matched by a coordinately constructed interpretive skill that film itself entrenches.

I have no doubt that the effect of Sophocles on an Athenian audience must have been electric. (It still is to the trained reader.) But it was perhaps only in Euripides that something of the experimental manipulation of our sensibilities may have been directly sensed by the Greek audience. That must have been what seemed so subversive in Euripides: his insinuation of plausible doubts about the fixed forms and structures of society. Such perceptions tend to elude modern audiences as well as modern readers, possibly because Euripides' "sophistic" maneuvers ("making the worse case seem the better") are so much akin to our own trained talents, which of course film mercilessly exploits. Whatever, on the sternest grounds, we take reality to be in the filmic world, we are not committed to any fixed order of causes, natures, or virtues. Instead, we find ourselves prepared to tolerate all sorts of transient loyalties, even against the loyalties of our customary world. But we *are* incipiently ready to find that the "real" world is altogether different from what we had supposed it to be (as with *The Cabinet of Dr. Caligari* or *Star Wars*). That may always have been true, but not through the peculiarly potent technologies that affect us now.

I must press the point in a leaner and more forceful way. There are good philosophical reasons for believing that no principled disjunction exists between what we legitimate as reality and what we legitimate as our knowl-

edge of reality. But since we ourselves, *as selves,* are first formed by internal-
izing (as the infant members of *Homo sapiens*) the contingent linguistic and
allied competences of this or that historical society, we are in a sense hybrid
artifacts of nature and culture.

The argument to that end is too strenuous to be summarized here: I ask
you, therefore, to treat my claim as a conditional one.[31] My point is this:
seen from the experiential and epistemic side (under that constraint), the
real world is, effectively, also "constructed"—though (as in the physical sci-
ences) it is entirely possible (and coherent) to form a picture (within its
terms) of a physical world "independent" of our cognizing conditions. That
is to say, the ontic independence of the physical world is, by a benign antin-
omy, a posit internal to our epistemic competence. Furthermore, on the ar-
gument, there cannot be a cognizable physical world unless the world of
human culture is as real as the other; anything less would require a disjunc-
tion between reality and knowledge. The montaged "reality" of film is not
that distant from the interpreted posit of our own reality.

Nevertheless, the reality of our cultural world includes ourselves and
what we make and do and interpret to be such. Here we cannot speak of a
similarly "independent" world, although of course we need not claim that
the real structures of societal life are simply whatever anyone arbitrarily sup-
poses they are.

In speaking of film's peculiar potency, therefore, I am not making any
such claim. What I say instead is that, short of denying the reality of selves
and cultures altogether, or of reducing all that to physicalistic terms, we
cannot, in any clear or dominant sense (comparably to what, for predictive
and technological reasons, we judge the "independent" world to be), easily
demarcate what is real and apparent or fantastic within any run of cultural
phenomena.

Now, the heart of what I am pressing is simply that there is no crisp way
to fix the meaning and structure of human life and human relations, or the
meaning of history and art, except (*a*) consensually (rather than criterially)
and (*b*) by interpretive means. I take this to be part of what Wittgenstein
had in mind (or a subversive possibility of what he had in mind) in speaking
of a form of life and "language games" within the human form of life.[32] If,

31. See, for a version of the larger argument, Joseph Margolis, *Historied Thought, Constructed
World: A Conceptual Primer for the Turn of the Millennium* (Berkeley and Los Angeles: University of
California Press, 1995).

32. See Ludwig Wittgenstein, *Philosophical Investigations,* trans. G. E. M. Anscombe (New York:
Macmillan, 1953), pt. 1, sections 241–42.

in addition, our interpretive resources were subject (as they are) to historical change and not reliably keyed or confined to fixed cultural events and artifacts, then the line of demarcation between the "real" world and what we cinematically "imagine" our world to be like would be very difficult to fix indeed. In fact, what we believe the real world to be like—in all sorts of ways—may well be formed by our interpretive appreciation of artists' interpretations of what may have been thought to be the relevant reality *ante*.

What I am claiming is that the motion picture is in a notably powerful position to form and transform our grasp of human history and the human condition: not merely in the sense, say, in which we might have adopted, and acted in conformance with, the meaning of the drought that occurred in the American West during the Great Depression years from the way it was defined by the filmed version of *The Grapes of Wrath,* though we were never "there," but also in the sense (a profounder sense) that our very conception of social reality might now be ineluctably tethered to the paideia of the filmic world and its adjuncts. I take it to be true that, in a sense deeper than the dictum that man is what he eats, we *are* what, through our media, we read and hear and view.

It is an obvious but constantly ignored truth. Of course, it already points to what is so seriously amiss in Benjamin's argument. Benjamin couldn't have understood the great arts of the past he loved so much, if he missed the sense in which early films already showed paideutic affinities with *everything* he found in auratic art. The "construction" of the self in Sophocles' day was surely different from the construction of the self at the time of Fritz Lang's *Metropolis* (1926) and *Doctor Marbuse* (also of the 1920s), but the general process of forming human identities and sensibilities cannot have been present in the one and absent in the other. Benjamin could only have been registering his own political and educative preferences; he couldn't have been speaking of the differential powers of the various arts. The irony is that the meaning of Plato's apparent philistinism (in the *Republic*) is clearer in the age of film and electronic music than it could ever have been to the man in the street before the "age of mechanical reproduction." It's not that "in our world" the line between fiction and reality is blurred or that the structure of the real world is provided by higher-order fictions but that the distinction is itself a constructed one internal to the symbiosis of reality and knowledge.[33]

33. The first option is the conceptual mistake favored, for instance, by Paul de Man, in *Blindness and Insight: Essays in the Rhetoric of Contemporary Criticism,* 2d ed., rev. (Minneapolis: University of Minnesota Press, 1983); the second is the conceptual mistake favored by Paul Ricoeur, in *Time and Narrative,* vol. 3, trans. Kathleen Blamey and David Pellauer (Chicago: University of Chicago Press,

Let me offer one final piece of evidence regarding the necessary correction of Benjamin's theory. Benjamin concedes that "a work of art has always been reproducible." The fault with "mechanical reproduction" is that it eliminates "the presence of the original," which (he says) is "the prerequisite" of the artwork's "authenticity."[34] "The authenticity of a thing," he explains, "is the essence of all that is transmissible from its beginning, ranging from its substantive duration to its testimony to the history which it has experienced." Effectively, mechanical reproduction "detaches the reproduced object from the domain of tradition" (from the "aura" of the original) (221). However, a motion picture constructed by an auteur or director or team of artists is the *original* artwork; it is not a "reproduction" of anything.

Benjamin has committed a simple *ignoratio*. He seems to rely on two considerations: (1) the sheer speed of the camera's function (he thinks) is too quick for the eye to catch, so that filming is no longer "manual" in the sense in which casting bronzes and minting coins are manual (220, 222); and (2) mechanical reproduction "emancipates the work of art from its parasitical dependence on ritual"—it bases art on "politics" (224). But, of course—regarding the first assumption—trained filmmakers are perfectly aware of what film can capture: it is *they* who decide what to allow and what to construe as the final composition of a film. You have only to appreciate the minute technical control of each frame of Hiroshi Teshigahara's *Woman in the Dunes* (1964) to see it is "manual" in the only sense that counts (as a form of craft expertise). The same is already true in Carl-Theodor Dreyer's much earlier *The Passion of Joan of Arc* (1928), which predates Benjamin's essay.

In fact, if you study Falconetti's face and bearing in *The Passion,* you see how impossible it is to deny that there *is,* in our encounter with film, something akin to a face-to-face encounter with the actor, in a sense every bit as authentic as our encounter with the actor in live theater. More than that, early attempts to film stage plays, using techniques that would have counted as authentic in the theater, are inauthentic on film. Sarah Bernhardt was made to learn that hard lesson when she played the lead in *Queen Elizabeth* (1912): reports indicate that her vaunted skills (which, on Stanislavskyan grounds, would have been inauthentic in any case) were clearly inauthentic on the screen. (I myself have never seen the film.)

1988). See, further, Joseph Margolis, *Interpretation Radical But Not Unruly: The New Puzzle of the Arts and History* (Berkeley and Los Angeles: University of California Press, 1995), chaps. 5–6.

34. Benjamin, "The Work of Art in the Age of Mechanical Reproduction," 218, 220. Further references in Chapter 4 to this work will be noted parenthetically in the text.

The obvious lesson is that the authenticity of acting is itself a contrived artifact. The gaze of Abraham Lincoln in the well-known photographs of him is as mysterious and arresting in marking the presence of "*l'Autrui*" as anything that would require the physical presence of Lincoln himself. Very often, the gaze or face of someone in a painting or a film is more commanding than it would be in the flesh. And, in any case, in theater and film, it's the "presence" of the *character* incarnate in the actor's work that is of paramount importance. The other conception is a confusion again between the merely physical and the significant in the context of art.

What, you may well ask, is authentic in the presence of a character? Benjamin cannot rightly answer, because he insists (mistakenly) that "the artistic performance of a stage actor is definitely presented to the public by the actor in person": on the familiar reports, neither Bernhardt nor Garrick "present" themselves in being physically "present" on the stage. Furthermore, in film, Benjamin says (again mistakenly), "the audience . . . take[s] up the position of a critic, without experiencing any personal contact with the actor" (228). (And, in the sense in which actors are present on the stage, the same holds for the actors in a film, once the different practices are sorted.) But if you have seen such recent films as *Shine* or Billy Bob Thornton's *Sling Blade,* you know at once that Benjamin cannot be right. We *learn* to perceive the authentic in film as we learn to perceive it in life.

In speaking of film's instruction, I am speaking of a particular potency of films. I proceed only by salient exemplar, not by any essentialism or inclusive generalization or even by a particular filmmaker's intention. Film instructs us in the analogies that hold between its own montaged worlds and the constructed narratives of actual life. In addition, film educates through the potentiated sensibilities of the latter reciprocally actualized by further filmic "utterances" in the former—reabsorbed by interpretive appreciation in the latter. That discovery is itself a second-order reflection on what to make of the human condition, the paideia of the arts, and the variant ways in which the intended lesson (one among many) illuminates the paideutic function of older arts. It is in this sense that Benjamin loses himself and us in the sheer detail of film's devices. All of the arts are the constructed utterances of an enabling age: we study ourselves in studying the arts, and we are thereby continually altered in the sensibilities with which we continue to do so. Hence, there cannot be any fundamental disjunction between our grasp of film and our grasp of any older arts, and we cannot understand ourselves or others if the arts are not legible. For, ultimately, they are us.

I see no difference in this regard between speaking directly to another

person, painting the "Starry Night," fomenting a revolution, directing the production of a film, and silently interpreting a poem. They are all forms of human "utterance": we are made intelligible through their intelligibility, and vice versa. Every episode of reciprocal utterance and interpretation alters the potentialities with which we may continue.

Furthermore, if what I have said about Benjamin's confusion holds, you see at once the preposterous but more important mistake of Emmanuel Levinas's touching attempt to ground the ethical, the meaning of Being, in the conceptual ineffability—the face-to-face encounter of myself in the presence—of another. For one thing, if "another" is a particular presence, it will be individuated and then conceptually "comprehended"; if it is "another," it will have to be physically embodied and then once again comprehended; and if it speaks or "utters" words, acts, or artifacts, it will be legible and will share with us a shared world. The "presence of another" (or the Other) is the sense of being in a human world, where art and artifact are as human as the human face.[35] What is human about the human face is a function of our enculturation, our historical paideia. I don't deny there must be a biological basis for that process (as Jerome Bruner, for one, has compellingly confirmed), but, then, humans will never be ineffable for at least that reason. There is an "amplitude," an inexhaustibility, in the human encounter, but ineffability is its absence. Benjamin would lead us up the garden path, not only in the matter of art but in humanity itself—which, ultimately, of course, are one and the same.

We are the sole, the quite mysterious, natural species that, by enculturation, becomes "second-natured" artifacts, apt for and drawn to the proliferating work of self-interpretation, socially and personally. Art, technology, and language yield the principal detachable artifacts of that absorption, so that their own extraordinary persistence as stable public objects of interpretation (sentences and artworks)—sharing in the unique way they do the Intentional complexities of the life of a community of selves—deflects us, mercifully, from the explicit realization that we are after all interpreting ourselves. When all is said and done, the "aura" of art, the aura of technology and history, for that matter, lies in the reflexive community of culture itself. There are no special props of authenticity: none are possible. Benjamin's disjunction of the technology of mechanical reproduction and the

35. See Emmanuel Levinas, *Totality and Infinity: An Essay on Exteriority,* trans. Alphonso Lingis (Pittsburgh: Duquesne University Press, n.d.), for instance 79–81. The association between Benjamin and Levinas arose in a conversation with my friend and colleague, Edward Casey, who advised me on the Levinas text.

enculturing technology of political life, therefore, is simply the denial of the ineliminable conditions of self-discovery in the entire career of art.

Allow me, then, to ask you to ask me for a final reckoning. What (you politely ask) is the "meaning" of the arts? I find I cannot avoid describing it as overcoming, without quite succeeding and without quite failing, the ephemeral history of the whole of Intentional life. We build and rebuild the dense structures of our artifactual world, partly out of memory but, more vitally, out of imagined possibilities read as perceived potentialities. We Intentionalize the world, not merely by piling artifact on artifact but by creating and deciphering the interpretively reflexive (the endlessly reinterpreted) history of that same undertaking. You will find the evidence already in ancient Egypt—for instance, in Ikhnaton's deliberate redefinition of the temple precincts in the name of his reform: hence, in our productive memory of the enabling precipitates of his own (Ikhnaton's) gradual (and local) failure.

Critical interpretation, like art and life, requires a logic adequate to its open-ended task. In the midst of obvious flux, we risk the loss of present "meaning" if we cannot repossess, by interpretive fiat—but not for that reason anarchically—the reinterpretation of our entire artifactual past. We need no necessary fixities here; none exist, in any case, to be recovered. Flux is the medium of our life: all that is needed is that change should not be too rapid to be grasped or too slow to fire our vision. The whole of art is, so to say, a society's homeostasis under fluxive history.

Let me put the lesson a little more compendiously. If we think of the arts, as we do language and action, as the *utterances* of culturally apt selves, then by an obvious metaphor we may think of selves as themselves "uttered" by the enculturing processes of their home societies. Then artworks, like sentences, may be thought of as the nominalized, relatively independent, detachable precipitates of that same process. We ourselves are constituted by the salient potencies of our historied world; we then continually reconstitute ourselves by the reflexive competence of assimilating the unfolding import of our experience and whatever our world deposits ("utters"). My suggestion is that, in our own time, film compellingly confirms the plausibility of treating our understanding of ourselves and our world as montaged in a sense analogous to the montage of filmic worlds. We learn to see ourselves that way—but we could easily make the same discovery by reading, say, Marx or Nietzsche, or by dwelling on psychopathologies or epochal histories, or by frequenting the theater or reading literature.

The arts collect certain notably absorbing utterances that become our

own evolving montaged sensibilities apt for further such absorption. Film is simply the most obvious, the most accessible, the most transparent metonym—and engine—of that process in a mass society. We certainly do not always think of human life this way, but it is now a natural conception, though no more than one among many. What the model confirms most compellingly is simply that, by enculturation, we acquire, as individuated selves embodied in the members of a biological species, an artifactual, collectively defined (and collectively shared) nature, which is subject, through the sheer exercise of the sensibilities we acquire, to the power to change and be changed by the historically contingent forces of our evolving world. The arts—notably, film, in our own time—provide the principal milieus for deliberately experimenting with such change, incorporating as well as can be done the conceptual and imaginative resources of every cultural sensibility that can be captured and transformed by our own sensibility.

Epilogue
Interpreting Art and Life

I cannot deny that, in bringing this account to a close, I have signaled a deeper enigma that has been only partly deciphered. No one should be surprised, however, that I have allowed its presence to be felt without hurrying to complete its analysis. What I am raising here is, of course, the ultimate question, the question of how we should understand our efforts to understand ourselves—an endless task. There is no short answer to round out the suggestion I've pursued in Chapter 4, namely, that in exploring the possibilities of cinematic imagination, we are actually exploring our own potentialities and (thereby) altering our capacity for further trials of imagination and (thus) further changes in our nature.

I view this reciprocity in two ways: in the sense that human beings, as selves or persons—not mere members of *Homo sapiens*—lack "natures" (natural-kind natures) and have instead "histories," or have historied natures; and in the sense that art, like language and action or behavior, is the utterance (or "expression") of ourselves as historied selves, made entitatively robust, individual, and discernible by virtue of being embodied (like ourselves) in one or another natural *materia*. Just as selves are embodied in

the individuated members of *Homo sapiens,* actions are embodied in physical movements; words and sentences, in uttered sounds; and sculptures (like Michelangelo's *Moses*), in "uttered" stone. Insofar as artworks are inherently Intentional in nature, the interpretive fortunes of their natures are not entirely separable from the fortunes of our own "second-natured" natures. Discourse requires that we individuate ourselves and artworks separately. But nothing can have Intentional properties (in a realist sense) apart from the continuing collective life of an actual human society. All human societies "utter" (or express) their second-natured potentialities in language, art, and action. Consequently, we alter ourselves (our creative and interpretive powers) in inventing new forms of self-expression, and what we utter cannot fail to be interpreted again and again as a result of such evolving changes.

There is, in this regard, no reason to suppose that, in a complex society not devotedly committed to an unquestioned body of timeless truths governing the whole of human life, it will take no more than one encompassing, total, linear, evolving interpretive thread to bind up all our histories. That is indeed the tacit assumption ultimately favored (in very different ways) by theorists as different as Beardsley, Hirsch, Iser, and (even) Gadamer.[1] There are bound to be as many diverse posits of interpretive possibility as the human mind can juggle, as ephemeral or as compelling as you please; within that motley, particular strands will be continually discarded or raised up to a saliency that cannot be ignored, at least for a time. Not infrequently, voices will appear attempting to impose a greater fixity on the consensual drift of our age, without ever ensuring any necessary or inviolable unity. The threat of interpretive instability—in the limit, the threat of indecipherability—is offset by the plain fact that human societies cannot fathom changes that are so radical or sudden that none of the fluent practices of Intentionalized utterance could possibly parse such changes, incorporate them, or make them familiar by standard exertions. (One thinks, here, for instance, of the original reception of the Fauves or the cubists or authors like James Joyce and Mallarmé at their most extreme.) If you look at the history of art and language, you cannot really find such discontinuities, except in the occasional pictographs of an entirely unknown, completely alien culture.

David Hume—conservative though he was—defined (in the *Treatise*)

1. See the review of Gadamer's account in Joseph Margolis, *Interpretation Radical But Not Unruly: The New Puzzle of the Arts and History* (Berkeley: University of California Press, 1995), chap. 3.

sameness of property so impossibly that the least perceptual change in a would-be exemplar from one instant to another signified total dissimilarity. If we followed Hume literally, all speech would become instantly impossible, for speech would then require a completely new vocabulary at every instant of attempted utterance. (Hume obviously grasped the point, abandoned the theory whenever he had anything of importance to say, and fell back to his theory only when nothing significant was being risked.) It is not uninstructive to say that ordinary life and speech fall neatly between the impossibility of Hume's limiting condition and the arbitrary confusion of the Parmenidean opposite. For Hume holds (officially) that no two successive moments are ever sufficiently alike to be intelligibly perceived as the same, in virtue of which the same general predicates can be assigned to each (possibly Hume's version of the Heraclitean flux), while Parmenides insists on a truth that can never really be demonstrated, namely, that change is neither real nor intelligible. (It was Aristotle, of course, who first explained Parmenides' errors, though Aristotle himself falls back to his own modal fixities.)

The essential theme to bear in mind is that predicative similarity is similarity in difference, and that, failing all the forms of Platonism, the "objective" detection of similarity is artifactual in being consensually tolerated within the *lebensformlich* practices of particular societies—in a sense that cannot be disjunctively separated (except by convention) from what is not so constituted. If you grant the point, you cannot fail to see its bearing on the objectivity of interpretive attributions. Any realist reading of interpretation must then accord with the ontic oddity of the nature of cultural entities, and that means admitting the eligibility of historicism and relativism.[2]

In interpreting a complex artwork, respondents reconstitute its Intentional structure. They may, but need not, do so in ways that radically depart from its earlier entrenched sense. It's only that, from a changing historical horizon, we must continually reconfirm the Intentional saliencies of our

2. This goes entirely contrary to Danto's well-known theory of history. Compare Arthur C. Danto, *Narrative and Knowledge* (New York: Columbia University Press, 1985); and Joseph Margolis, *The Flux of History and the Flux of Science* (Berkeley: University of California Press, 1993). Danto holds the same view of history and the interpretation of artworks (or so it seems), except for the profoundly troubling fact that, on his theory of art, artworks don't actually exist, though persons do. Of course, Danto does speak of particular works of art in the usual way. Although I leave the full analysis of Danto's theory for another occasion, I wish to point out that, both with respect to history and to art (and for the same reason), Danto favors a "telic" picture of interpretation, fixed originally "at one end" (the past) and unfolding (additively) to accommodate a future that never reconstitutes the past meanings of cultural life, except for error.

own ethos, confirming as well the perceived Intentional import of past segments of history, particular artworks, and texts already deposited. Intentional structure exists only in the historicized symbiosis of encultured selves and their encultured deeds and artifacts.

All that is embodied (as I have said) in the material world. But the very existence and nature of such entities are emergent in a *sui generis* way, and their objective specificities are interpretively labile in ways that are not found anywhere else in nature. Admitting that much sets no limits I can see on the freewheeling practice of interpretation—except that not all interpretations will be judged to be of equal weight or equal objectivity, will follow the same scruple regarding what to count as objectivity, will even remember the same interpretive exemplars or the same history of interpretation, or will be reconcilable with the formal constraints of a bivalent logic. What then?

I see no reason to suppose that, if historicism and relativism and a consensual account of interpretive objectivity prove coherent, we would be better served by refusing such possibilities of constative freedom in favor of bringing the logic of history and criticism (and self-understanding) into line with bivalence and the putative determinacy of physical objects.

Let me put this a little more forcefully. In an entirely different context of discourse, Michael Dummett offers the following pronouncement, which he obviously believes should apply everywhere with respect to real "states of affairs":

> A statement, so long as it is not ambiguous or vague, divides all possible states of affairs in just *two* classes. For a given statement, either the statement is used in such a way that a man who asserted it but envisaged that state of affairs as a possibility would be held to have spoken misleadingly, or the assertion or statement would not be taken as expressing the speaker's exclusion of that possibility. If a state of affairs of the first kind obtains, the statement is false; if all actual states of affairs are of the second kind, it is true. It is thus *prima facie* senseless to say of any statement that in such-and-such a state of affairs it would be neither true nor false.
>
> The sense of a statement is determined by knowing in what circumstances it is true and in what false.[3]

3. Michael Dummett, "Truth," *Truth and Other Enigmas* (Cambridge: Harvard University Press, 1978), 8.

When Dummett says that it is "*prima facie* senseless" to speak of a statement about a particular "state of affairs" as being "neither true nor false," he obviously means that it is only when it (a given statement) is "ambiguous or vague" that one would so speak; otherwise, the possibility would not arise. In effect, he means it is senseless to regard states of affairs as inherently vague, ambiguous, indeterminate, or similarly encumbered.

Two answers can be found to this position. C. S. Peirce gave the first a classic form, writing that no principled disjunction exists between a "state of affairs" (possessing certain determinate properties) and its determinate properties depending on our use of the discursive categories in terms of which such determinacies may be affirmed.[4] The second response depends on the ontic peculiarity of cultural entities (which has already been laid out). The point of the counterargument is simply that if theorists who address the logic of truth in the context of realist inquiries (as with Dummett) suppose that bivalence (or *tertium non datur*) is unavoidable (because any other policy would be "senseless": a Fregean assumption), they owe us an argument about the nature of the real world, *not about logic*. I do not say that Intentional predicates are vague but, rather, determinable yet not determinate. (Peirce's theory, if I understand it rightly, is that all predicates, in some insuperable measure, are determinable and are made, by additional thought or discourse, determinate.) But if the cultural world is thus determinable (because interpretable), then bivalence cannot hold everywhere, and where it *can* hold, it does so only under antecedently assigned degrees of logical freedom or constraint. In addition, I hold (against Peirce, in effect, since I oppose Peirce's teleologism in inquiry and reality) that Intentional attributes are inherently open-ended and determinable and that interpretive determinacy holds provisionally, only within a historicized consensus. What holds for artworks holds for selves as well, and vice versa.

This is the most radical theme I can find that might be expected to bridge our own transition from the end of one century to the beginning of the next and attract adherents. It plainly invites a closer study of the similarities and differences between selves and artworks—that is, under the shared condition that both are cultural artifacts, have histories rather than natures, and have determinable Intentional properties that are interpreted and reinterpreted in accord with the shifting horizon of our enabling culture. The essential puzzle of this comparison lies with the obvious fact that selves (but

4. *Collected Papers of Charles Sanders Peirce,* ed. Charles Hartshorne and Paul Weiss (Cambridge: Harvard University Press, 1962), sections 5.446–50.

not artworks—normally at least) are biological creatures; hence, the changing interpretation of their careers is affected and constrained (as that of artworks is not) by the process of biological growth. The interpretation of a human career depends on the biological pattern of the embodying entity (a member of *Homo sapiens*), whereas nothing similar can be claimed for artworks (which are, nevertheless, also materially embodied). But remember that the change in "nature" I am flagging is a certain entity's Intentional attributes, *not* its physical attributes.

Michel Foucault, who is in sympathy with these themes (though he expresses himself in an entirely different way), advances the bolder conjecture that human *bodies* are also altered by significant changes of interpretive epistemes moving from one historicized age to another. That is, of course, the basic theme of his *History of Sexuality* and, in an abbreviated form, of *Discipline and Punish*. But Foucault would never say that the bodies of persons living in the past were altered, as far as the historical past was concerned, by our interpretive, or epistemic, activities in the present. That would hardly make sense. (I myself nowhere urge such a doctrine.)

When, however, Foucault reinterprets Velázquez's *Las Meninas* in the fresh way he does, what he says would (similarly) make no sense unless the interpretable features of Velázquez's painting were labile in the way I suggest.[5] I don't claim that Foucault shares my "metaphysics" of art and history, only that the account I offer renders in a natural and legible way what Foucault does say time and time again in interpreting human history. (Of course, I mention Foucault as a congenial spirit.)

If you suppose that Foucault's remarks about *Las Meninas* have any prospect of being objectively valid—not "true" but (as I should say) "reasonable" (in a truthlike sense) in accord with a relativistic logic—then you will have to yield to something akin to my reading of historicity. The matter is almost completely neglected by the Fregeans, even those who confine themselves to the arts and their criticism.

This reasoning goes entirely contrary to the usual canons in the theory of art. I claim it is the linchpin of any viable cultural realism. When, for example, it was discovered that Dante's *Commedia* was, in all likelihood, a detailed Christian reinterpretation of a hitherto unknown Muslim exemplar, the determinable meaning, the Intentional structure, of the *Commedia* was thereby altered (at its putatively assigned origin). When Euripides composed

5. See Michel Foucault, *The Order of Things: An Archaeology of the Human Sciences,* translated (New York: Vintage, 1970).

the *Iphigenia at Aulis,* he altered our sense of the "original" Intentional import of Homer's brief treatment of the episode in the *Iliad.* The relevant histories oblige us to construe the determinable structure of the works in question as (now) "originally" and objectively hospitable to determinate interpretations that might not have passed muster in an earlier phase of their interpretive careers. I cannot see how that can be denied—particularly in the spirit of cultural realism and assuming the determinability of Intentional predicables. It is in this same sense that Foucault alters our sense of *Las Meninas:* he brings to bear on a putatively original (or contemporaneous) sensibility a genuinely contemporary successor of such imagined interpretive imagination, in returning to the canonical or contemporaneous reception of the Velázquez under the influence of our own retrospective sensibility. If you see that, you see how and why the historical past (as distinct from the physical past) cannot fail to be open to change. For every real Intentional structure is, when admitted to be real, genuine within the *lebensformlich* space of our own interpretive powers of reclamation.

The logic of all this is not my concern here. I have already laid out my view of the resources of relativism and my conception of the metaphysics of a work of art. However, in order to strengthen the plausibility of treating artworks and selves in the same interpretive way, one important link needs to be clarified. Someone is bound to point out that human beings change over time as they grow from childhood to maturity; that's why we reinterpret their lives in the way we do. Nothing of that sort happens to artworks, and yet I say artworks are "like" persons and because of this similarity are open to reinterpretation. How can I justify this claim?[6]

I offer two replies. First, the question pretty well shows that, in interpreting the "meaning" of a life, it is common to assign to early behavior, in the light of later behavior and even later theories of behavior, otherwise inaccessible meanings of what has gone before. I have no doubt, for instance, this is the right way to read Augustine's admission of the early theft of an apple, that is, in the light of Augustine's own account of the providential import of the whole of human life—in accord with the master theme of the *City of God.* The meaning of the past is characteristically projected (and continually redefined) from our changing understanding of our own present. Second, as I have already remarked, what is common to selves and artworks is not biology but Intentionality: selves and artworks are materially

6. The question was nicely posed by a reader for Penn State Press, who preferred to remain anonymous.

embodied in different ways, but what is embodied are Intentional struc-
tures, and it is those structures that are affected in similar ways under inter-
pretation. So there is nothing strange in saying that artworks are "like"
persons—without their being persons themselves. I don't deny that the sim-
ilarity needs to be spelled out more fully. But, of course, what persons and
artworks share, in virtue of which the interpretations of them behave in
similar ways, is their possessing or being histories rather than possessing
natural-kind natures or being natural-kind entities.

I take it that histories, the numerically unitary Intentional careers of in-
dividuated selves or artworks, are what is subject to the plural, open-ended,
even "incongruent," reinterpretively transformable forms of interpretation I
support. Nothing bearing on the form of (material) embodiment, different
among selves and artworks (as well as among different kinds of artworks),
gainsays that. The notions of "embodiment" and "incarnation" are no more
than conceptual devices for ensuring that we need not be confronted with
any form of mind/body dualism or any analogue of such a dualism applied
to the relationship between nature and culture.[7]

This is a complicated matter in its own right, I don't deny. But what
needs to be remembered is that, on an argument already presented, the pre-
cise peculiarity of cultural entities is that they may be firmly individuated,
assigned "number," referred to successfully in terms of numerical identity
and reindentifiability—at least as well as anything in physical nature can
be—in spite of the fact that, unlike that of physical objects, the natures of
cultural works are not entirely determinate, even though (or because) they
are interpretively determinable. They are determinable in the sense in
which relativistic interpretation may be objective. In short, to legitimate rel-
ativistic interpretations is tantamount to admitting that artworks are, in the
relevant sense, "like" persons. Artworks acquire trailing histories of interpre-
tation in terms of which (in various selective ways) future interpretations
reconsider past phases of their interpreted careers. Nothing could be more
straightforward. (You must remember that reference can never be fully fixed
by purely predicative means.)

But what, you ask, is the sense of the similarity between selves and art-
works? It's nothing more than the sense in which the conditions of "objec-
tive" interpretation are admitted to obtain (even if relativistically construed).
That's all. You must bear in mind that to interpret a poem or a painting or a

7. See, further, Joseph Margolis, *Historied Thought, Constructed World: A Conceptual Primer for the Turn of the Millennium* (Berkeley and Los Angeles: University of California Press, 1995).

human life or a historical event is to locate its Intentionally salient features in an interpretively hospitable way within the historical ethos of our society—within whatever we may construct or reconstruct as our *Lebensform* or *Lebenswelt* or episteme or *habitus* or tradition, which is, of course, reciprocally affected by what can be said about the other.

We cannot claim to interpret a life or artwork objectively unless we can isolate a relatively stable part of our encompassing cultural world as pertinent to that undertaking. There can be no uniquely adequate or appropriate milieu relative to which alone any life or artwork can be objectively interpreted. Whatever interpretive work is deemed objective becomes, for that reason, a salient part of the encompassing ethos from which further interpretive possibilities may be drawn and pertinently weighted.

The truth is, we rely on exemplary instances drawn from a sprawling run of consensually tolerated interpretive practices: different exemplars will be favored by different practitioners, with no plausible prospect of restricting these by way of any would-be objectivist canons. (Such canons—Romantic, New Critical, structuralist, reader-response, and others—will prove unable to vindicate exclusively whatever formalized account of objectivity they may pretend to favor.)

Once you concede these complications, the solution glides into view. The similarity between selves and artworks lies in their sharing Intentional structure, not in their material embodiment. For, of course, what they share is the unity of expression and expressive agency, linked as structured precipitates and structuring energies within the same encompassing ethos. The history, the evolving career, the meaningful unity of life and art rests with what is defensibly affirmed within the narrative account of a life's or an artwork's persistent presence in our culture.

The cultural world contains no principled disjunction between "subject" and "object": paradigmatically, we examine and interpret ourselves, and we do so by examining and interpreting the individuated utterances of individual and aggregated life. Those utterances will be deemed (as they must be) the expressions of a collective ethos that is itself endlessly reconstituted in preparation for, and in response to, the utterances (past and future) of our evolving culture.

In art, therefore, we interpret ourselves by cultural utterance, and in criticism, we interpret ourselves by interpreting our detachable utterances. In art and life, selves and artworks are nothing at all if separated from the enabling ethos of interpretation. For, under interpretation, we ourselves become the expression of, not merely the agency for expressing, the

narratized potentialities of that same collective ethos. Where Intentionality is lacking, we suppose an independent world. Where Intentionality is present, no such independence can exist. In the latter circumstance, objectivity is inherently consensual (though not criterial). Correspondingly, the natural world is objectively known only through the resources of the cultural world. Here lies a benign antinomy that explains the division of labor between the arts and the sciences—but also their inseparability.

Index

abstract expressionism (Pollock), 19, 20, 21–22
Aeschylus, 8
"aesthetic" (Kant), 10
"alethic," 45
Alice in Wonderland (Carroll), 74
Antigone (Sophocles), 120
Apel, Karl-Otto, 9
"appropriation" (Danto), 16, 31
Aristotle (Aristotelian), 10, 39, 43, 44, 45, 47,
 72–73, 79, 80–86 passim, 119, 131
 on bivalence and invariance, 47
 Metaphysics Gamma, 11, 43, 65, 72
Arnheim, Rudolf, 101, 104, 106
art (artwork, work of art)
 attributionist, 23, 28, 30–31
 changed by interpretation, 80–86 passim, 89,
 90–91, 92, 94, 95, 97, 98
 compared with person, 135–38
 as cultural artifact (construction), 23, 32, 33,
 34, 65, 89, 98, 133, 136
 Danto on, 20–21, 30–31, 32–34, 35, 37–39,
 61–62
 defining, 15–16, 67–69, 71
 determinate in "number," 65
 embodied and emergent, 68, 99, 132
 end of, 17, 18, 38
 as entity, 34–35, 39, 67–71 passim, 76, 78, 79,
 80–81, 88
 essentialized, 20–21, 23, 24, 25, 30
 existence of, 100
 Gombrich on, 24
 Greenberg on, 19–20, 26, 27, 28–30
 and histories of interpretation, 81–84, 136
 as history or historied career, 34, 36, 88,
 90–91, 98
 individuation and identity of, 89
 as interpretively determinable, 65, 73, 99,
 133–36
 as lacking fixed nature, 72–73

art (artwork, work of art) (*cont.*)
 modern and postmodern, 16
 "nature" of, 36, 90, 92, 94–95
 perception of, 32–34, 35, 36, 37–38
 periodized, 16–17, 22, 39
 as possessing Intentional structures, 32, 34,
 64, 87, 92–93, 97
 posthistorical (Danto), 16–18, 20, 23, 27,
 30–31, 33
 as token-of-a-type, 70
 as type, 69–70
 as utterance, 61, 125, 126–27, 130
artworks, confused with natural objects, 27,
 35–36, 76–77, 108
 bearing of *Laocoön* on, 29, 33, 108
 in Benjamin, 108, 124
 in Danto, 30–33, 35–36, 37–38
 in "flatness," 28–29, 33
 in Greenberg, 27–29, 30, 33, 35
 in Hanslick on music, 33
 in Panofsky, 105–6, 110
 with regard to Intentionality, 31, 33–34
attributionism, 23
Auerbach, Erich, 109
Augustine, Saint, 135
"aura" (Benjamin), 104, 108, 109, 114–17, 118
authorial intent, 80

Bakhtin, Mikhail, 22–23
Barthes, Roland, 11, 49, 59, 66, 82, 95
Bauman, Zygmunt, 2 n. 6
Bazin, André, 101, 102
Beardsley, Monroe, 47, 50, 60, 61, 74–79, 80–86
 passim, 92, 130
 The Possibility of Criticism, 74, 76, 78
Benjamin, Walter, 101, 104–5, 107, 108–17,
 119, 122–25
 "The Work of Art in the Age of Mechanical
 Reproduction," 112, 116, 124

Bernhardt, Sarah, 112, 124
Bidlo, Mike, 23, 31
bilinguals, 41
bivalence, 45–46, 47–48, 49, 51, 54, 58, 63, 64,
 73, 78
 applied constructively, 62–64
 Beardsley on, 60
 Hirsch on, 60
Bloom, Harold, 58, 95
Bonaventure Hotel, 26
Bordwell, David, 110–11
Brandenburg (Bach), 90
Brentano, Franz, 56, 92
Bruner, Jerome, 125
Burnyeat, Myles, 55 n. 13

Cabinet of Doctor Caligari, The (Wiene), 109, 120
career, 37
"carnavalesque" (Bakhtin), 22–23
Carrier, David, 21
Carroll, Noël, 105 n. 11, 110, 111
Cavell, Stanley, 101
Cézanne, Paul, 19, 27–29 passim, 107, 108, 116
Citizen Kane (Welles), 106
Classical Symphony (Prokofiev), 64
cognitive privilege, 6, 7
Commedia Divina, La (Dante), 134
Constable, John, 24
constructivism, 59, 65
cubism, 37
cultural entities, realist treatment of, 49, 51, 56,
 57, 60–62, 84, 88, 90, 98, 104
cultural relativity, 53–55, 65
culture and nature, 12–13, 46–47, 52, 88, 89–91

Danto, Arthur, 16–22, 23–26 passim, 27, 29–39,
 56, 57, 61, 95, 131 n. 2
 After the End of Art, 17, 19, 21, 30–31, 32,
 37–39
 Transfiguration of the Commonplace, The, 32
Davies, Stephen, 47 n. 5, 67 n. 1, 68 n. 3
Dead Souls (Gogol), 69–70
Death of a Salesman (Miller), 120
Deleuze, Gilles, 9
de Man, Paul, 7–8
Demoiselles d'Avignon, Les (Picasso), 66, 93–94
description and interpretation, 49–50, 62, 78
determinate/determinable, 73, 75
Dickinson, Emily, 89

Dilthey, Wilhelm, 62, 80
Doctor Marbuse (Lang), 122
Doctorow, E. L., 7
Dummett, Michael, 132–33
Dürer prints, 89–90

"embodied," 29, 68, 69, 98, 136
"end of art" (Danto), 17, 38
"entity," 69, 88
Euripides, 120, 134–35
"exists," 69

facts, as artifacts of history, 54
Falconetti, 123
film
 and "(in)authenticity" (Benjamin), 113,
 115–17, 123, 124
 and *Laocoön,* 102–6 passim, 109, 110–11,
 112, 113
Fish, Stanley, 82, 95
"flat(ness)" (Greenberg), 3, 19, 27–29, 33, 37
flux(ive), 4, 9, 10, 86
Foster, Hal, 19
Foucault, Michel, 9, 10, 43, 54, 62, 82,
 134–35
Frankfurt Critical (school), 9
Frege, Gottlob (Fregean), 133, 134
French Revolution, 7, 10, 43

Gadamer, Hans-Georg, 62, 80, 81, 82, 130
Garrick, David, 112–124
Geist (Hegel), 23, 62
genres, Hirsch on, 60, 77, 80
Gombrich, E. H., 21, 24–25
Goodman, Nelson, 70–71, 95
Gould, Glenn, 112
Grapes of Wrath (Steinbeck), 122
Greenberg, Clement, 1, 3, 10, 18, 19–22, 23–25
 passim, 26–30, 33–39 passim
 "Modernist Painting," 27–28
 "Toward a New Laocoön," 29
Greenblatt, Stephen, 95

Habermas, Jürgen, 2, 9, 10
Hamlet (Shakespeare), 49, 70, 72, 90, 91, 97
Hassan, Ihab, 2
Hegel, G. W. F. (Hegelian), 7, 17–18, 21, 23, 26,
 30, 31–33, 62, 87
Heidegger, Martin, 9, 62, 105, 106, 108, 115

hermeneutic circle, 60, 77, 80, 83
Hirsch, E. D., Jr., 47, 50, 60, 61, 75–79, 80–86
 passim, 92, 130
historical past, 39, 83, 135
historicity, 5, 7, 8–9, 10, 16, 18, 85–86
history, 21, 23
 essentialized, 17
 Hegel and the Hegelians on, 17–18
 periodized, 16, 17
 and the posthistorical, 17, 18
 sui generis objectivity of, 39–40
 telos of, 18
 theory of, 23
history of art, end of, 17
history of painting
 Danto on, 18–21, 27, 29–40
 Danto on Greenberg on, 19, 20–21, 37
 essentializing, 16, 21, 23
 Foster on, 19
 Greenberg on, 18, 19, 20, 21, 26–30
 Greenberg and Danto as Hegelians on, 18,
 26, 30
 Krauss on, 19
 objectivity of, 39, 40
Horkheimer, Max, 62
human existence, 104, 108
human nature, and the motion picture, 102,
 103, 107–8, 118–19, 120–22, 124, 126–27
Hume, David, 130–31
Husserl, Edmund (Husserlian), 56, 81, 82, 83,
 92
Hutcheon, Linda, 2, 7–8

Ikhnaton, 106, 126
"incarnate," 98, 100, 136
incommensurabilities, conceptual, 4, 5
"incongruent" interpretations (truth-values),
 48, 53, 55–56, 60–61, 62–65 passim,
 76–77
Intentional predicates (properties), 12, 55–56,
 63–64, 65, 92–93, 94, 98–100
 Danto on, 57, 61
 determinable but not determinate, 58, 60,
 65, 73, 75
 discernibility of, 57
 not reducible in physical terms, 76–77
 realist standing of, 55–57, 61
interpretation, 65–66, 72, 131
 of art and life, 126–27

Beardsley on, 74–75, 78
 and bivalence, 46, 49
 boundaries of, 66, 79, 93, 137
 and change in meaning, 75, 78
 constraints on, 85–86
 historicist view of, 86–87
 and individuation, 11
 and objectivity, 98
 and relativism, 71
 self-, 137–38
 and *sittlich,* 66
Iser, Wolfgang, 78, 80–82, 83–86 passim, 92,
 130
 The Implied Reader, 79, 82, 83

"Jack in the Beanstalk," 74
Jameson, Fredric, 11, 103–4
 The Political Unconscious, 103
Jencks, Charles, 1
Jones, Ernest, 91

Kant, Immanuel (Kantian), 9, 10, 23, 27, 106
Kiefer, Anselm, 63, 64
Kivy, Peter, 69 n. 6
Klee, Paul, 42
knowledge and legitimation
 constructivist recovery of, 6
 postmodernist view of, 5–6
Kracauer, Siegfried, 101, 103–4, 105, 108–9,
 117–18
 Theory of Film, 117
Krauss, Rosalind, 1, 3, 10, 19, 21–22, 25
Kuhn, Thomas S., 43, 54, 59, 87

Langer, Susanne, 101–2
language games (Wittgenstein), 62, 121
Laocoön (Lessing), 29, 33, 102, 103, 105, 109,
 113, 115
Last Supper (da Vinci), 90
Last Year at Marienbad (Renais), 106
laws of nature, as artifacts, 44, 52
Lebensform (Wittgenstein), 62, 121
Leotard, Jean-François, 2, 9, 10
Levinas, Emmanuel, 10, 125
Lincoln, Abraham, 124
literary criticism
 Beardsley on, 74–79 passim
 Hirsch on, 75–78
 Iser on, 79, 80–83

literary work (text)
 Beardsley on, 74–76, 77, 78, 79–80
 Hirsch on, 76, 77, 80
 and history of interpretation, 81–84
 Iser on, 79, 80–83
Luhmann, Niklas, 9

Manet, Edouard, 15, 20, 26–29 passim
Maninas, Las (Valázquez), 46, 85, 95, 134–35
many-valued logic, 48, 50–61
"Marseillaise, La," 75
Marx, Karl, 9, 62
McIntyre, Alasdair, 4–5, 10
 Whose Justice? Which Rationality?, 4–5
"mechanical reproduction" (Benjamin), 104,
 105, 108, 109, 110, 113, 114, 115, 123
"mere real things" (Danto), 32, 34–35 passim
Merleau-Ponty, Maurice, 107
Metropolis (Lang), 122
Michelangelo, 29
Miss Lonelyhearts (West), 58, 64
modal invariances, 4, 9, 10, 44
modernism, 5, 6, 25, 36
 and escape from historicity, 8
 Greenberg on, 19, 20–21, 23, 26–28, 29–30,
 35
 and neutrality, 5
modernism/postmodernism debate
 a distraction, 6–7, 39
 and historicity, 8
 local quarrels within, 1–3, 8, 9
 and modal invariances, 4, 9
 symptom, not problematic, 3, 8
modernity and objectivity, 5
montage, 115, 119, 121, 126
Morawski, Stefan, 2 n. 7
Moses (Michelangelo), 89, 130

"natural" but not "natural-kind," 97
neutrality, loss of, 5–6, 54
New Criticism, 74
Nietzsche, Friedrich, 23, 62
Night Watch (Rembrandt), 90
"number" and "nature," 11–12, 39, 87, 95

objectivism, 12, 54, 58, 65, 80, 85
objectivity, 3, 5, 6, 13, 54, 57, 58–59, 65, 80, 88
ontic (metaphysical) fixity (invariance), 72, 77, 86
Oresteia (Aeschylus), 91

paideia, and filmic worlds, 111, 118–19,
 121–22
Panofsky, Erwin, 101, 102, 104–6, 108–10, 112,
 115, 118
 "Style and Medium in the Motion Picture,"
 110–11, 117–18
Parmenides, 44, 131
Passion of Joan of Arc, The (Dreyer), 123
Peirce, Charles Sanders, 133
perceiving art and language, 34–36, 37–38
perception, Danto on, 30–34
perceptual similarity, 30–33, 64
performance, on stage and in film, 104,
 112–13, 123, 124
periodized history, 16–18, 20, 23–24
Petterson, Torsten, 50
Picasso, Pablo, 27–29 passim, 66, 107
Plato, 37–38, 43, 44, 87, 122
 Theaetetus, 46, 54–55, 65
Platonism, 11–12, 17, 20, 21, 27, 28, 29, 33, 63,
 64, 70, 131
Pointillism, 26
Pollock, Jackson, 19, 20–22, 25–26, 27, 37, 39
pop art, 38, 39
"post-historical" art (Danto), 16–18, 23, 36
postmodernism, 5–9 passim, 15–26, 36
predication, 11–12, 63–64, 72, 87, 92, 131
predicative similarity, 131
principle of charity, the, 64, 96
Protagoras (Protagorean), 43–44, 46, 51, 52,
 54–55, 59, 65, 70
Purple Rose of Cairo, The (Allen), 119

Queen Elizabeth (1912), 123
Quine, W. V., 54

Rauschenberg, Robert, 39
Rawls, John, 10
"real," 69
realism of the cultural, 49, 56–57
reductionism, 76–77
relationalism, 54–55, 59, 65
relativism
 alethic, ontic, epistemic features of, 45–46,
 50, 51, 52–53, 54
 alleged incoherence of, 43, 46, 51, 54–55
 ancient attack on, 43–44, 45, 46
 and bivalence, 46–48, 49, 55, 57, 58
 and constructivism, 59, 65

contrasted with cultural relativity, 53–54, 55
contrasted with skepticism, 53
defense of, 44–45, 50, 57–58, 61–62
history of, 42–44, 45, 46, 47, 59
"logic" of, 48–49, 50–51, 64–65
and objectivity, 49–50, 53, 62
opposed to relationalism, 54–55, 59, 65
and realism, 49
Riffaterre, Michael, 2, 8, 10
Romantic (hermeneutic) theory, 11, 75
Rorty, Richard, 2, 10
Rush, Geoffrey, 113

Sarrasine (Balzac), 11, 47, 58, 85, 94
Schindler's List (Spielberg), 119
Schleiermacher, Friedrich, 80
"second-best" (Plato), 87
"second-natured," 35, 125
selves
 as cultural artifacts, 35, 56, 76, 88, 125, 127,
 129–30, 133–34, 137
 embodied, 129–30, 132
 as having histories, not natures, 129
 and Homo sapiens, 35, 56, 97, 121, 129
 "second-natured," 125, 130
 as "uttered," 126–27
Shakespeare, William, 35, 89
Shine (Hicks), 113, 124
Shusterman, Richard, 50 n. 20
"significance" (Hirsch), 75, 77
similarity (predicative), 64
Sistine Chapel (Michelangelo), 29, 64
sittlich (Hegel), 62, 64, 115, 116
Sling Blade (Thornton), 124
Smith, Barbara Herrnstein, 58 n. 20
Socrates, 54–55, 59, 65
Sophocles, 120
Star Wars (Lucas), 120

Stecker, Robert, 47 n. 5, 73 n. 11, 91 n. 37, 100
 n. 45
Steichen, Edward, 109
"superimposition" (Beardsley), 74–75, 78
surrealism, 19–21

thinking
 Hegel on, 18
 as historicized, 7, 8, 10, 18, 24, 39
 as incarnate, 71
Thomson, George, 91
Three Musicians (Picasso), 28
three-valued logic, 48
Thucydides, 8
"token-of-a-type," 70
"transfiguration" (Danto), 35, 61
truth-value gaps, 48
Tugendhat, Ernst, 9
"type," 70

understanding "meanings," 41–42
unicity (of careers), 90–91, 94
unity (of natures), 90, 94
universals, theory of, 63

Van Gogh, Vincent, 15
Vasari, Giorgio, 24, 25
Vendler, Helen, 84
Venturi, Robert, 1
"verbal meaning" (Hirsch), 75, 77

Warhol, Andy, 29, 37–39 passim
Weitz, Morris, 68 n. 2, 84
Wittgenstein, Ludwig, 87, 121
Wollheim, Richard, 69 n. 6, 95
Wolterstorff, Nicholas, 69
Woman in the Dunes (Teshigihara), 123
Worringer, Wilhelm, 114

About the Author

Joseph Margolis is Laura H. Carnell Professor of Philosophy at Temple University. He is the author of more than thirty books, including most recently *The Truth About Relativism* (Oxford, England: Blackwell, 1991), *The Flux of History and the Flux of Science* (Berkeley and Los Angeles: University of California Press, 1993), *Interpretation Radical But Not Unruly* (Berkeley and Los Angeles: University of California Press, 1995), *Historied Thought, Constructed World* (Berkeley and Los Angeles: University of California Press, 1995), and *Life Without Principles* (Oxford, England: Blackwell, 1996).